HISTORIC PHOTOS OF
CHRISTMAS IN
CHICAGO

TEXT AND CAPTIONS BY ROSEMARY K. ADAMS

TURNER
PUBLISHING COMPANY

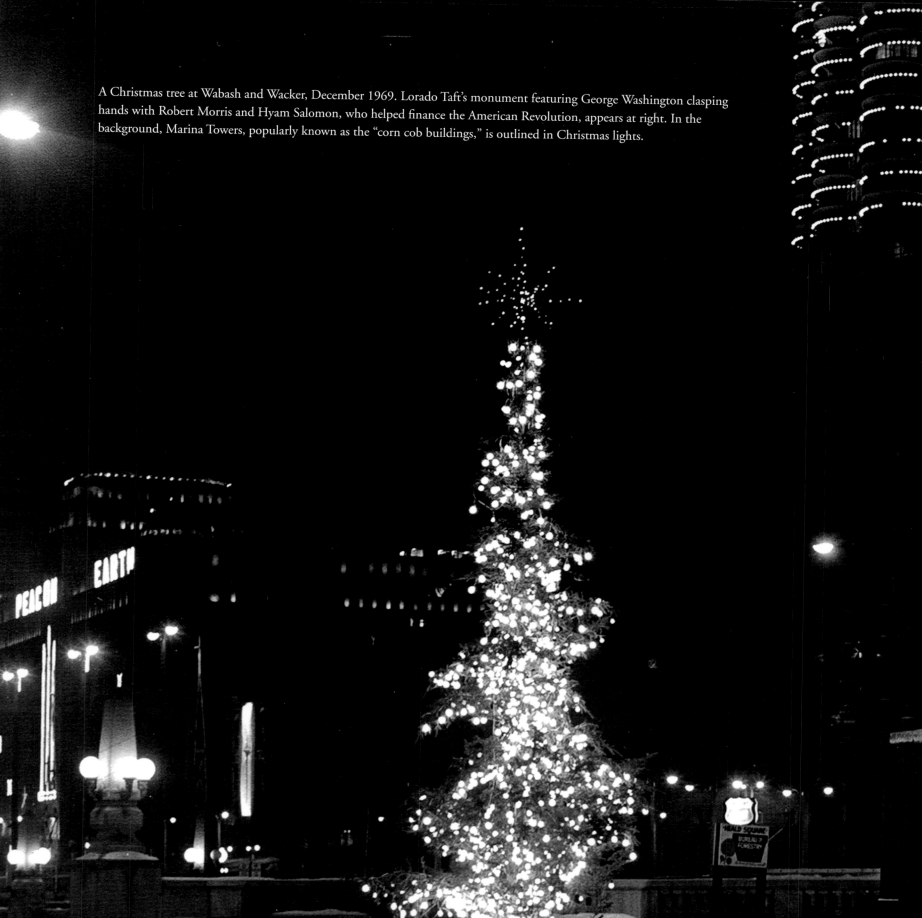

A Christmas tree at Wabash and Wacker, December 1969. Lorado Taft's monument featuring George Washington clasping hands with Robert Morris and Hyam Salomon, who helped finance the American Revolution, appears at right. In the background, Marina Towers, popularly known as the "corn cob buildings," is outlined in Christmas lights.

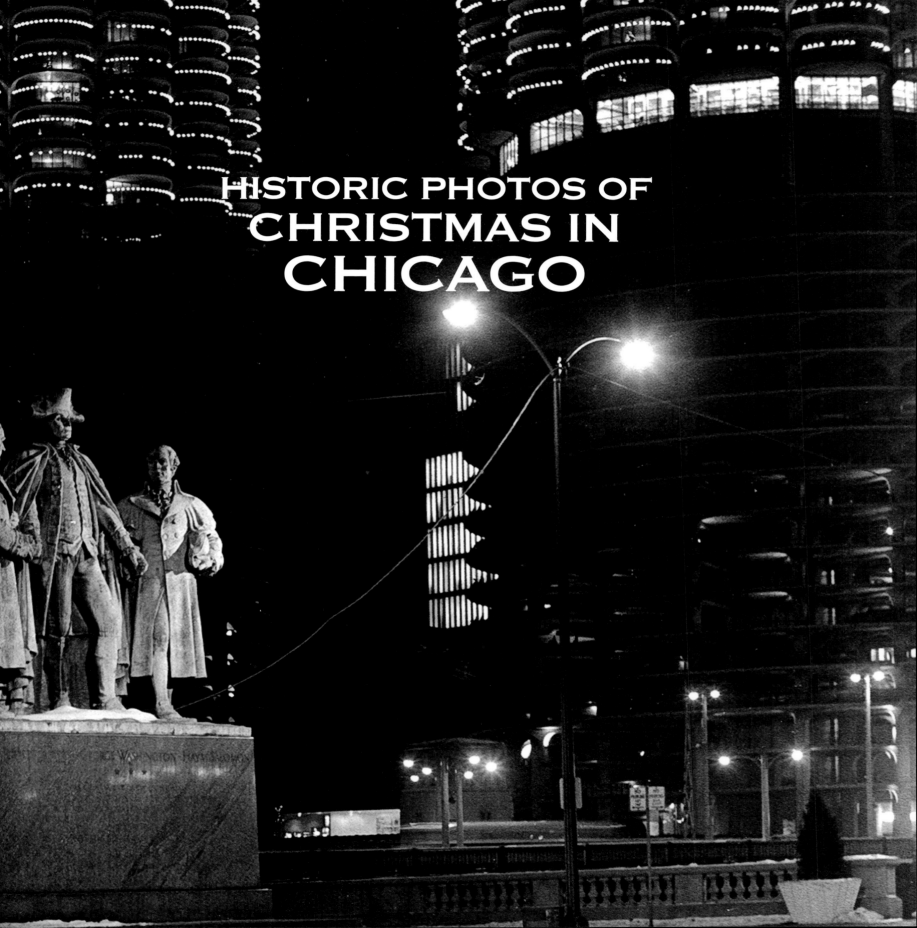

HISTORIC PHOTOS OF
CHRISTMAS IN
CHICAGO

Turner Publishing Company
200 4th Avenue North • Suite 950
Nashville, Tennessee 37219
(615) 255-2665

www.turnerpublishing.com

Historic Photos of Christmas in Chicago

Copyright © 2008 Turner Publishing Company

Library of Congress Control Number: 2008907573

ISBN-13: 978-1-59652-511-5

Printed in the United States of America

08 09 10 11 12 13 14—0 9 8 7 6 5 4 3 2 1

CONTENTS

Even in the heart of the city, Chicago takes on old-fashioned country charm after a snowfall, as in this view of Lincoln Park.

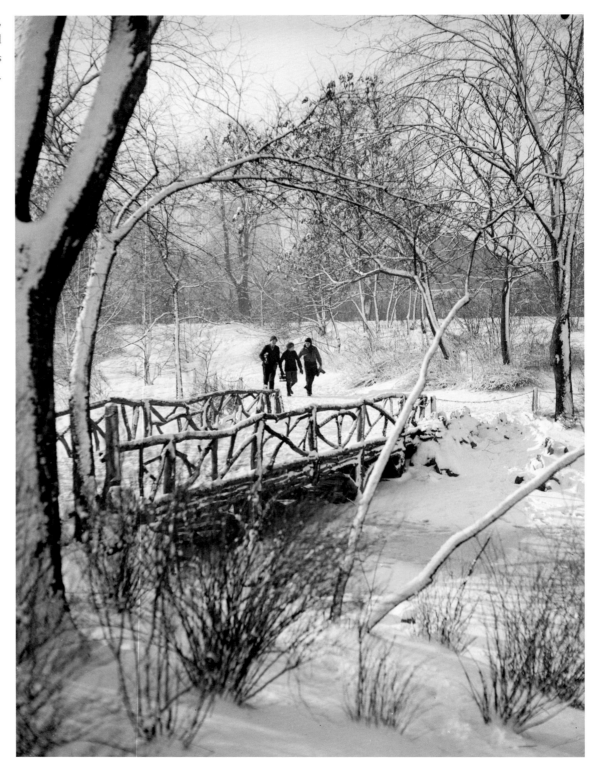

ACKNOWLEDGMENTS

With the exception of cropping images where needed and touching up imperfections that have accrued over time, no other changes have been made to the photographs in this volume. The caliber and clarity of many photographs are limited by the technology of the day and the ability of the photographer at the time they were made.

This volume, *Historic Photos of Christmas in Chicago,* is the result of the cooperation and efforts of many individuals, organizations, and corporations. It is with great thanks that we acknowledge the valuable contribution of the Chicago History Museum for its generous support.

I would like to thank Rob Medina, rights and reproduction coordinator at the Chicago History Museum, in particular for his work on this book. His knowledge of the photography collection and his coordination of the image scanning were invaluable. Photographers John Alderson and Jay Crawford brought their usual professionalism and expertise to the digital imaging process. Simone Martin-Newberry organized the photography orders with a great eye for detail. Publications interns Laurie Stein and Catherine Gladki provided invaluable assistance for this book. I also am grateful for the support of Gary Johnson, president; Russell Lewis, executive vice president and chief historian; and Phyllis Rabineau, vice president for interpretation and education for their support on this project.

For my parents, Kenneth and Irene Adams

—*Rosemary K. Adams*

PREFACE

As the twentieth century dawned in Chicago, expectations for the twenty-first century far ahead were dim, as this futuristic vision in a *Chicago Tribune* editorial from December 1900 revealed:

> Christmas in the year 2000 dawned bright and clear over Chicago, only that comparatively few persons were interested in it in that early stage. Santa Claus and St. Nicholas had been myths for seventy-five years, and the ravages of the twenty-five years before had stripped the north woods of their evergreens. The reindeer was extinct and the furry robes once accredited to these guardian genii of Christmas were to be found only in museums of natural history. . . . The spirit of Christmas became lost.

It appeared that the abundant fears of the unknown and the worst possible scenario imaginable could be summed up with the disappearance of Christmas, a fate that seemed grim indeed.

Happily, like many visions of the future, this one has not been realized. American cities have changed dramatically over the past century, and in viewing images of Chicago at Christmas during this era, it is tempting to focus on the differences from one decade to the next. But what are more striking are the similarities: Chicago of the twenty-first century celebrates Christmas with as much enthusiasm and with many of the same traditions as it has for much of its history. In 1900, Chicagoans bought fresh Christmas trees on corner lots, crowded State Street in search of the perfect gifts for family and friends, dropped coins in Salvation Army baskets to help the less fortunate, and dreamt of a white Christmas. New customs gradually became traditions: the city's first official Christmas tree appeared in 1913, and Marshall Field and Company on State Street became nearly synonymous with the holiday with its whimsical windows and famed Walnut Room tree. Celebrating Christmas today—whether in your home, your neighborhood, or on State Street—remains a familiar part of city life.

In Charles Dickens's *A Christmas Carol,* Ebenezer Scrooge had the unique opportunity to visit Christmas past, present, and future one unforgettable night, and he came to understand how each of them is but one part of the great tradition of Christmas. It is not surprising that the story unfolds in London. Dickens understood how cities were transforming his nineteenth-century world, and *A Christmas Carol* thus gives the tradition of Christmas a special place in the whirl of a rapidly changing city. Today, despite our hurried pace—or perhaps because of it—the holiday season is a time to reflect on Chicago and the world and to feel the flood of memories of Christmas past as we look to Christmas future.

—Rosemary K. Adams

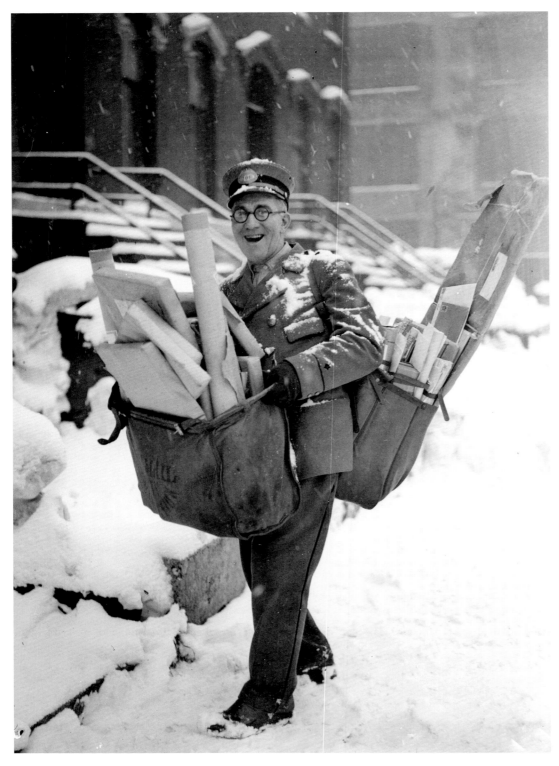

Mailman N. Sorenson poses with his heavy load of Christmas mail and parcels, 1929.

BEGINNING TO LOOK A LOT LIKE CHRISTMAS

DECORATING THE CITY

Chicago's tradition of decorating for the holidays reaches back to the middle of the nineteenth century. Newspaper articles from as early as the 1860s extol the decorations that help brighten this special time of year. For decades, the Loop and the major shopping thoroughfares, such as State Street and Michigan Avenue, have boasted the city's most elaborate decorations. In early days, Christmas trees and swags of evergreen branches appeared around the city. Eventually, sidewalks blazed with lights strung along trees and around store windows. Skyscraper lighting created seasonal shapes such as stars and crosses. Since the early twentieth century, the city of Chicago has decorated an official tree, often unveiled or dedicated by the mayor. Parades have been another popular way to celebrate.

Nature plays its role in setting the stage for the holidays. Chicago winters are notorious—cold, blustery, snowy, and seemingly endless. Snowstorms cripple the city, disrupt air travel nationwide, and can even doom a mayor's chances of re-election. Yet each year with the approach of December 25, Chicagoans wish longingly for a white Christmas, and meteorologists' predictions for the big day take on a suspense unknown the rest of the year. Snow is a fact of life in a Windy City winter, but a sparkling blanket for the holidays seems almost a requirement for celebration. In 1899, the *Tribune* consoled readers that although there was no snow, the cold weather made for spectacular ice skating: "It was one of the few old-fashioned, outdoor winter sports that could be enjoyed. The ice at Lincoln Park was perfect, and those who had regretted that the great winter holiday was a green one found consolation when the sharp steel struck the hard ice."

Irving Berlin's 1942 song "White Christmas," recorded by Bing Crosby, expressed a nostalgic longing for such cozy winter weather; it was particularly poignant for soldiers serving in World War II who were not sure when they would see home again. It seems, however, that white Christmases happened more often in Chicagoans' imaginations than in actuality: in 1965, after promising a white Christmas for that year, the *Tribune* reflected, "Chicagoans should be getting used to not having a white Christmas. Weather charts show that in only about one-third of the last 72 years has there been enough snow to provide a truly white Christmas."

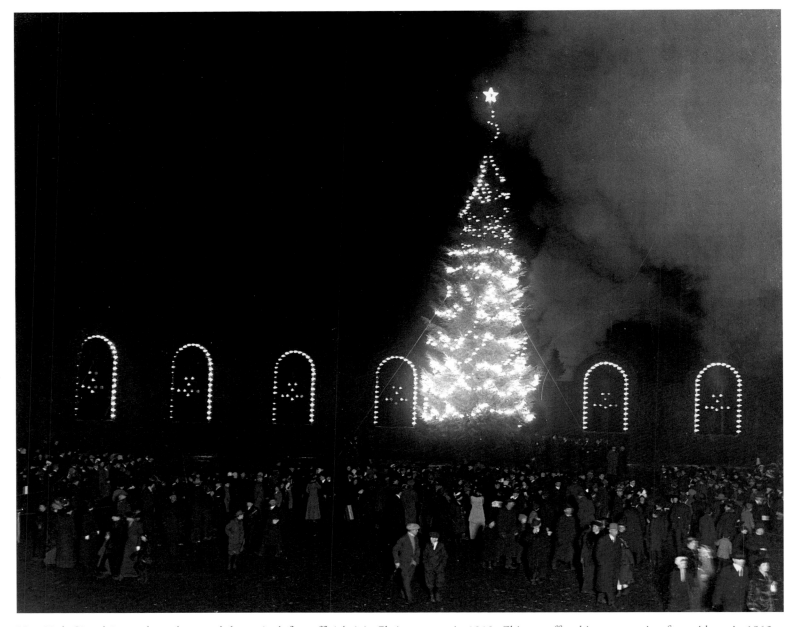

New York City claims to have decorated the nation's first official civic Christmas tree in 1912; Chicago offered its own version for residents in 1913.

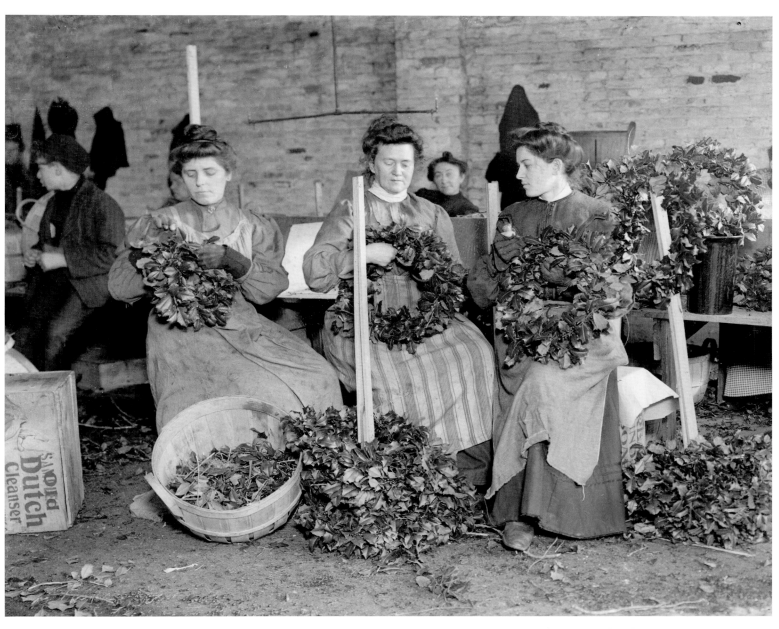

A group of women make Christmas wreaths, ca. 1906.

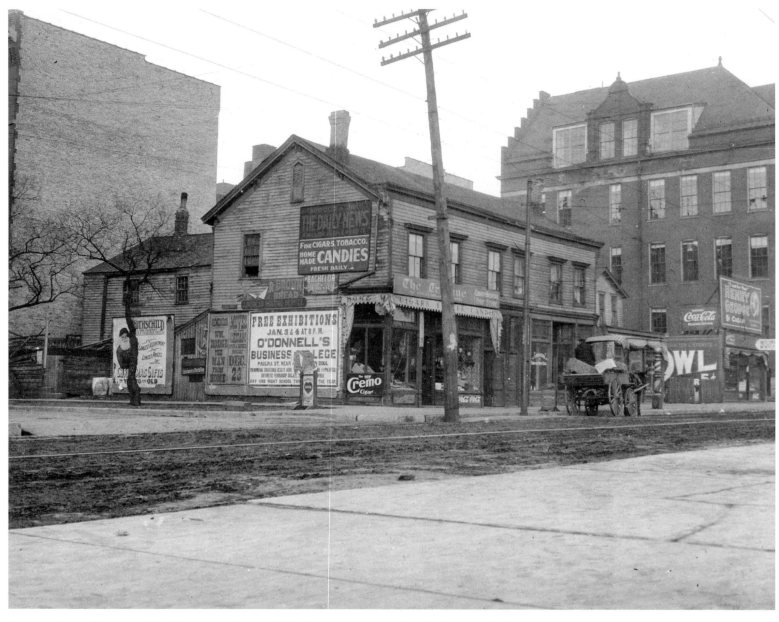

Santa peeks out from an ad for Maurice L. Rothschild & Company on the side of a shop, at left, 1905.

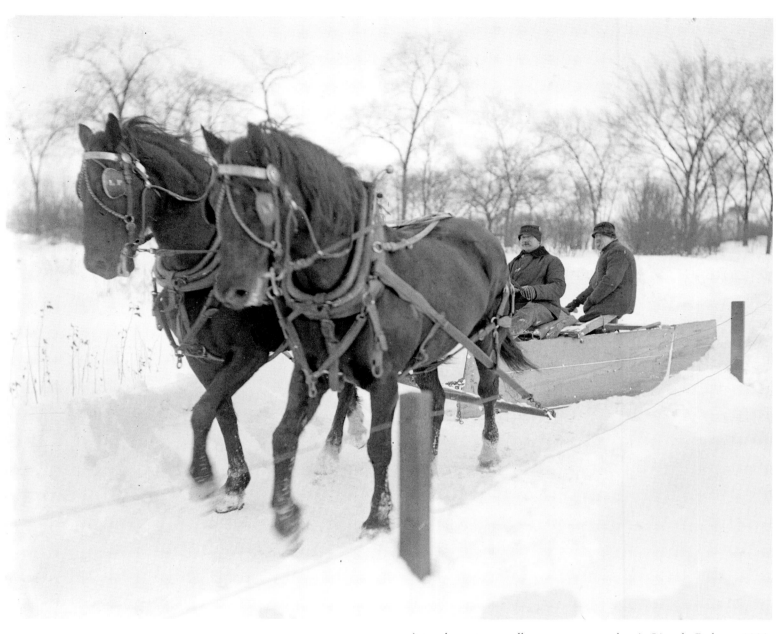

A two-horse team pulls men on a snowplow in Lincoln Park, ca. 1903.

Following Spread: A white Christmas has long been the sentimental ideal, and Chicagoans have enjoyed many over the years. Here, shoppers brave a storm, ca. 1905.

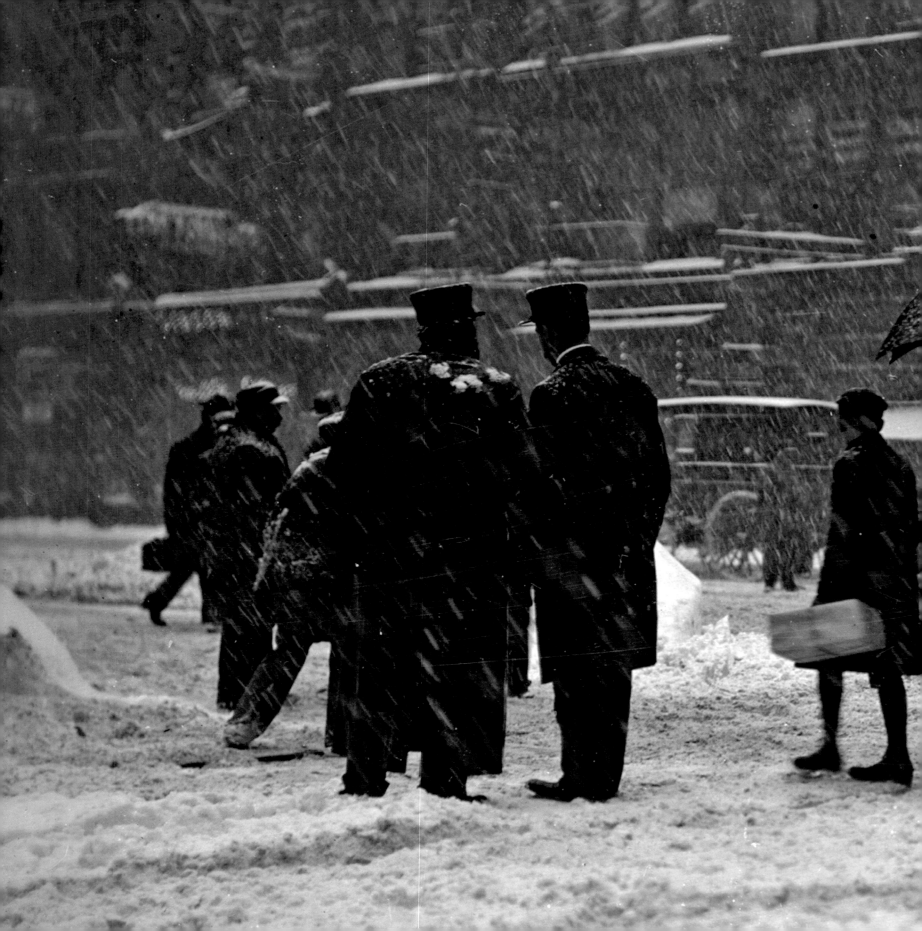

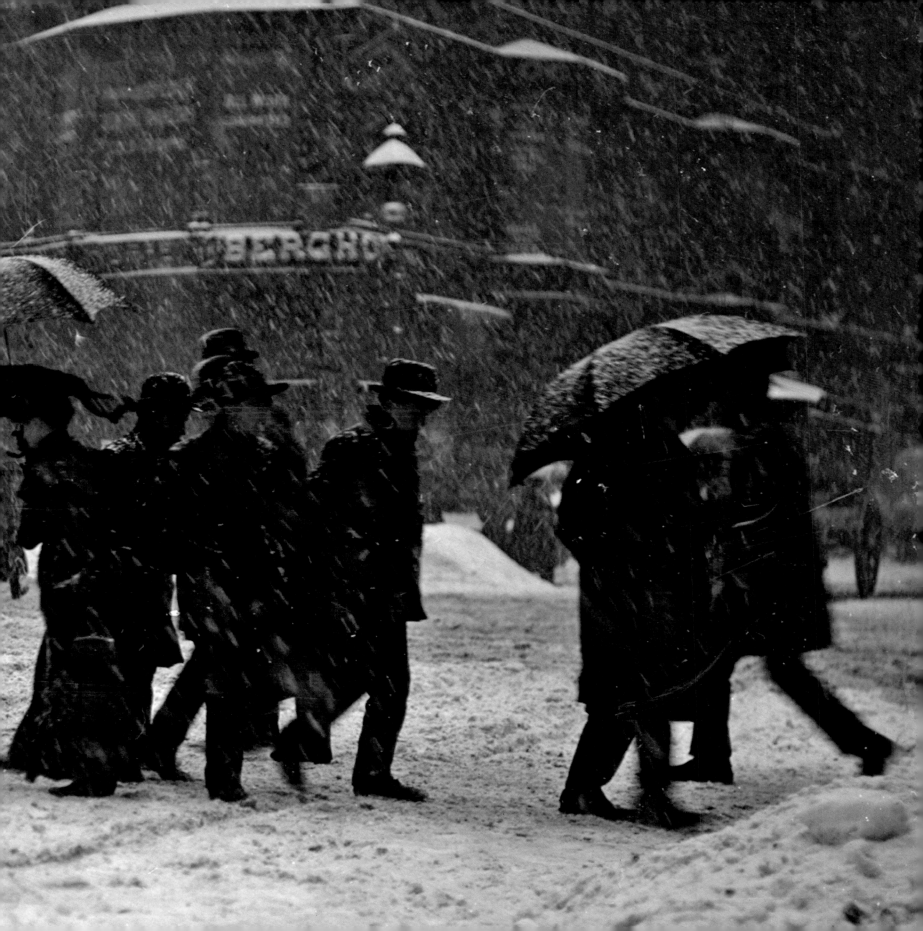

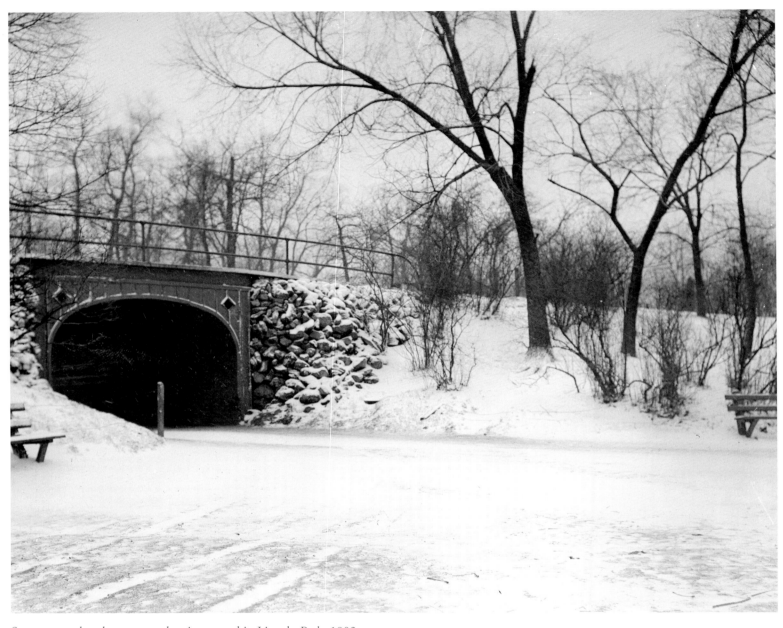

Snow-covered paths near a pedestrian tunnel in Lincoln Park, 1903.

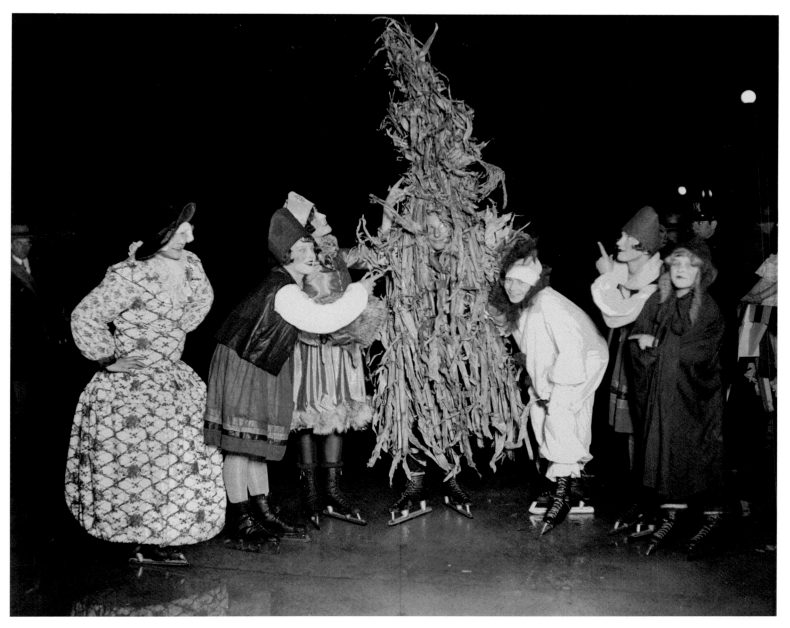

Children wearing skates and costumes pose on the ice at the Chicago Daily News Ice Carnival. The "tree" in the center is actually a child in costume.

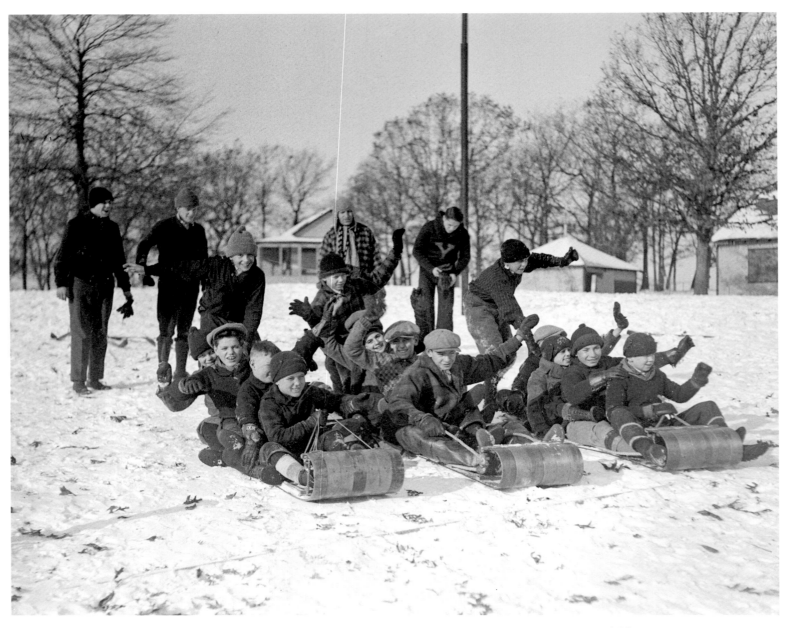

Children prepare to race, ca. 1927.

Christmas lighting at
the Board of Trade,
1935.

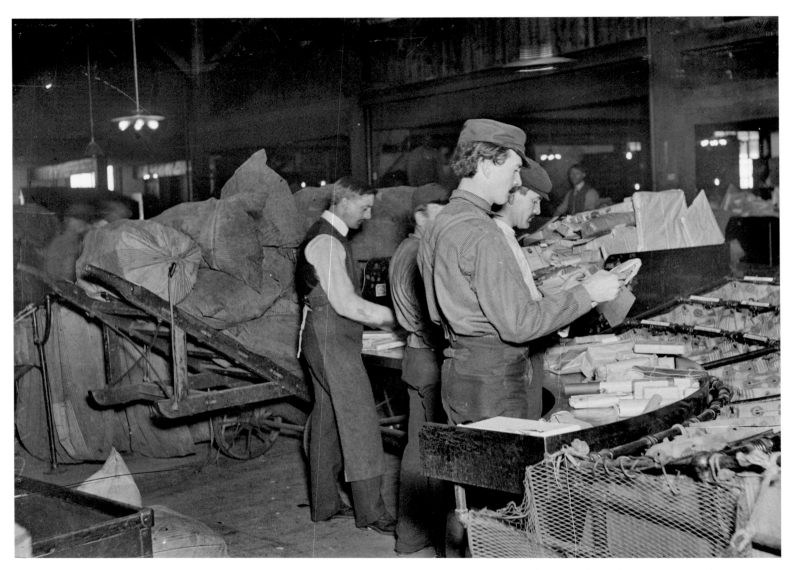

Postal workers sort through an abundance of holiday mail.

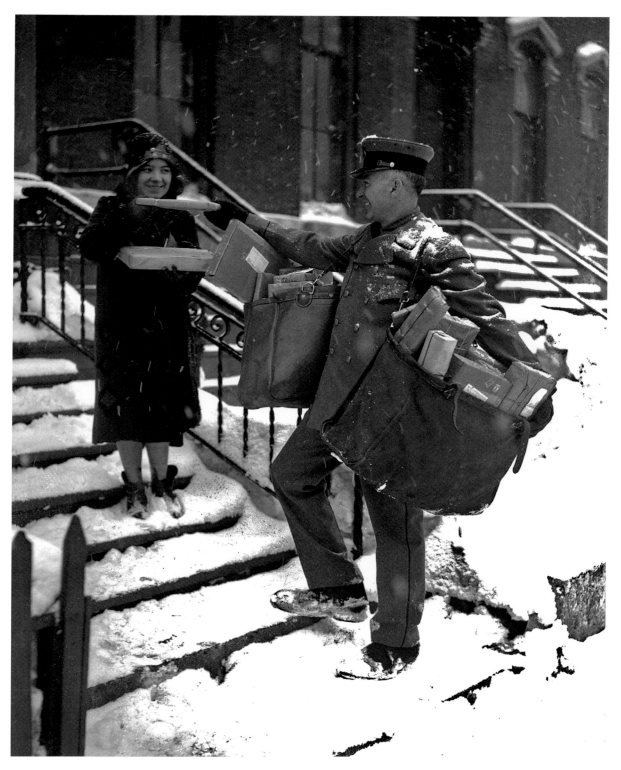

N. Sorenson delivers mail through the snow to Florence Webb.

Children wave as they sled through a snowy Lincoln Park, 1929.

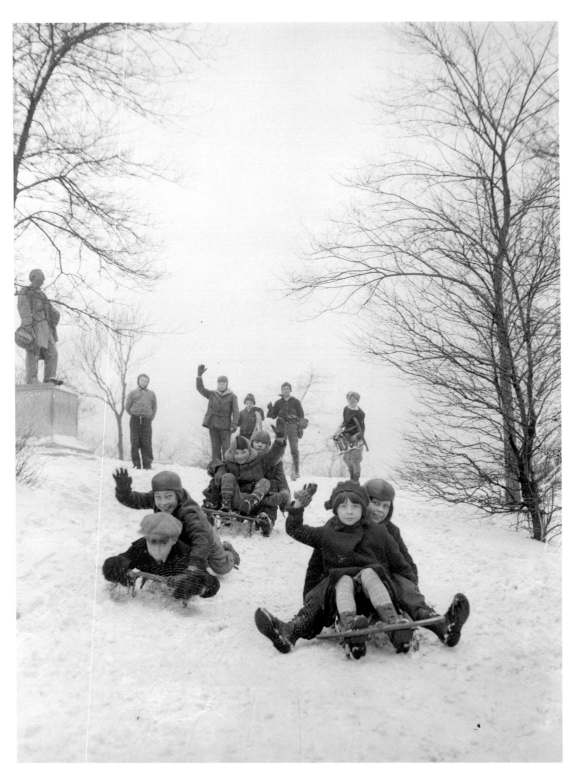

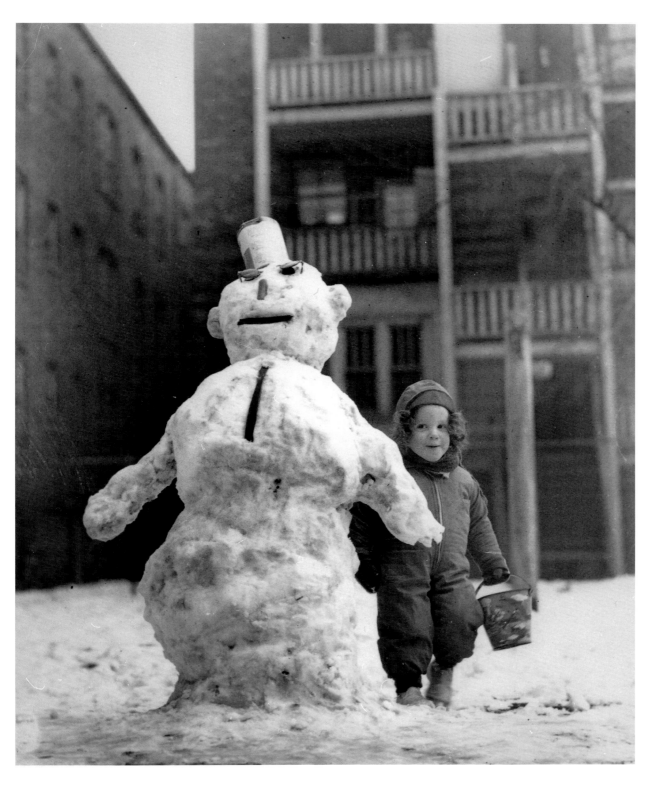

A little girl poses proudly with her snowman.

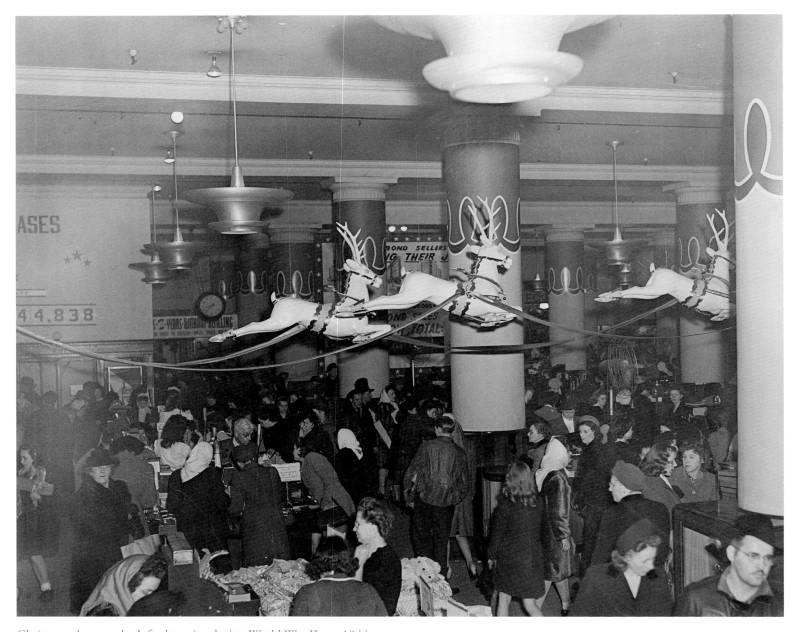

Christmas shoppers look for bargains during World War II, ca. 1944.

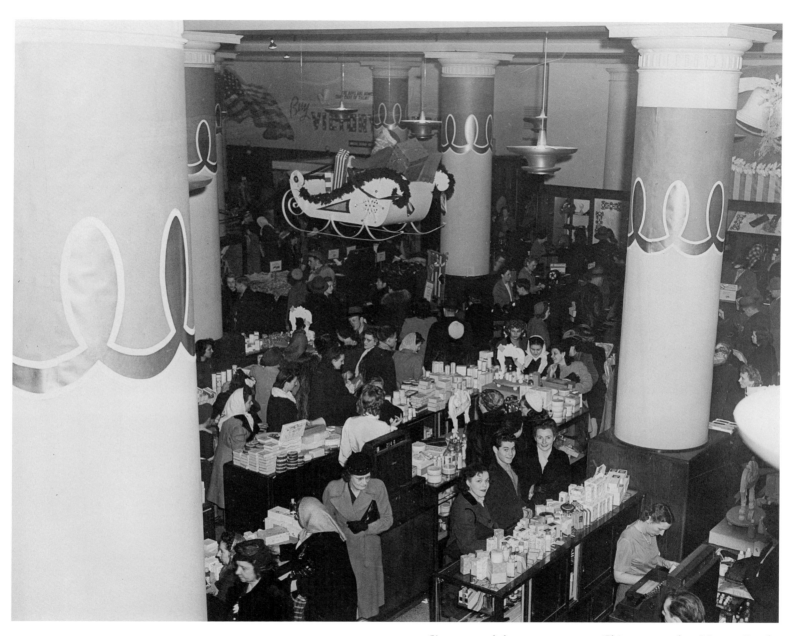

Signs around the store encourage Chicagoans to buy Victory Bonds.

A winter scene in the Loop near State and Randolph streets, 1942.

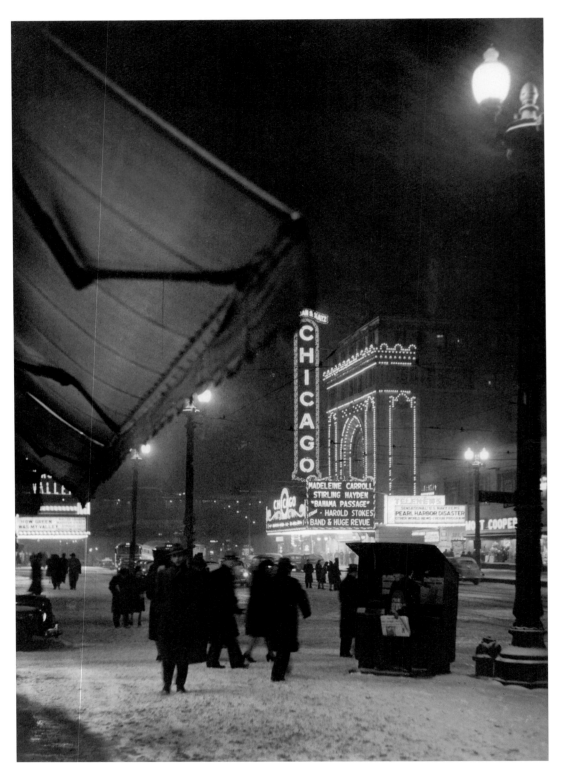

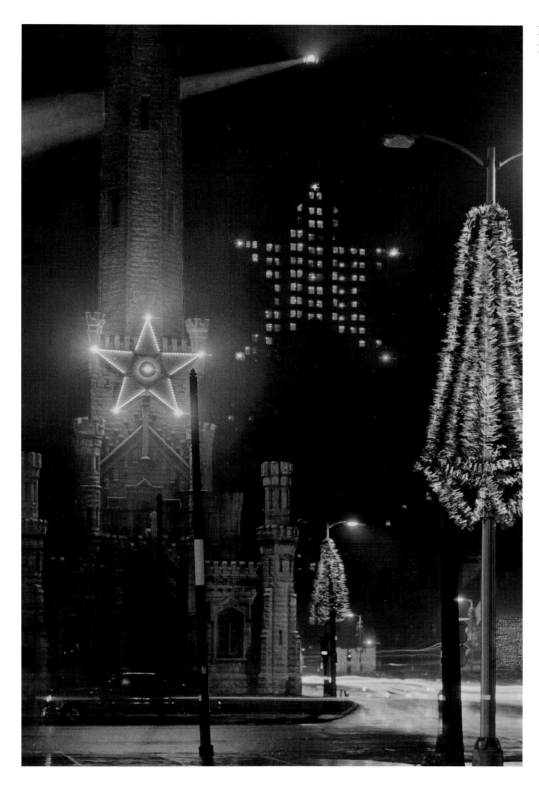

Lighted stars adorn the Water Tower and the Palmolive Building.

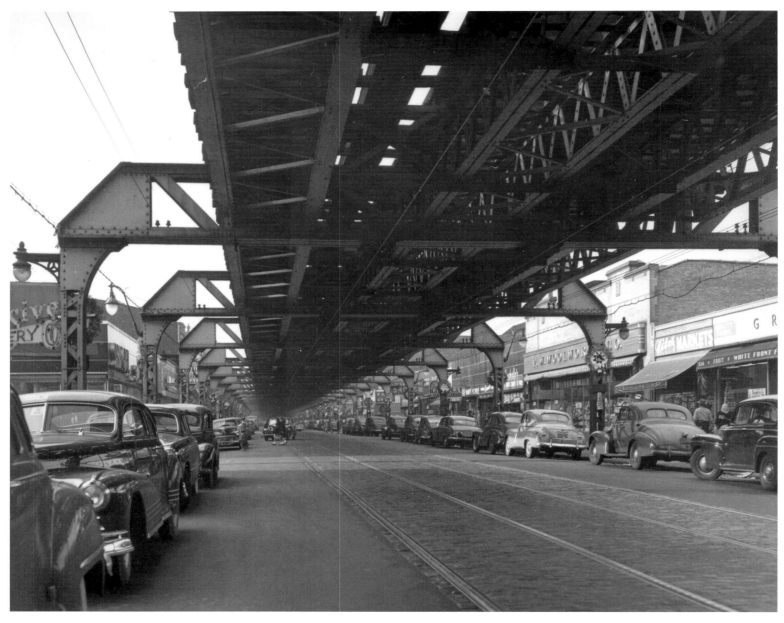

A view of East 63rd Street at Christmastime, 1948.

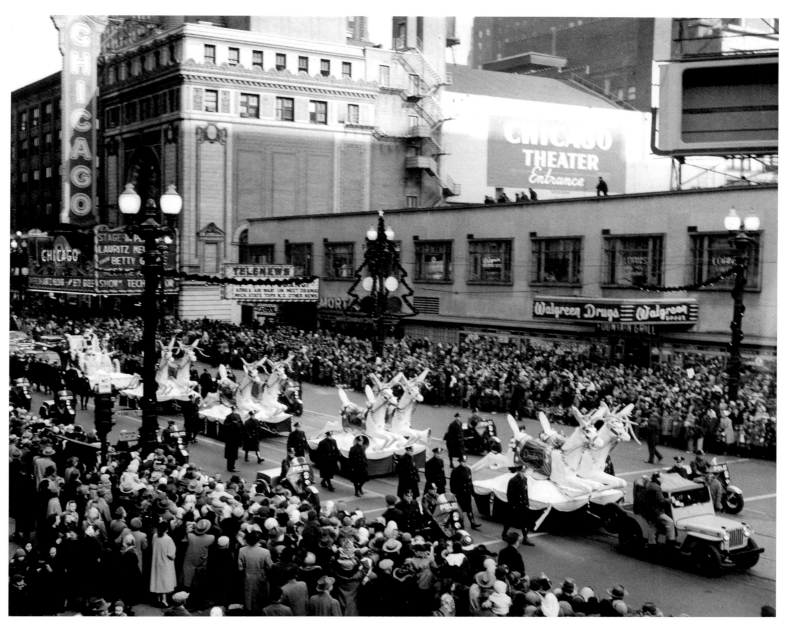

This view of the Santa Claus Parade of November 17, 1951, at the corner of Randolph and State streets, captures not only the Christmas spirit, but some Chicago icons as well. To the left, the Chicago Theater marquee towers over the street, while a Walgreens store appears at the right.

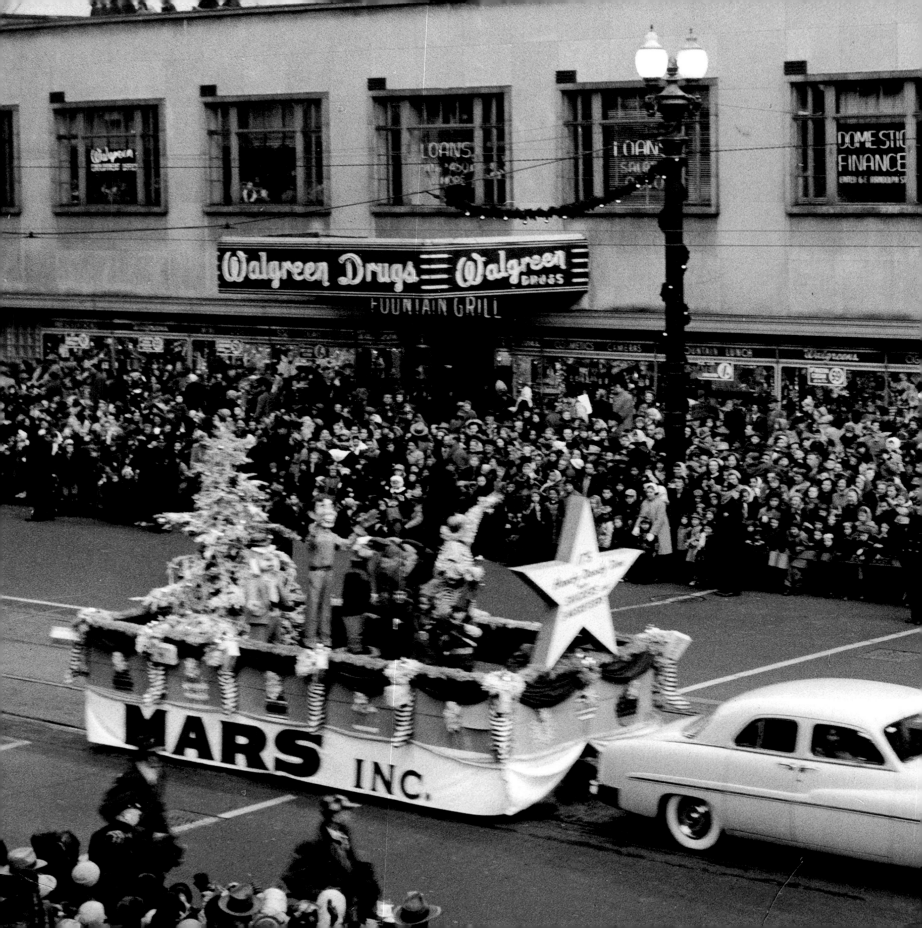

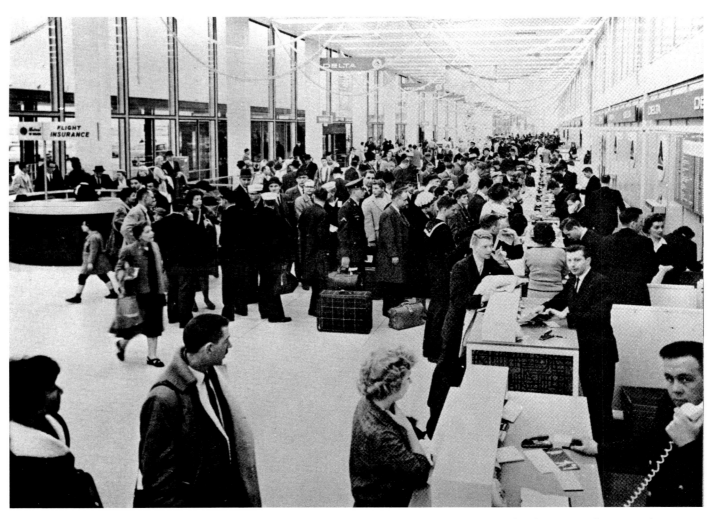

As one of the nation's busiest airports, O'Hare hosts hundreds of thousands of travelers between Thanksgiving and New Year's Day, as seen here in 1962.

The Palmolive Building at night with lights cascading from the beacon at the top.

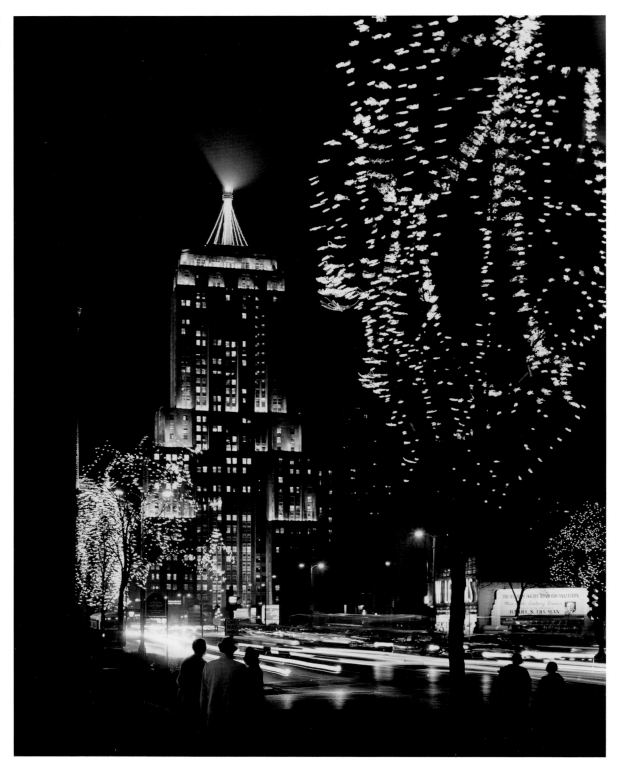

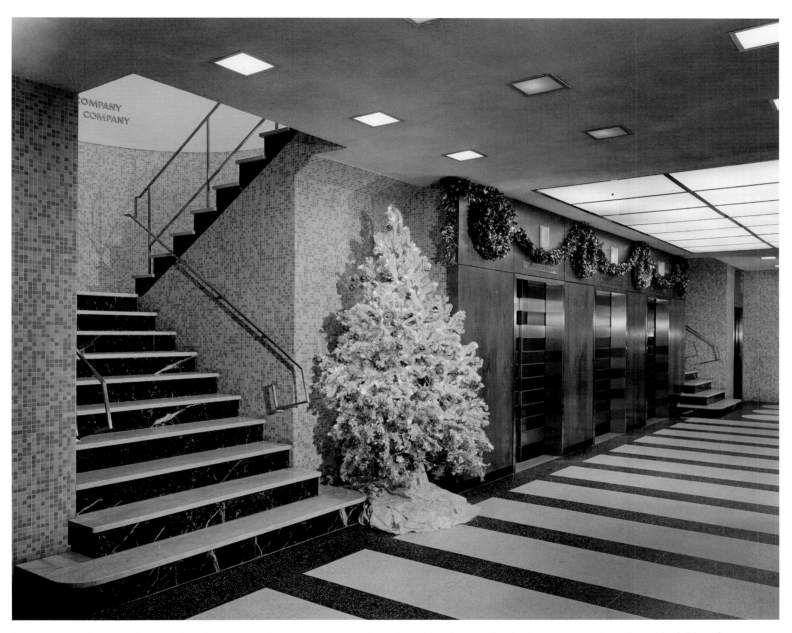

In postwar Chicago, different styles of Christmas decorations emerged, such as this white artificial Christmas tree that adorns the lobby of an office building.

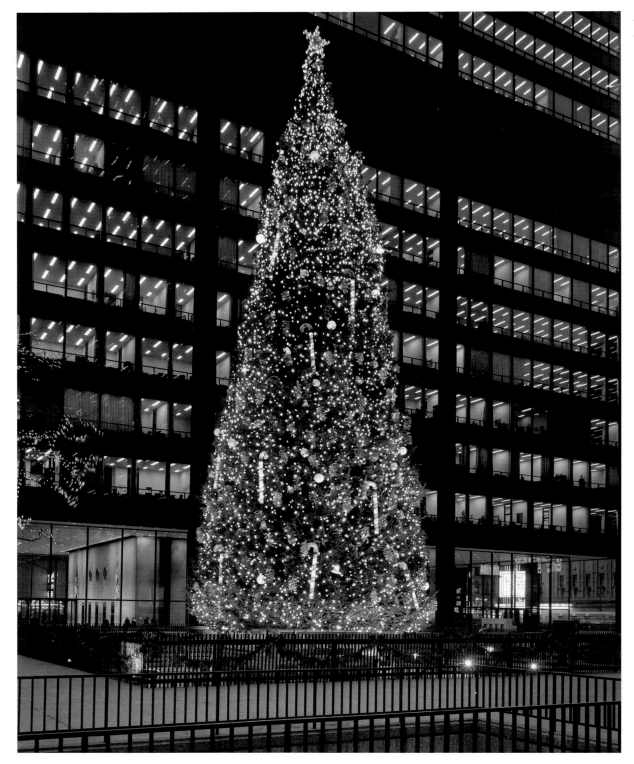

An undated view of the official city tree.

An undated, more
unconventional view of the
municipal tree with a model.

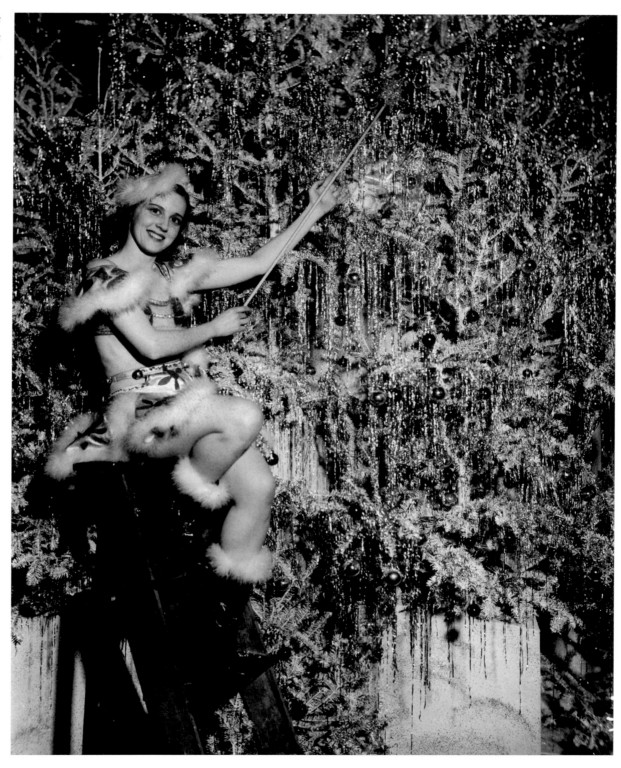

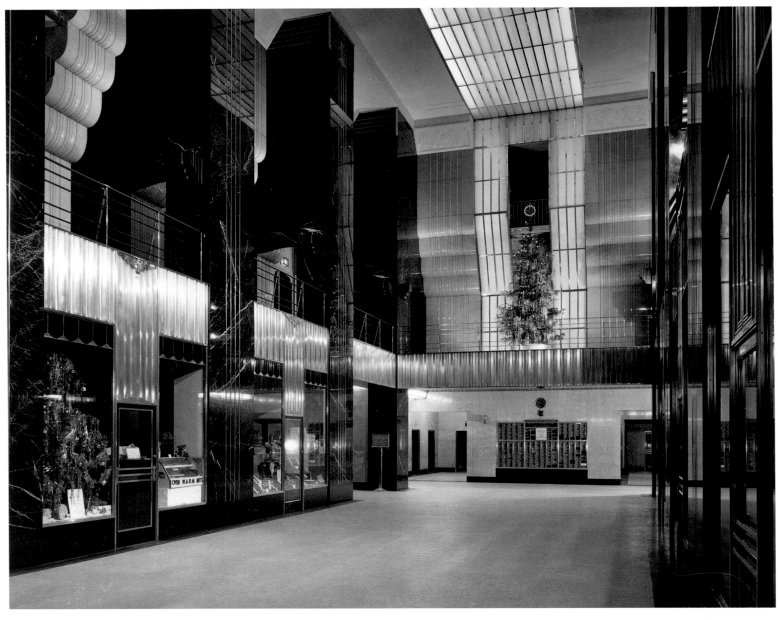

Interior view of the lobby of the Board of Trade Building featuring a Christmas tree.

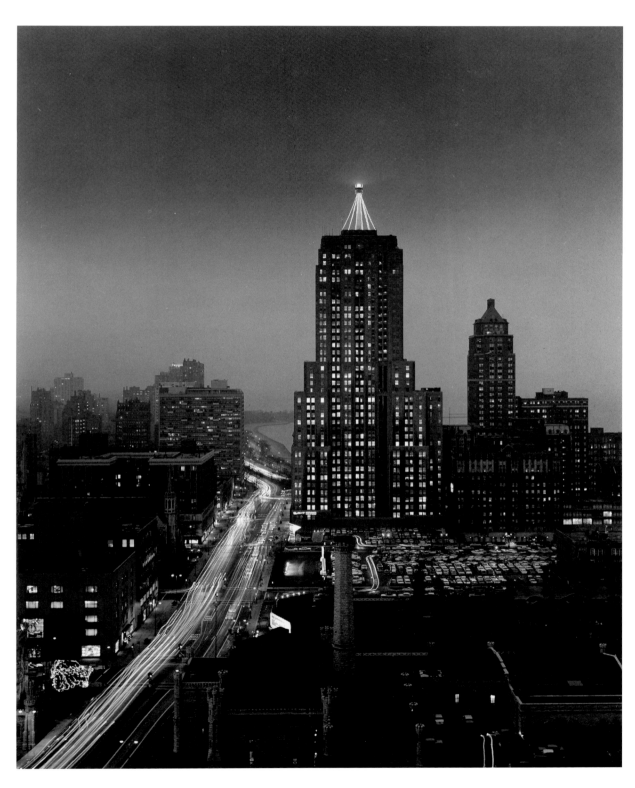

The Palmolive Building silhouetted against the night sky.

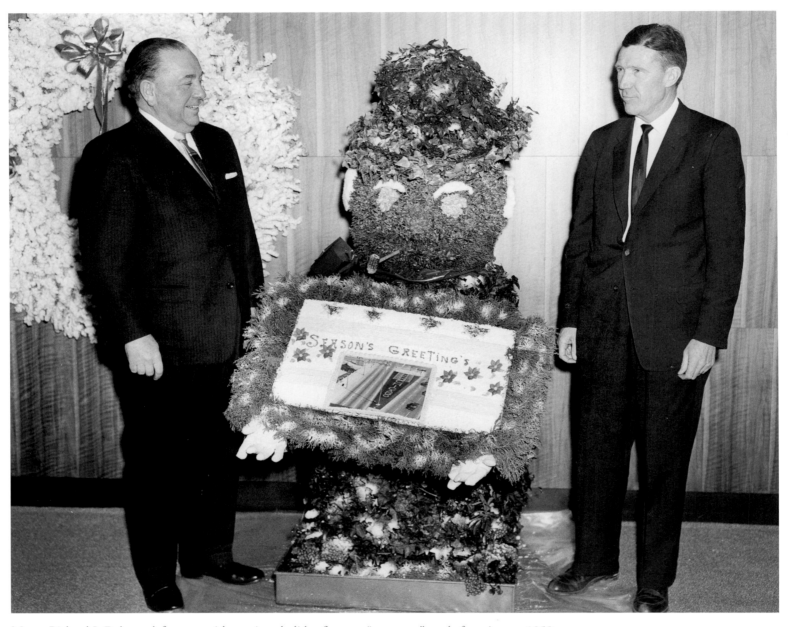

Mayor Richard J. Daley, at left, poses with a unique holiday figure, a "snowman" made from ivy, ca. 1958.

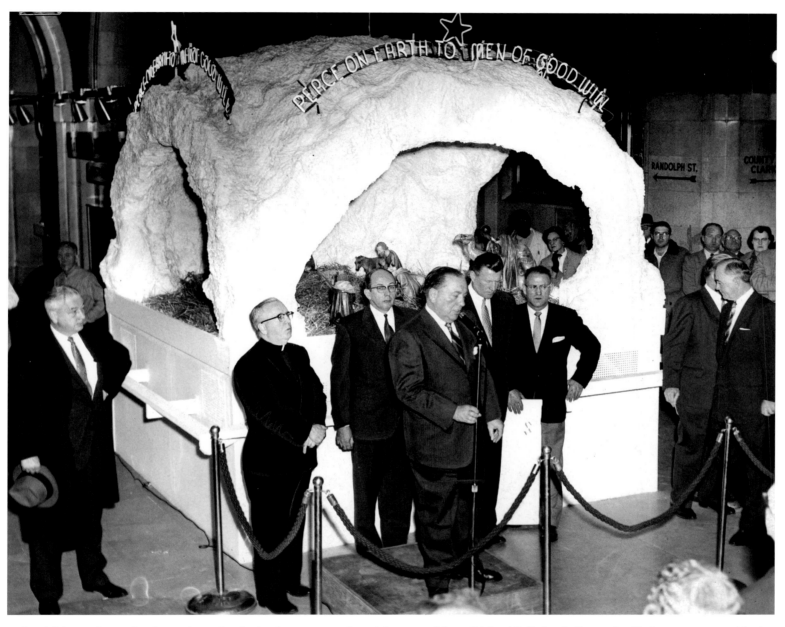

In addition to its secular decorations, the city has long presented a crèche scene. Mayor Richard J. Daley dedicates the Christmas manger with city, state, labor, business, and religious officials at City Hall.

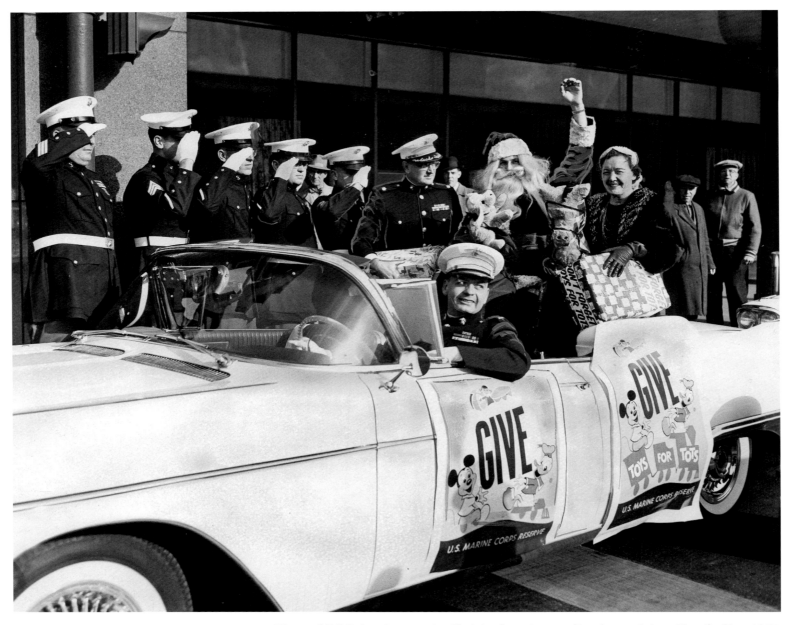

Eleanor "Sis" Daley, the mayor's wife, joins Santa in spreading the word about Toys for Tots, 1957.

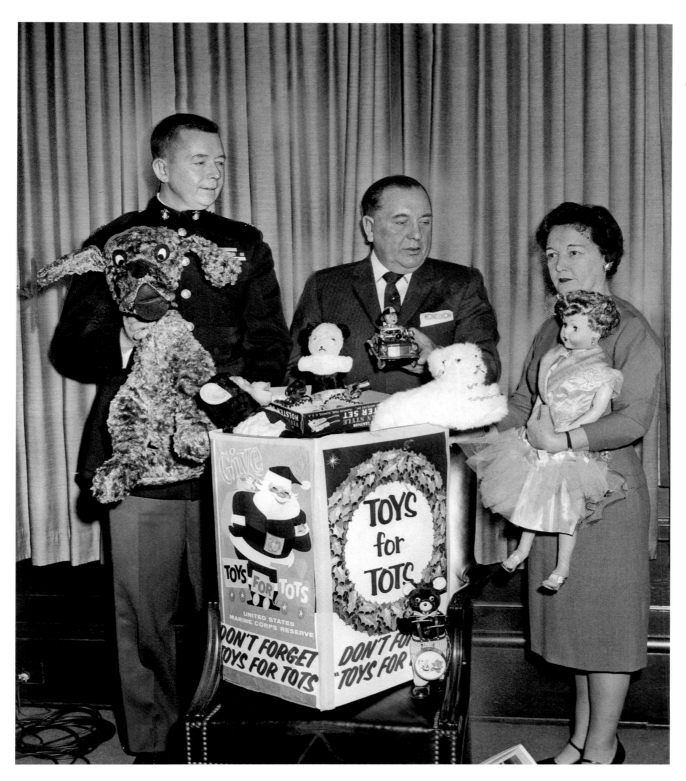

Mayor and Mrs. Daley help kick off the Toys for Tots campaign of 1958.

One of the city's iconic buildings, Palmolive, displays a Christmas star along with its trademark beacon light.

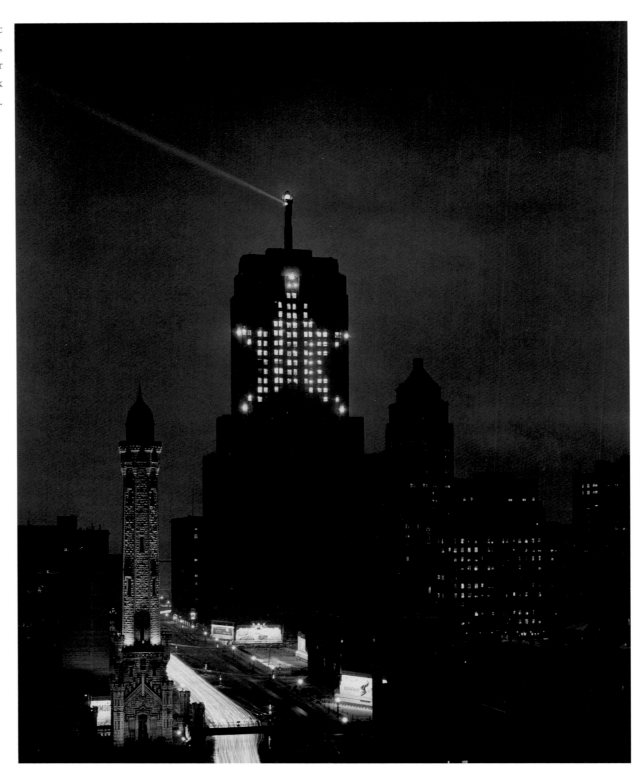

Santa's reindeer appear on a float at the Christmas Parade, State Street and Wacker Drive, November 1959. Clement C. Moore named the magical creatures who flew Santa's sleigh around the world in his poem "A Visit from St. Nicholas," published in 1823.

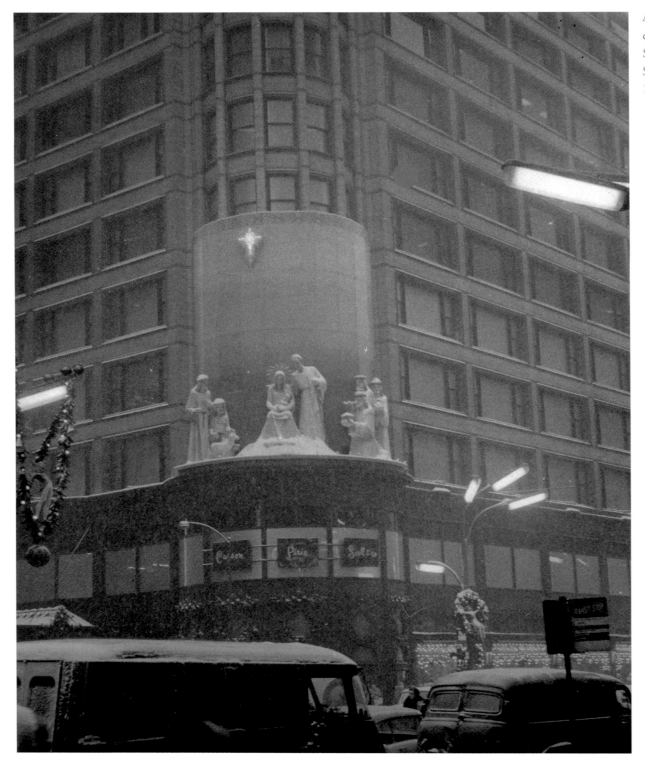

A crèche scene above the entrance of Carson Pirie Scott and Company on State Street, December 19, 1959.

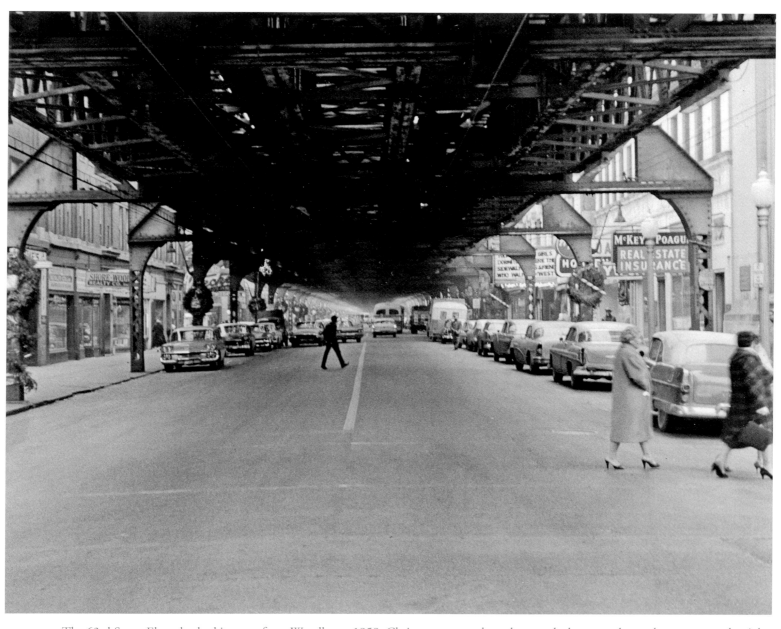

The 63rd Street El tracks, looking east from Woodlawn, 1959. Christmas canes adorn the wreaths hung on the track supports to the right.

Christmas tree at the
Eisenhower Expressway,
January 1, 1960.

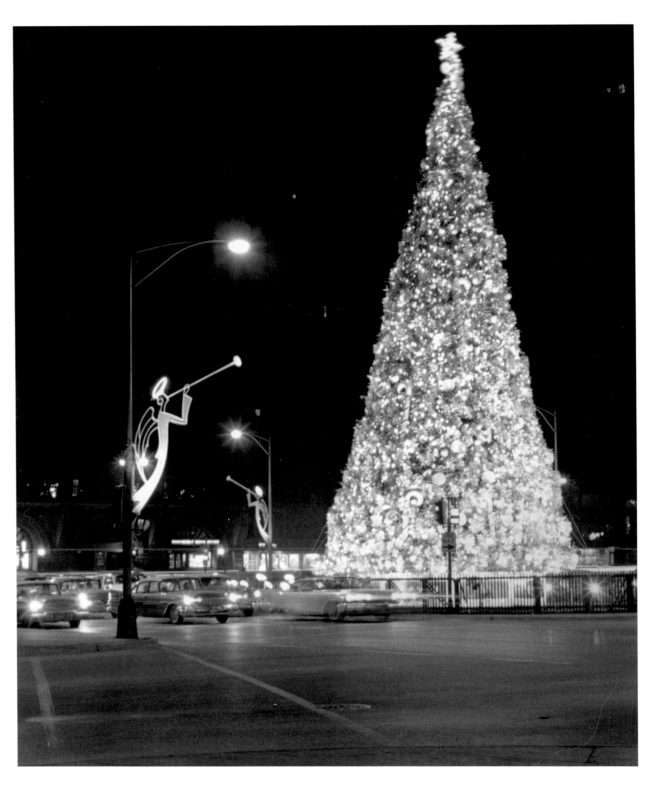

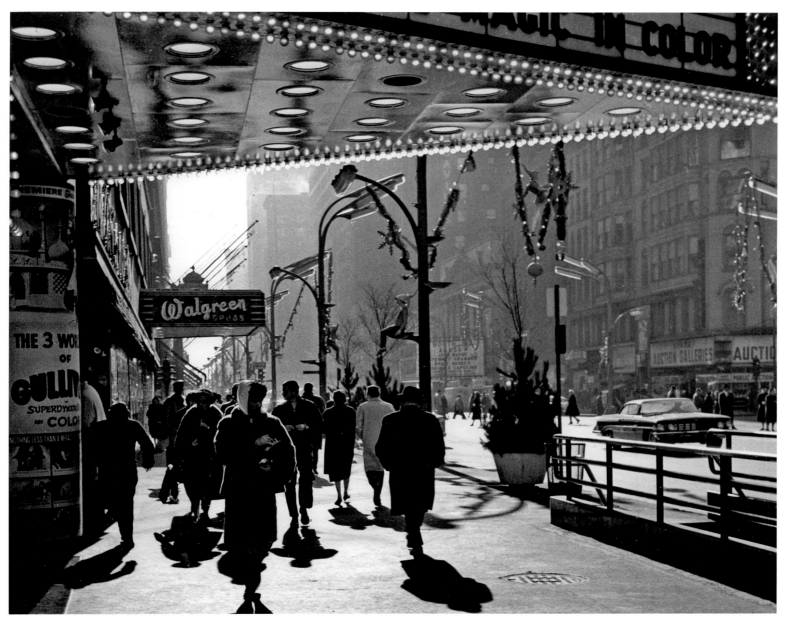

Christmas Eve, 1960, on State Street near Randolph. The entrance to the Chicago Theater is in the foreground.

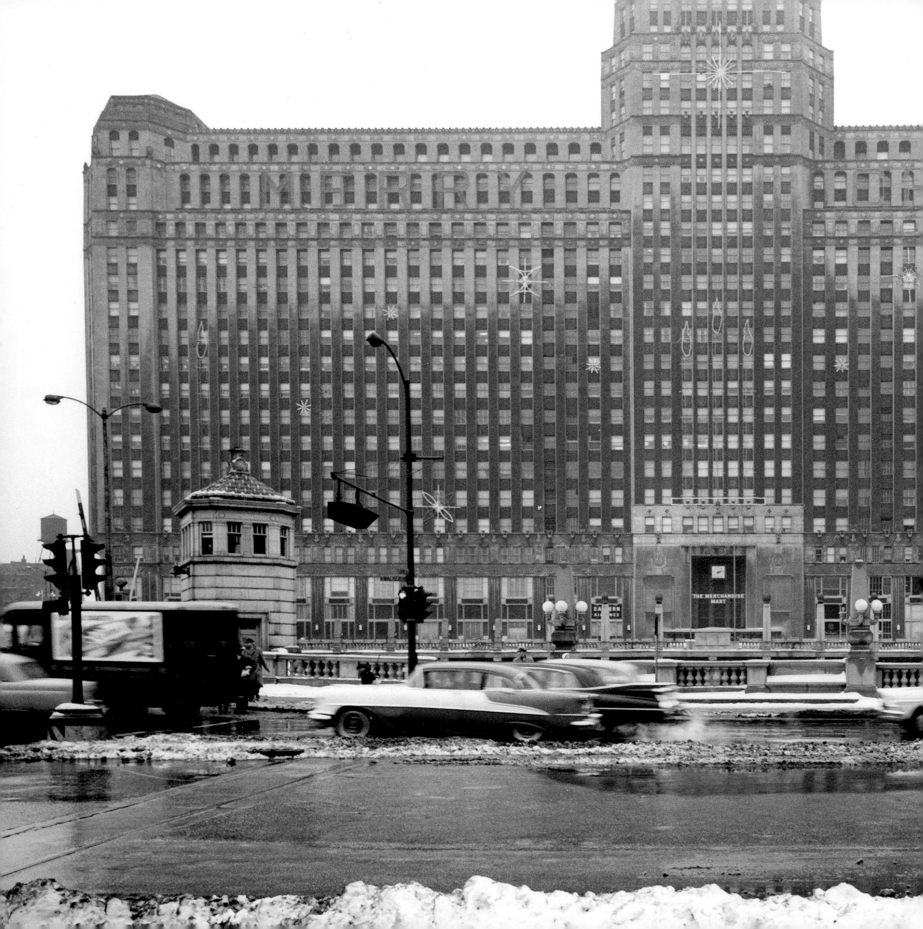

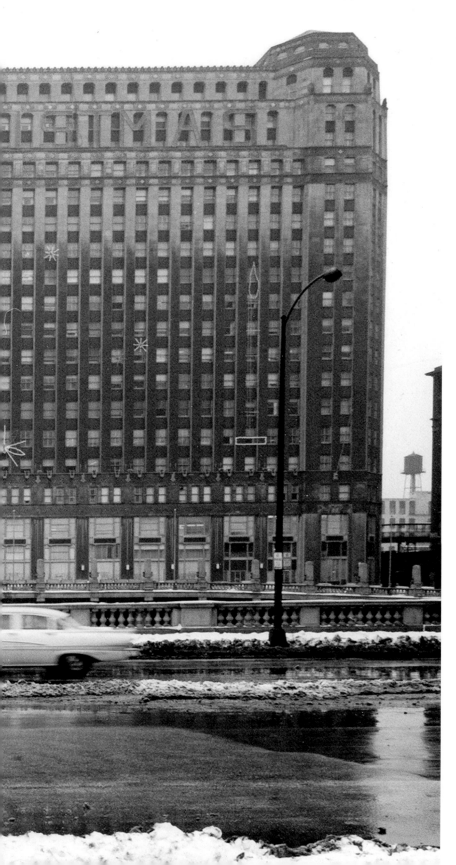

The Merchandise Mart during the day at holiday time.

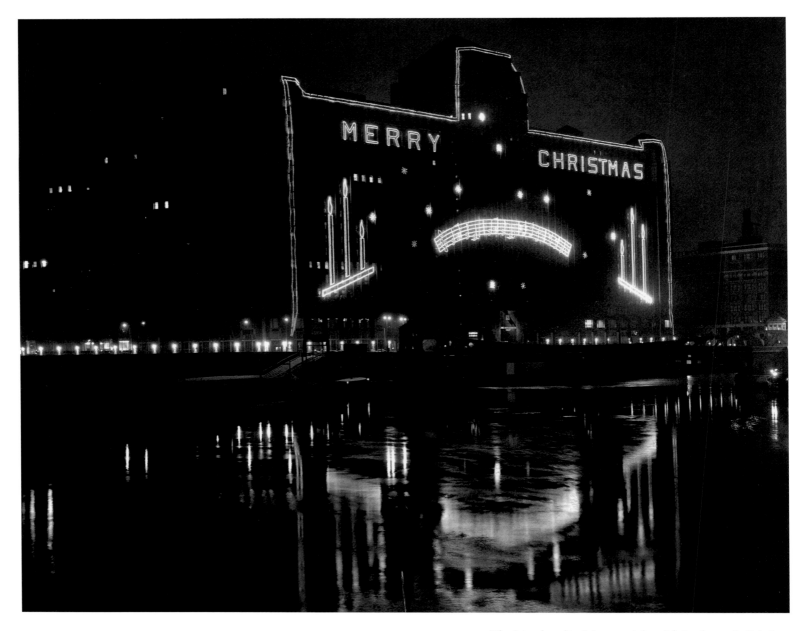

The Merchandise Mart at night with its dramatic lighting.

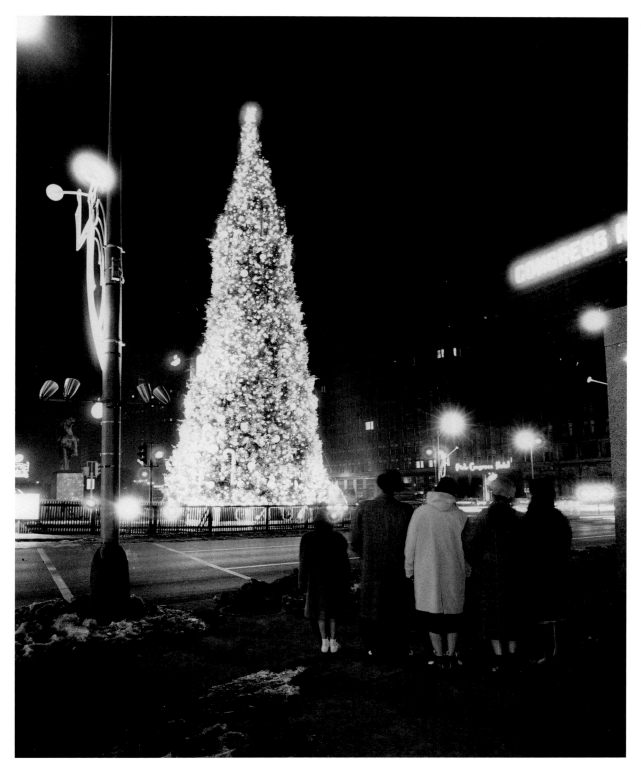

Admiring Chicago's
Christmas tree at Congress
and Michigan, January 1,
1960.

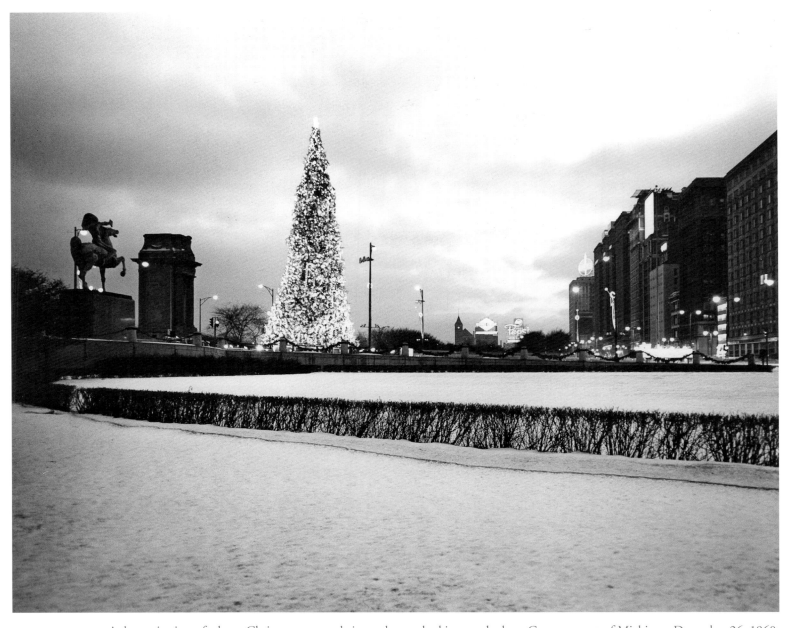

A dramatic view of a huge Christmas tree and city sculpture, looking south along Congress, east of Michigan, December 26, 1960.

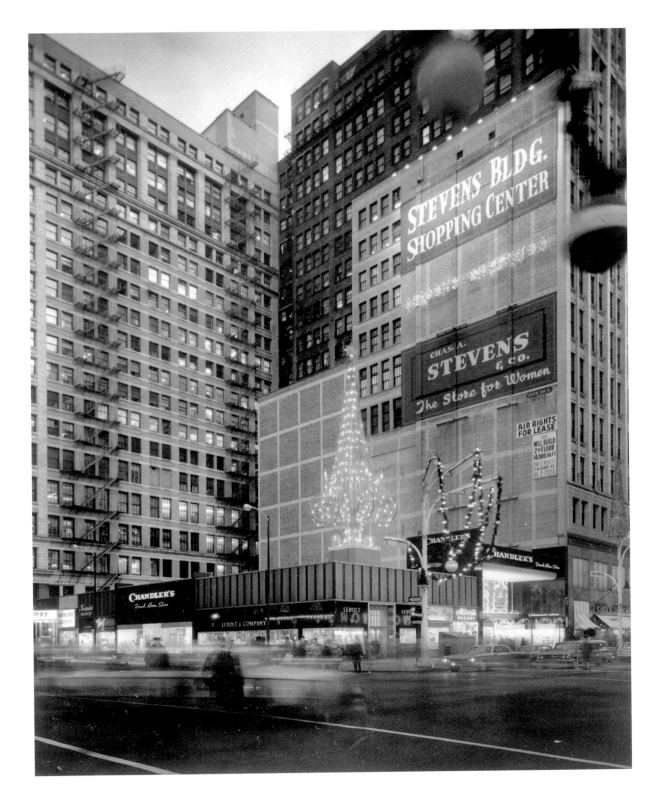

State Street decorated at night, with a view of the Chas. A. Stevens building.

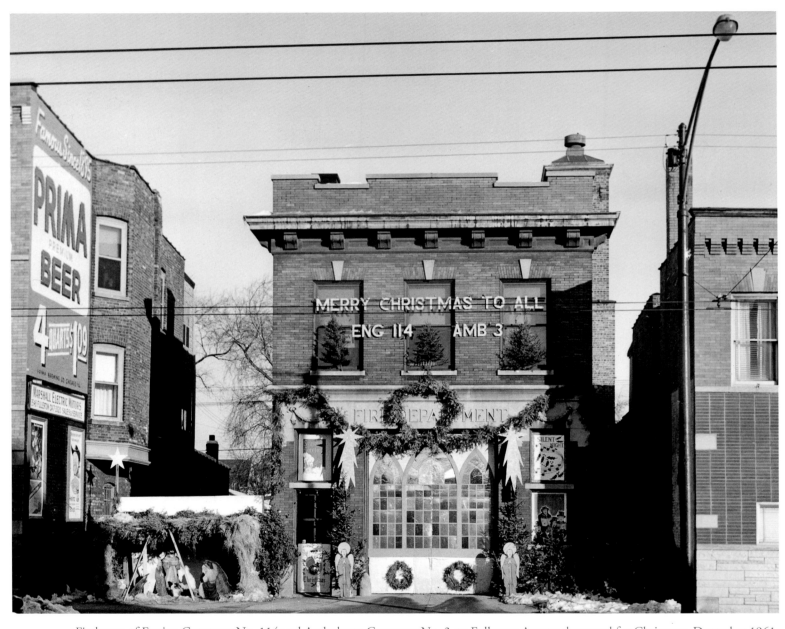

Firehouse of Engine Company No. 114 and Ambulance Company No. 3 on Fullerton Avenue decorated for Christmas, December 1961.

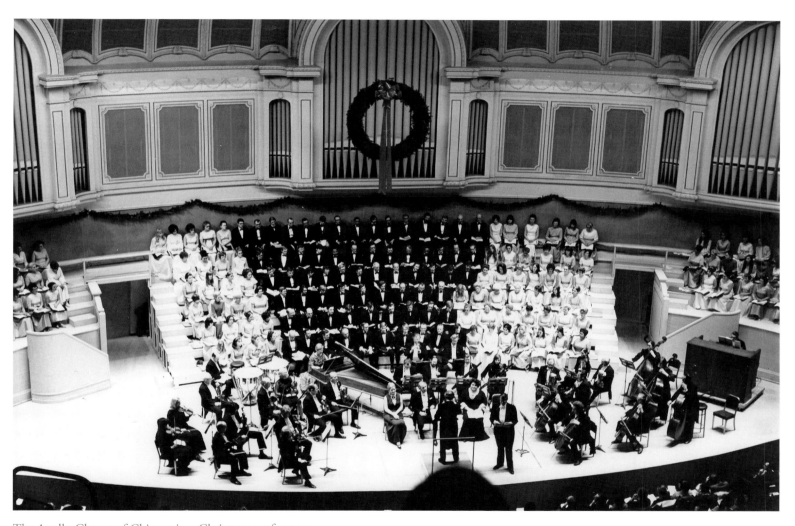

The Apollo Chorus of Chicago in a Christmas performance.

A Christmas scene in Grant Park, 1964.

An elf sits cheerfully
waving above State Street
on December 23, 1964.

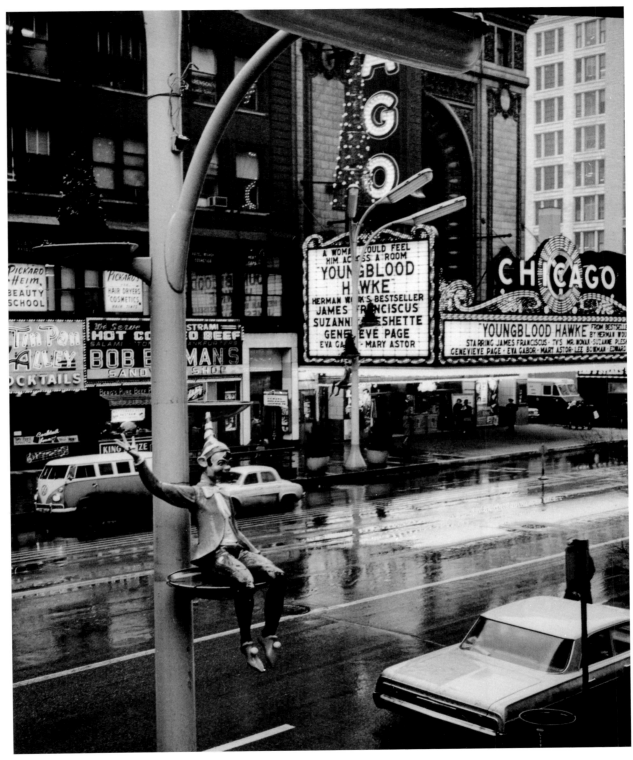

The Water Tower surrounded by Christmas lights in 1967. As one of the few buildings to survive the Great Fire of 1871, it was an important landmark in the days after disaster and today remains a familiar and popular attraction.

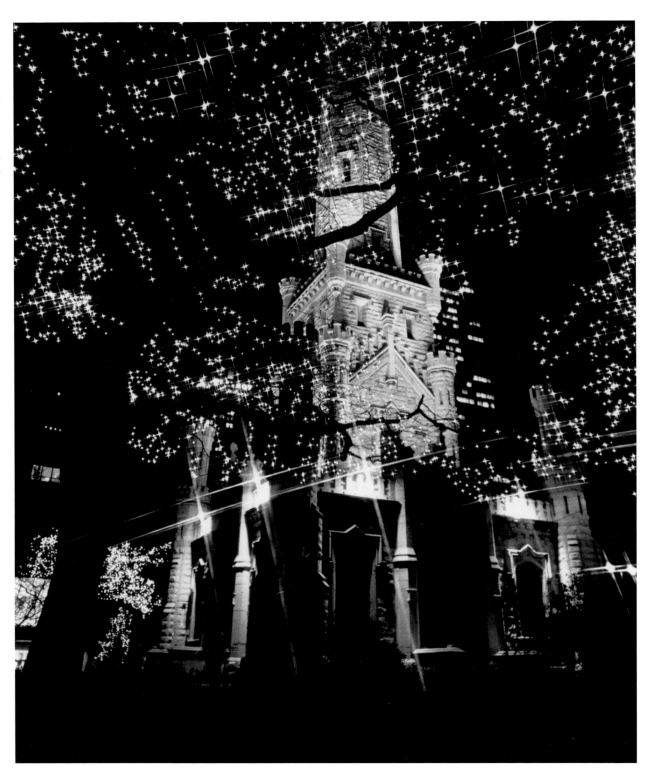

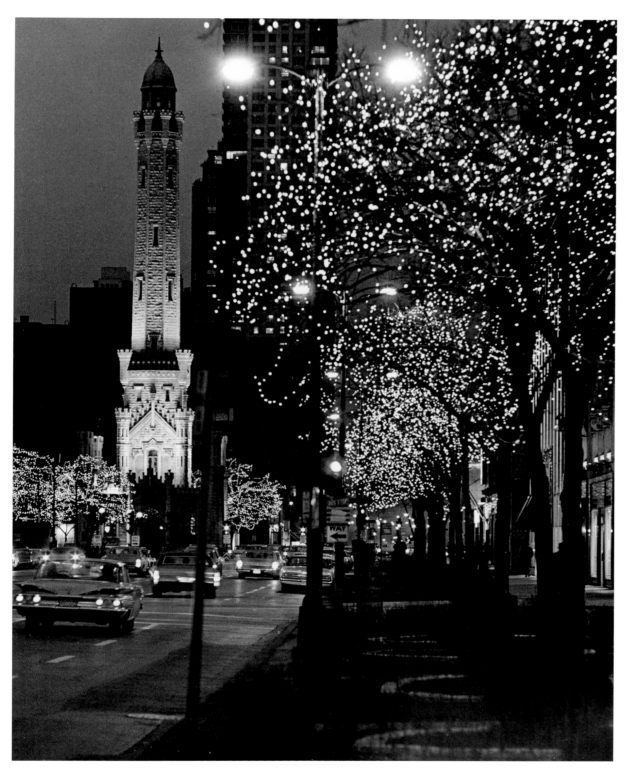

The Water Tower's
neighborhood is lit to festive
effect for the holidays in
1972.

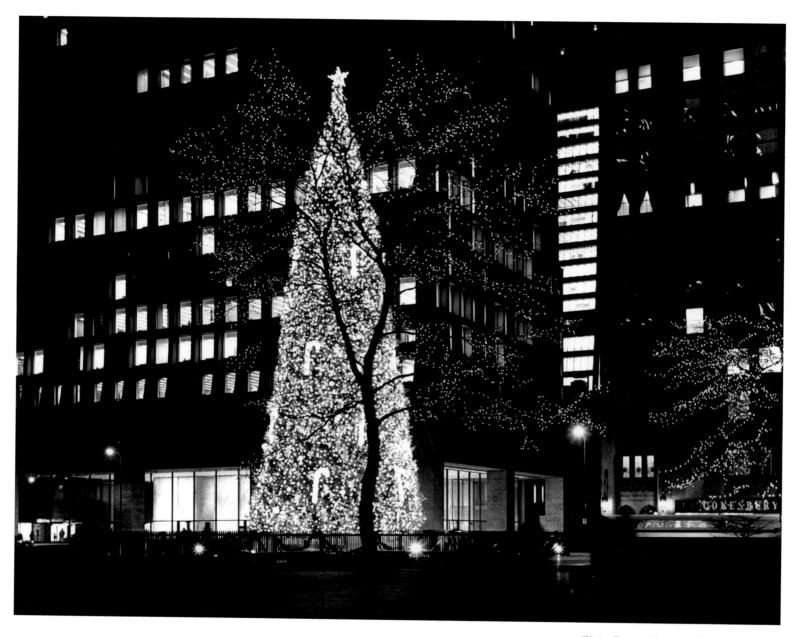

Civic Center Plaza at Christmas, 1968.

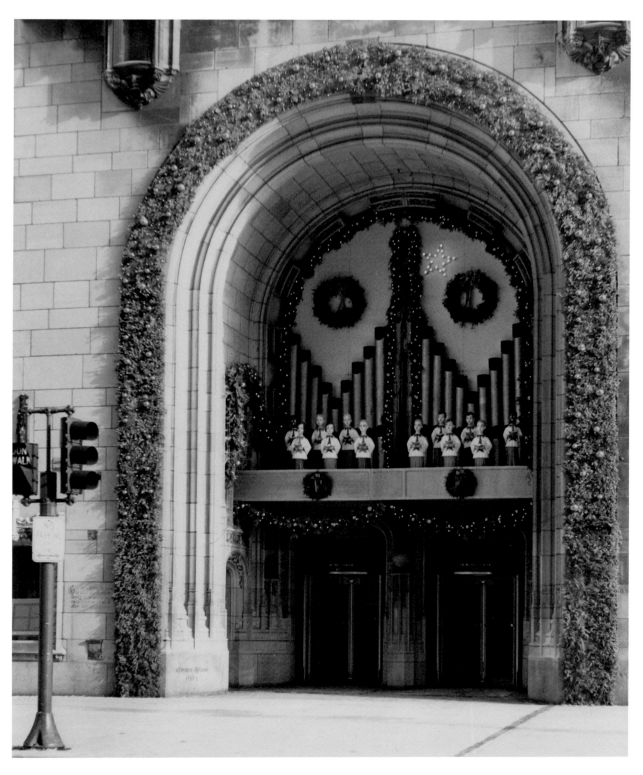

The Tribune Tower's neo-Gothic facade provides the perfect backdrop for Christmas decorations, December 1968.

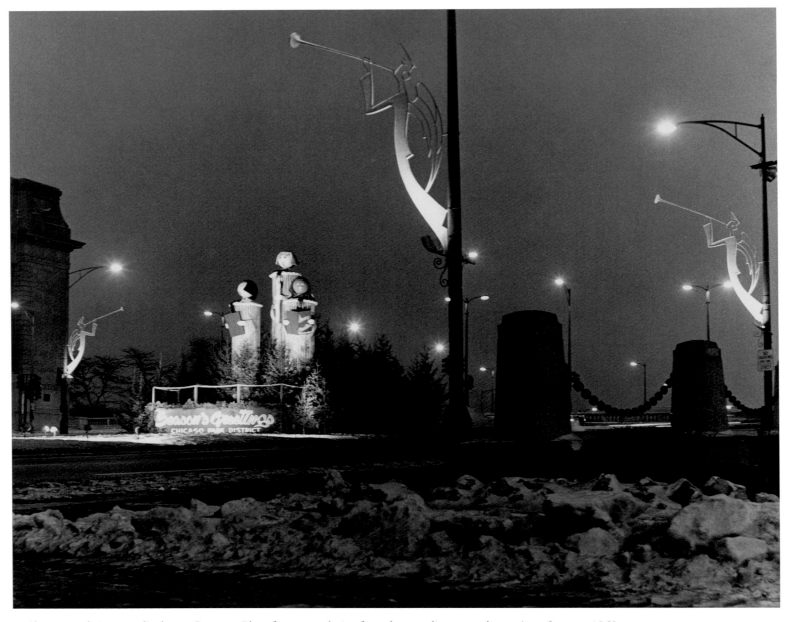

A Chicago Park District display at Congress Plaza features a choir of angels extending season's greetings, January 1969.

Even Chicago's smallest residences decorate for Christmas. At the Museum of Science and Industry, Colleen Moore's popular Fairy Castle received a festive makeover in 1975.

The Hyatt Regency O'Hare boasted a 60-foot-long, 13-foot-high, steel-and-wire sculpture of Santa's sleigh and reindeer, covered with more than 5,000 Italian lights.

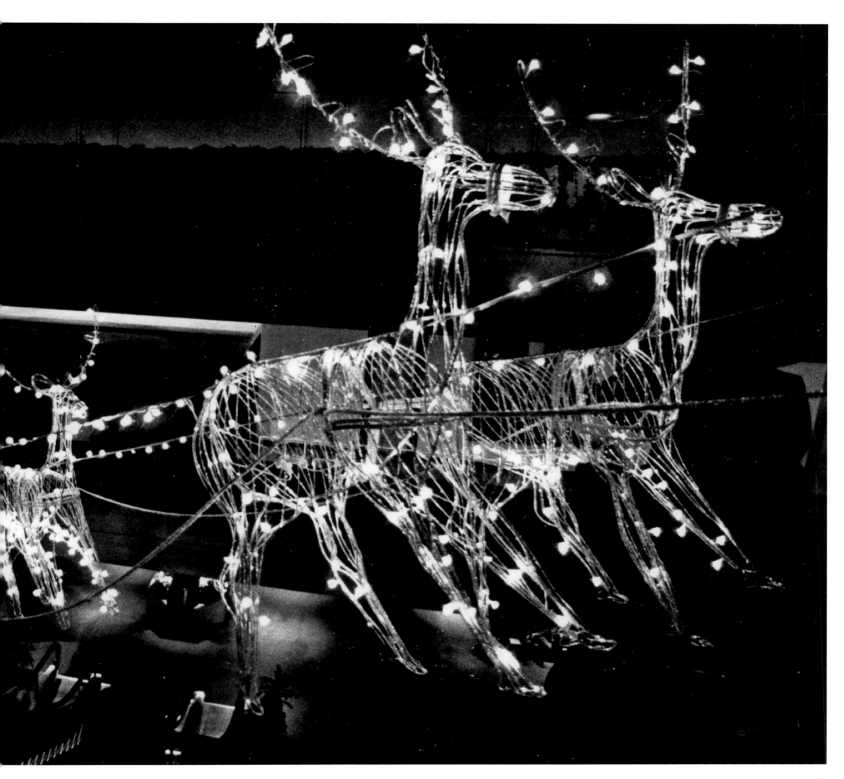

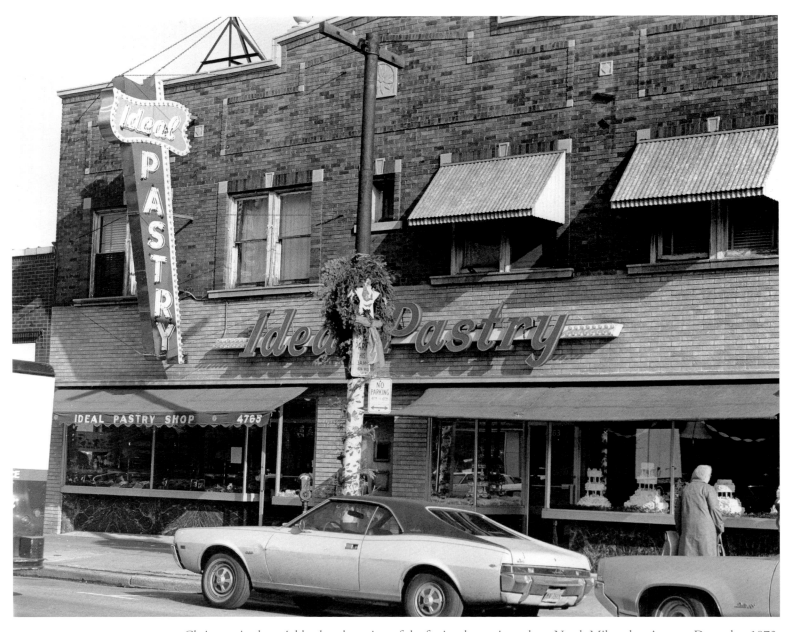

Christmas in the neighborhoods: a view of the festive decorations along North Milwaukee Avenue, December 1973.

O Christmas Tree

An Evergreen Tradition

Many Chicagoans begin their celebration of the holiday season by decorating their Christmas tree. There are numerous legends and theories of the origins of the evergreen's role in Christmas, but most people agree that early Christians appropriated a pagan symbol—one that had represented fertility, regeneration, and eternal life—and adapted it for their own beliefs.

People began decorating trees around the seventeenth century in Europe, and the custom became particularly popular in Germany; Protestant reformer Martin Luther supposedly added candles to trees to mimic the magnificence of a starry evening sky. German immigrants are credited with bringing the custom to the United States, perhaps as early as the Revolutionary War. A depiction in 1841 of England's Queen Victoria with her family gathered around a Christmas tree in a widely distributed image helped popularize the custom even more.

Chicagoans were celebrating the holiday with decorated trees as early as the 1850s. "Christmas Tree Ships" traveled the Great Lakes each fall to bring back loads of the trees that brightened Chicagoans' homes; Captain Herman "Santa Claus" Schuenemann is the most legendary supplier, but there were many others in the same business. Much like today, small lots sat on street corners throughout the city, where residents could purchase not only trees, but also wreaths, holly, and mistletoe. In 1900 the *Chicago Tribune* warned its readers of a mistletoe shortage but reassured them about other items: "There is no lack of other Christmas greens. . . . Xmas trees have met with ready sale this season. . . . Holly is plentiful."

For Chicagoans concerned with deforestation, the Sears catalogue offered artificial trees, made from goose feathers, as early as 1913. Trees made of plastic and other materials did not gain widespread popularity until the 1950s-60s. The symbolism of the "evergreen" was pushed aside as silver, white, pink, and other colors replaced the traditional natural hue. The debate over real vs. artificial began: "This thing of beauty, this symbol of Christmas, is gradually being replaced by a metallic imitation," wrote a disillusioned Chicagoan to the *Tribune* in 1964. The debate continues, but the tradition of the Christmas tree is cherished by Chicagoans young and old, and the magic of waking up to a tree surrounded by presents on Christmas morning remains.

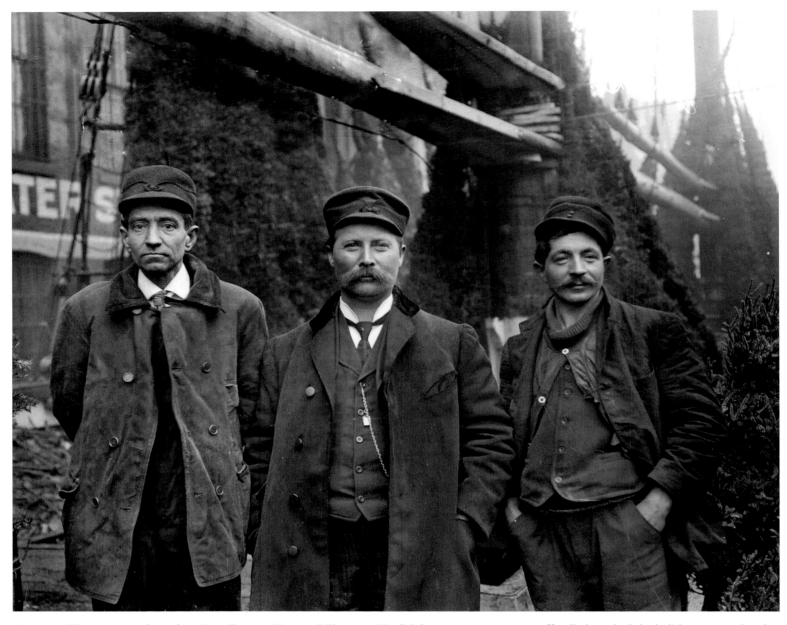

For many Chicagoans in the early 1900s, Captain Herman "Christmas Tree" Schuenemann, at center, officially launched the holiday season when he docked his ship, the *Rouse Simmons,* full of evergreens from Upper Michigan, at the Clark Street Bridge.

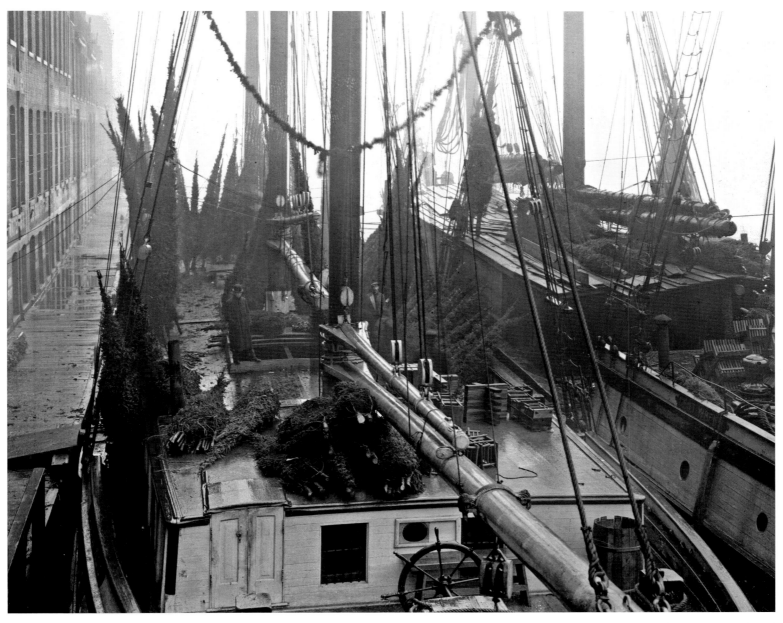

The *Rouse Simmons* docked on the Chicago River. Although not the only ship that transported trees, it was the most famous, and newspapers referred to it as the "Santa Claus Ship."

The schooner *Arendal* is seen here docked at Clark Street to deliver Christmas trees from Michigan. Although less celebrated than the *Rouse Simmons,* the *Arendal* was no less important in ensuring Chicagoans had their Christmas trees.

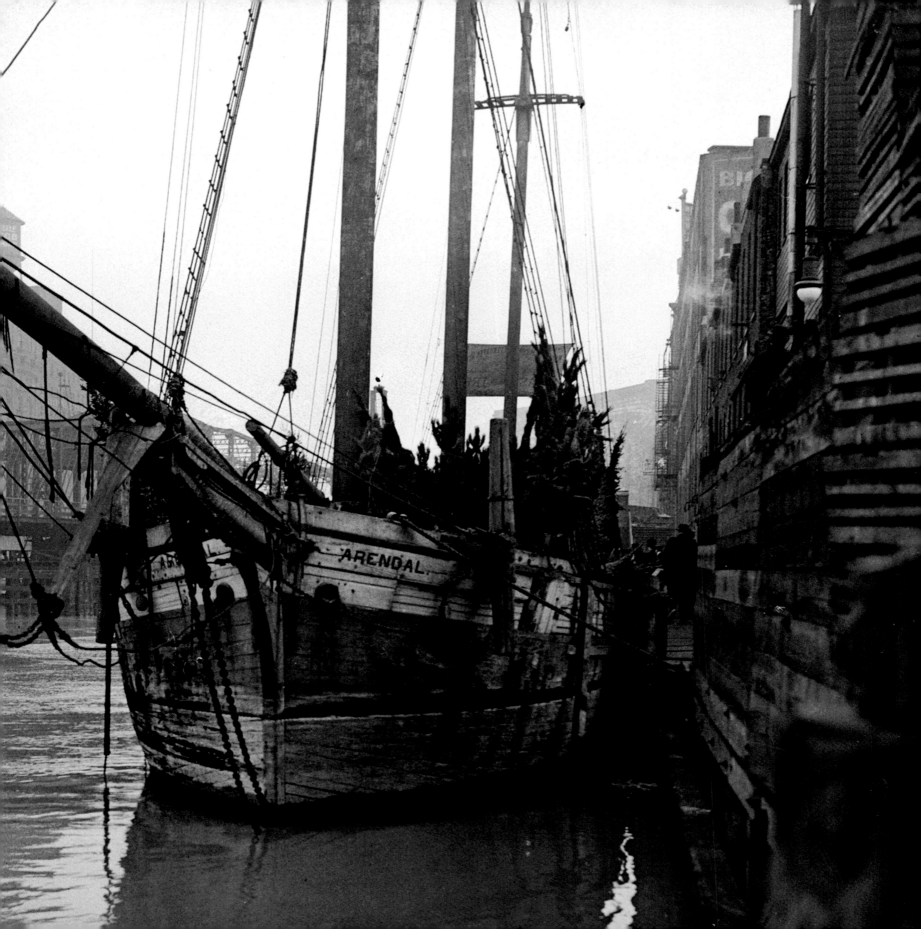

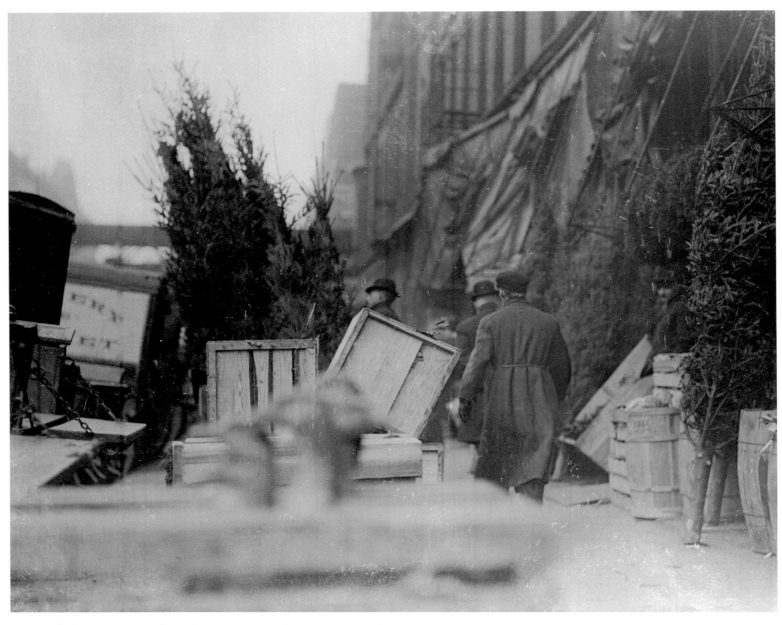

A view of Christmas trees and wooden crates on South Water Street in the Loop, 1909.

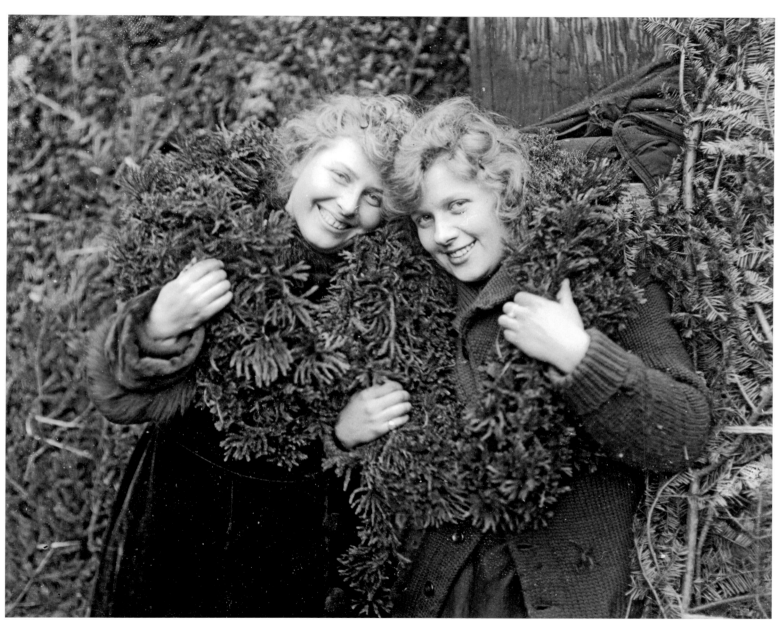

The twin sisters Hazel and Pearl Schuenemann, seen here around 1917, were familiar faces at their family's Christmas tree business, which their mother continued after the captain's death in a shipwreck in 1912.

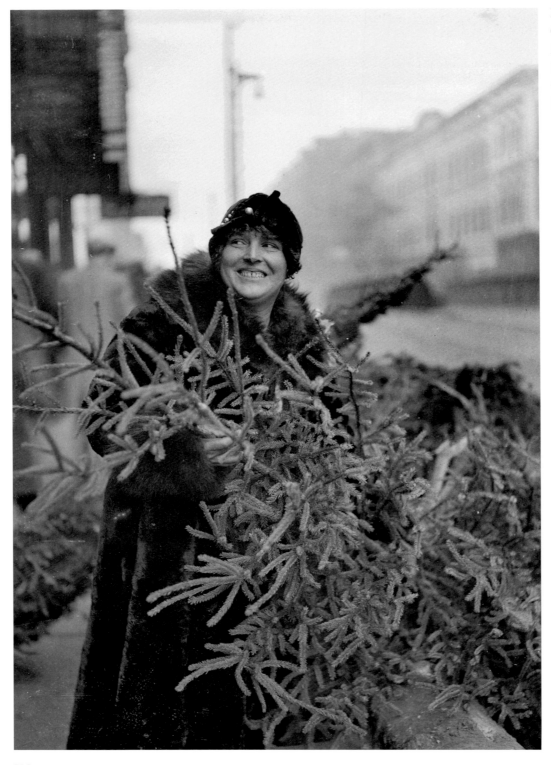

Elsie Schuenemann Roberts holds a Christmas tree, ca. 1928. In the 1930s, Elsie and her sisters, the twins Hazel and Pearl Schuenemann, opened their own Christmas tree business on North LaSalle Street.

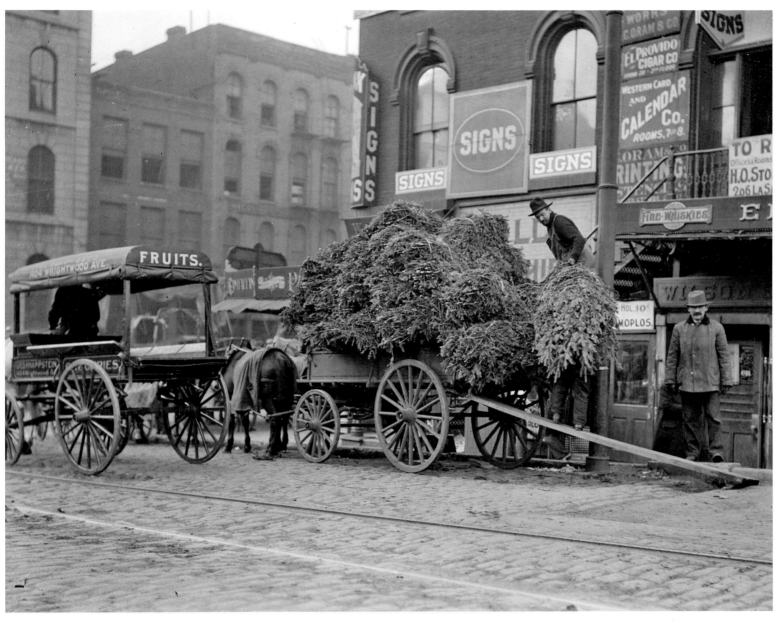

A man unloads evergreen trees from a wagon, ca. 1904. German immigrants brought to America the custom of decorating trees for Christmas.

A young woman poses with her cat and a Christmas tree, December 1913. The trees shipped from Upper Michigan ended up in homes like this one.

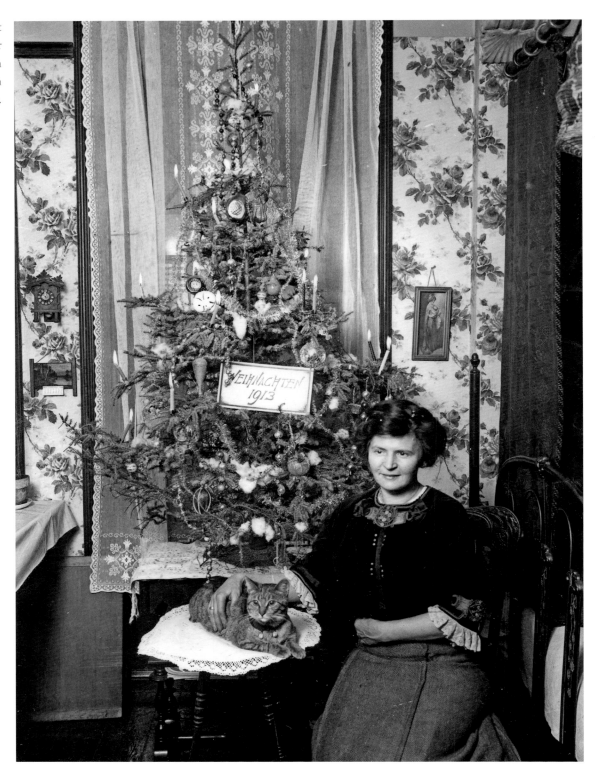

A man decorates his Christmas tree at home, ca. 1905.

Women decorate a tree in a factory,
December 1904.

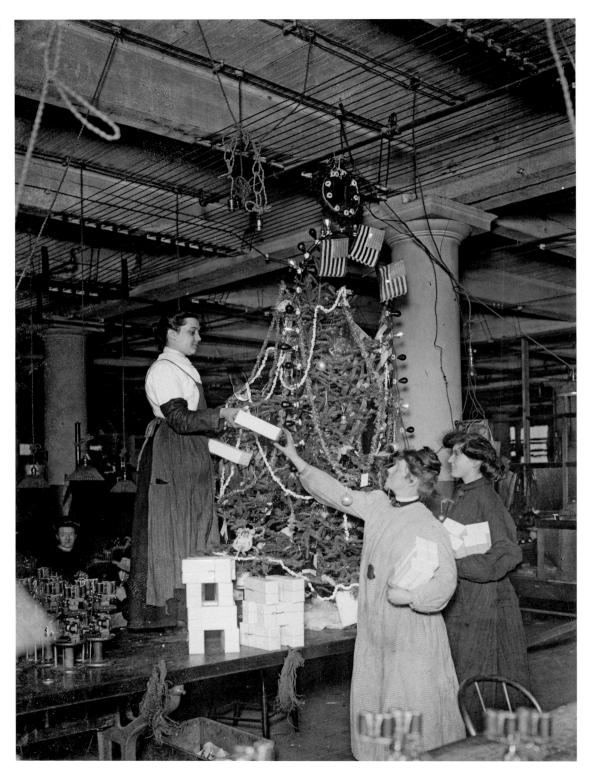

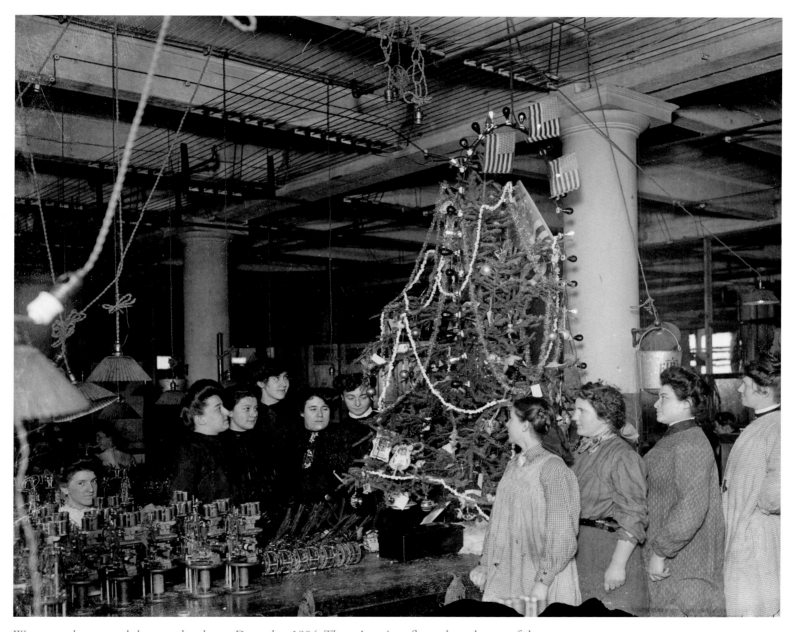

Women gather around the completed tree, December 1904. Three American flags adorn the top of the tree.

Children gather around a tree surrounded by presents in a schoolroom in 1905.

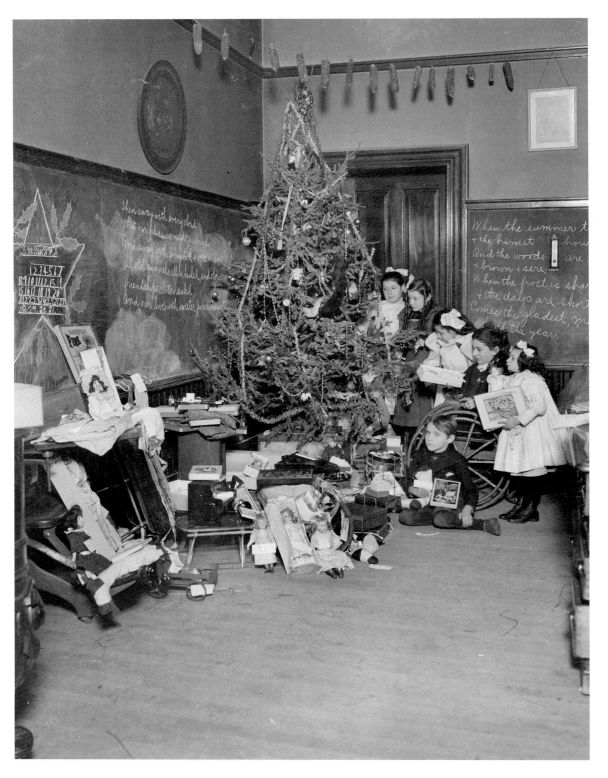

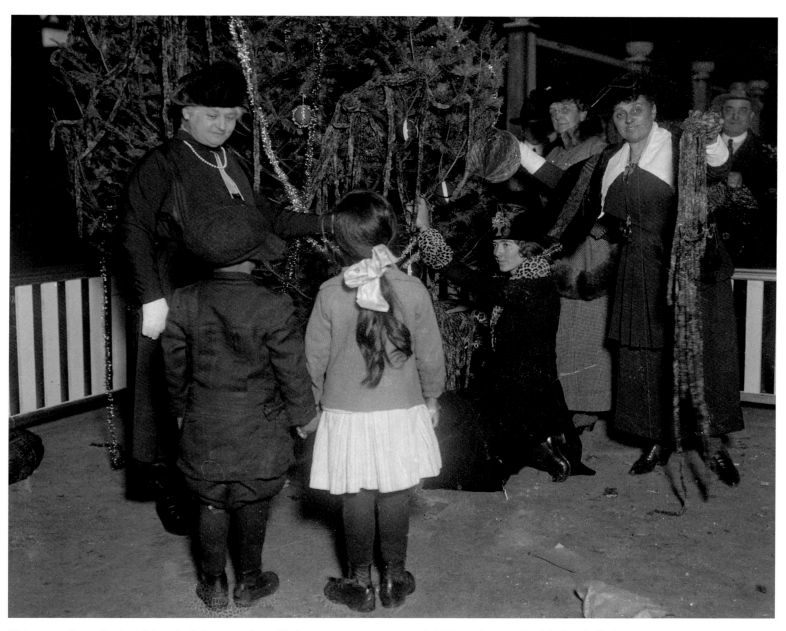

Chicagoan Gusta Rothschild, at far left, stands by a Christmas tree as women and children decorate it with tinsel, Christmas 1917.

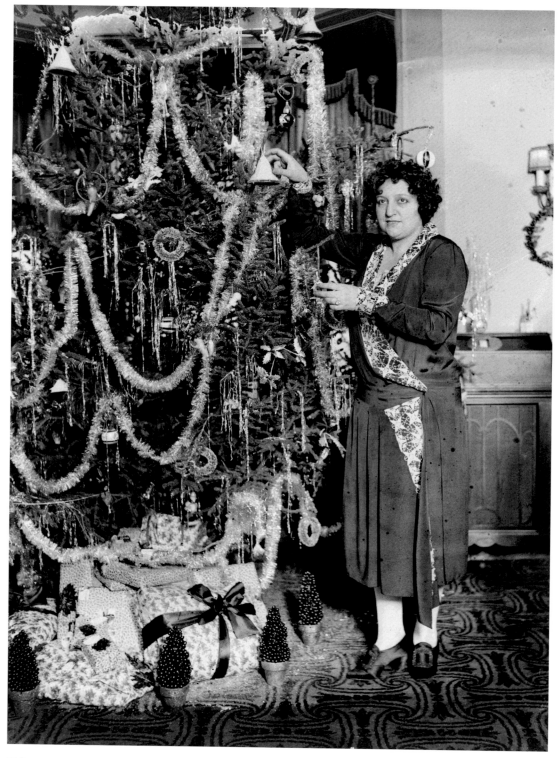

Claudia Muzio decorates a Christmas tree, 1928. The Italian-born opera singer was well known to Chicago opera lovers through her regular performances in the city.

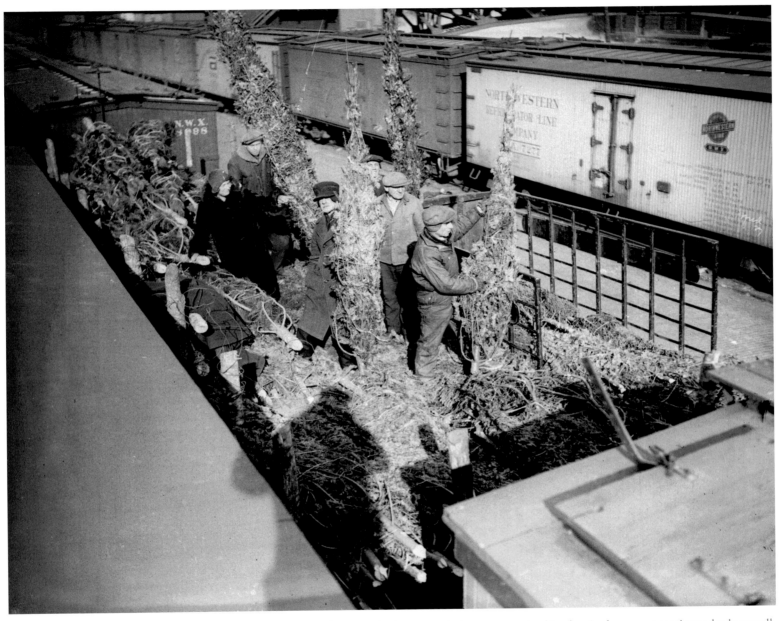

Although the legends and lore of the Christmas tree ships have inspired songs and plays, trees arrived in the city by more prosaic methods as well. Here, in 1929, a woman and several men stand on top of a pile of Christmas trees recently delivered by train.

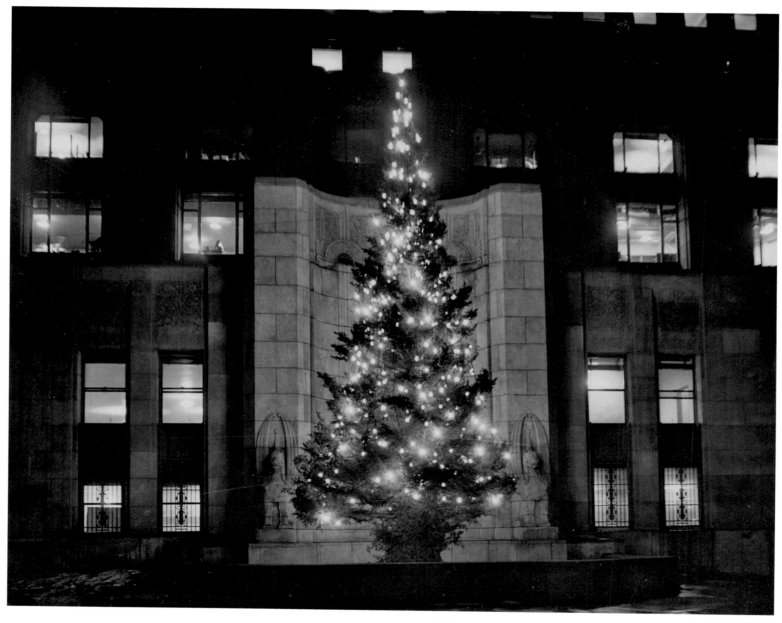

A lighted Christmas tree outside of the Daily News Building, 1929.

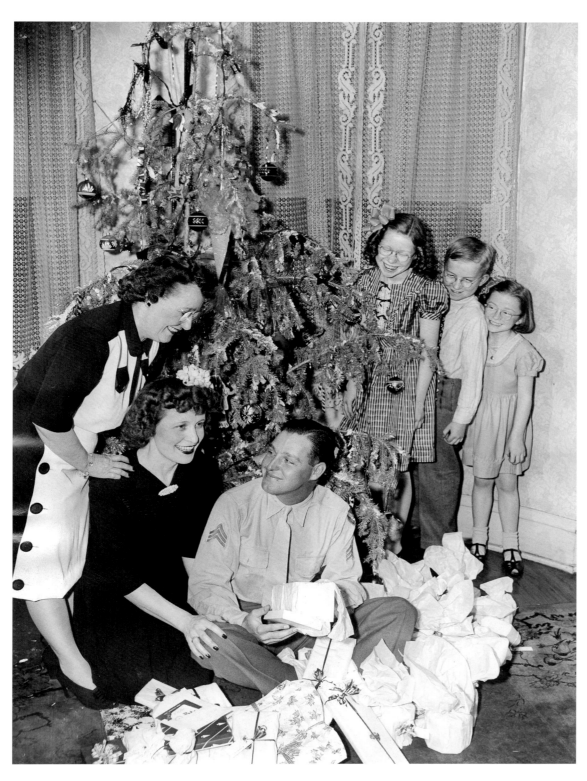

A young soldier surrounded by his family opens a gift—three months after Christmas. Sergeant Oliver Minder was unable to make it home for the holidays in December, so his family kept the tree trimmed and the presents wrapped until he could join them in March 1945.

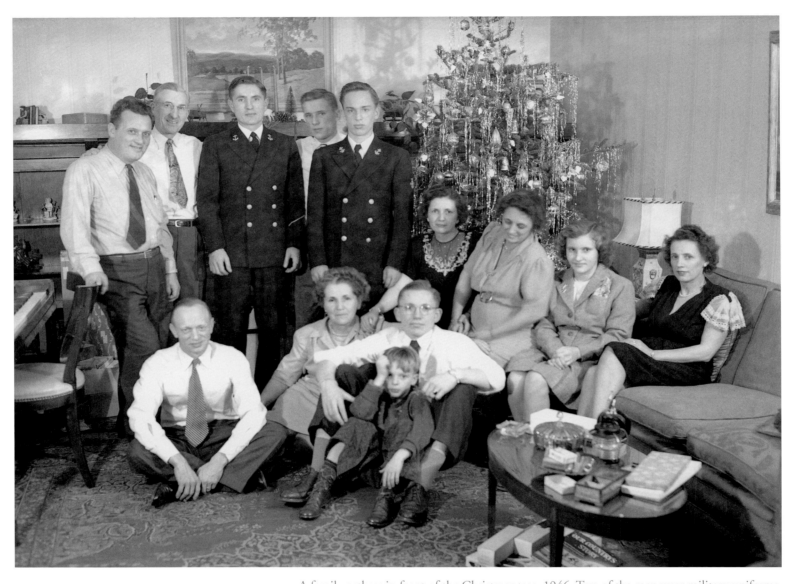

A family gathers in front of the Christmas tree, 1946. Two of the men wear military uniforms.

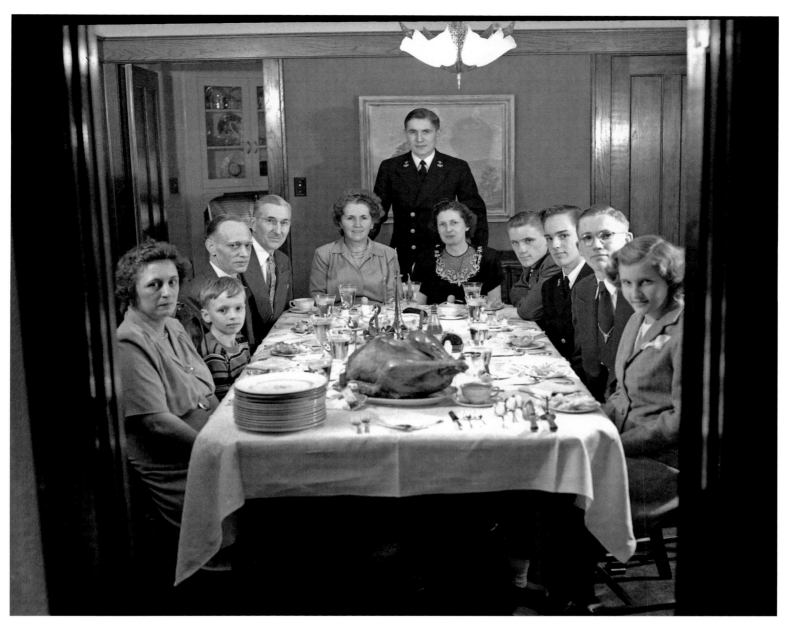

The same family prepares for dinner.

A Christmas tree chopping
party, ca. 1920.

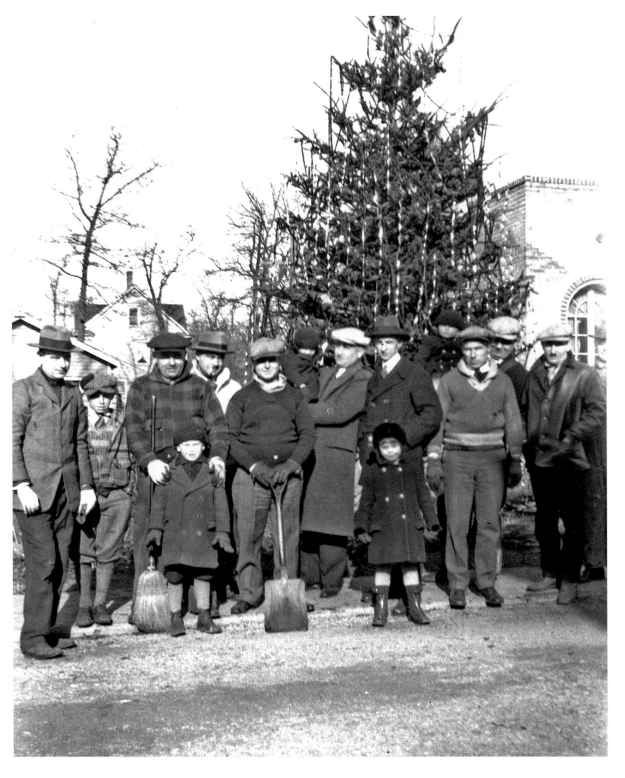

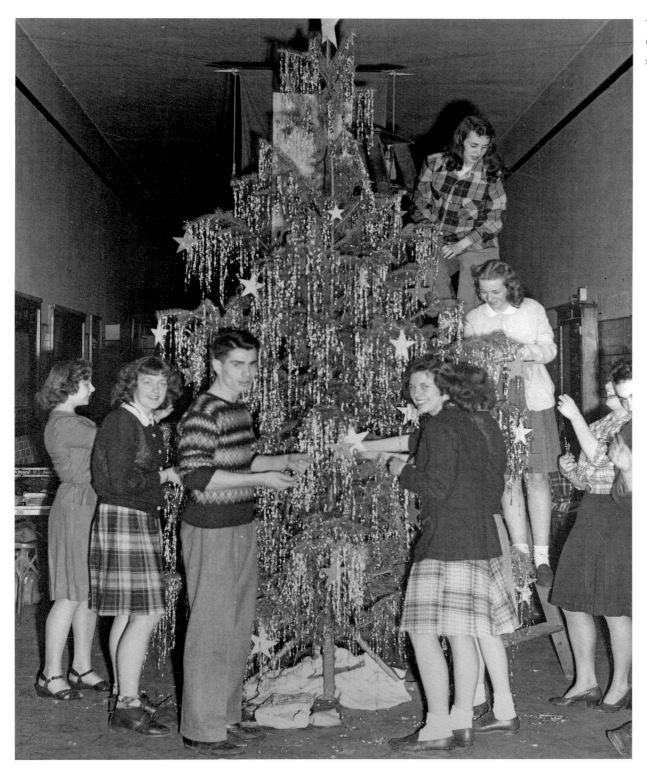

Teenagers decorate a
Christmas tree inside a
school, ca. 1945.

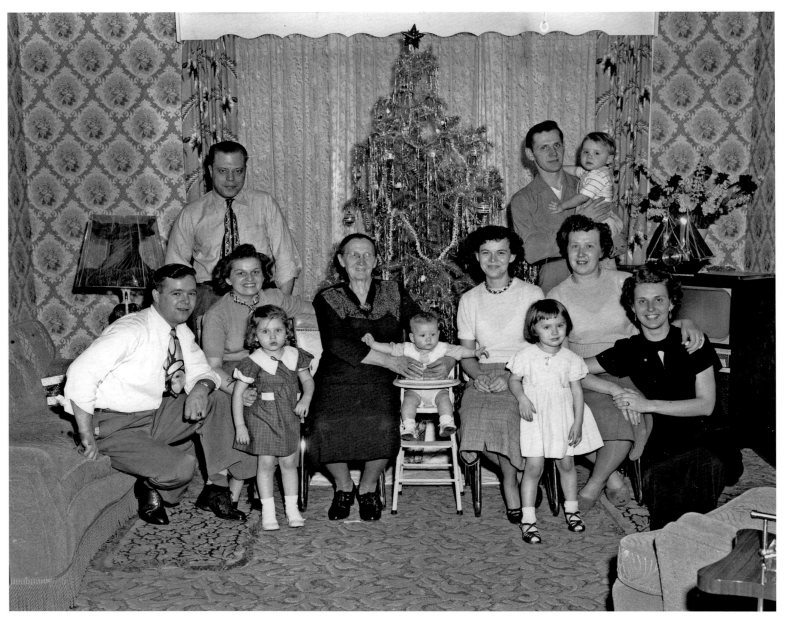

A multigenerational family gathering, December 1950.

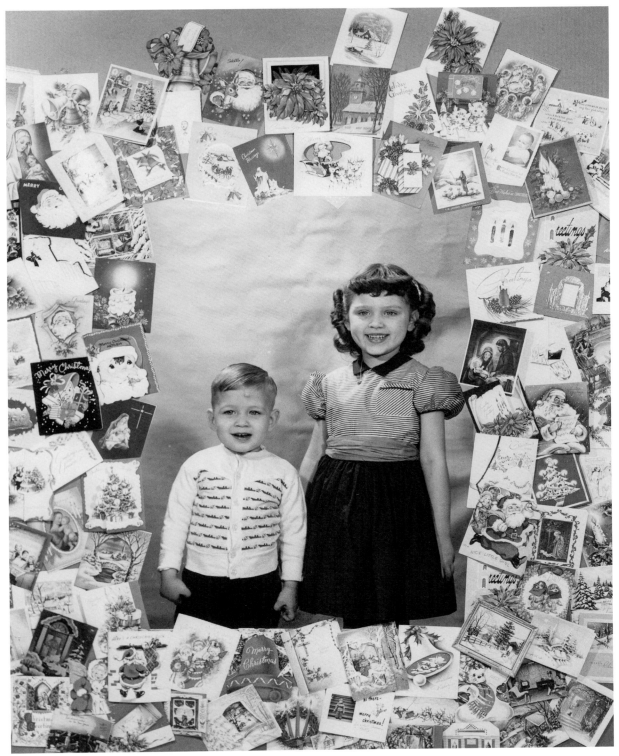

A Christmas card portrait featuring Christmas cards, 1953. The earliest American Christmas cards were made in the 1850s.

A little girl receives two
Raggedy Ann dolls on
Christmas morning, 1953.

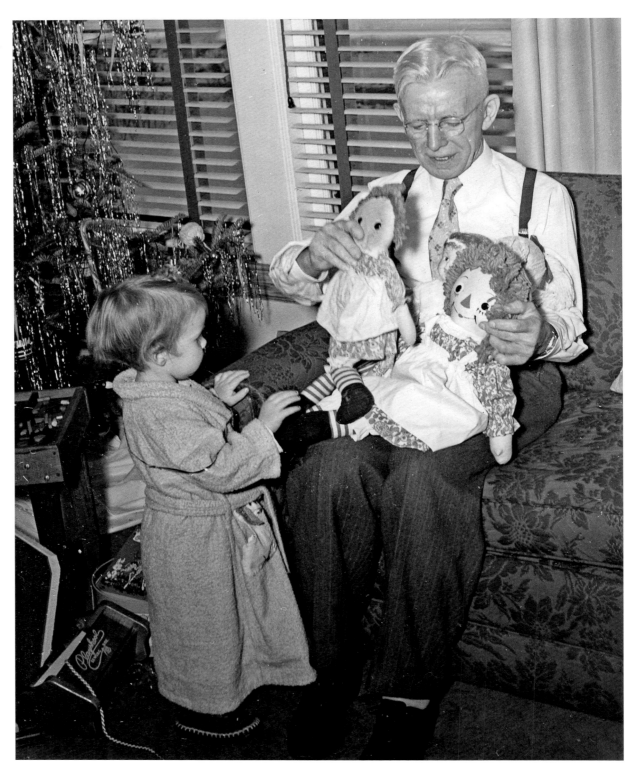

The tradition of the holiday television specials reaches back to the early days of the medium. Here, Chicago's own Kukla and Ollie extend season's greetings.

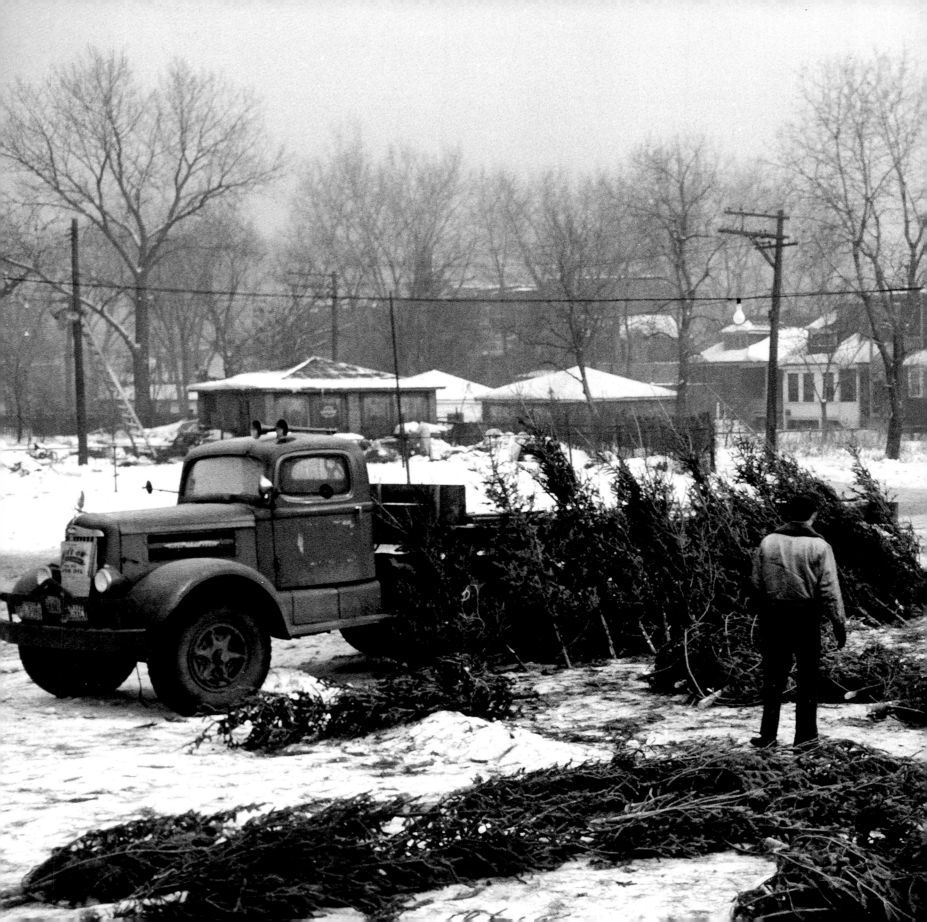

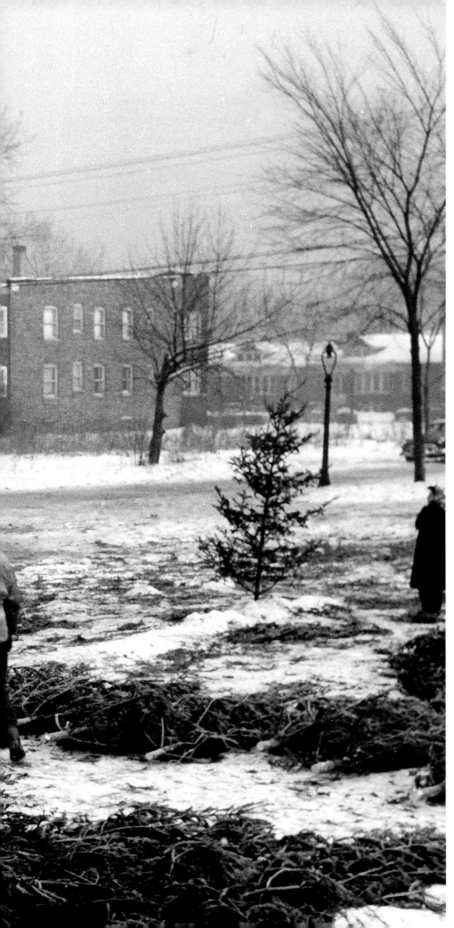

A Christmas tree market on 72nd Street east of State Street, December 23, 1951. By this time, decades after the demise of the famous ships, Christmas trees arrived via trucks.

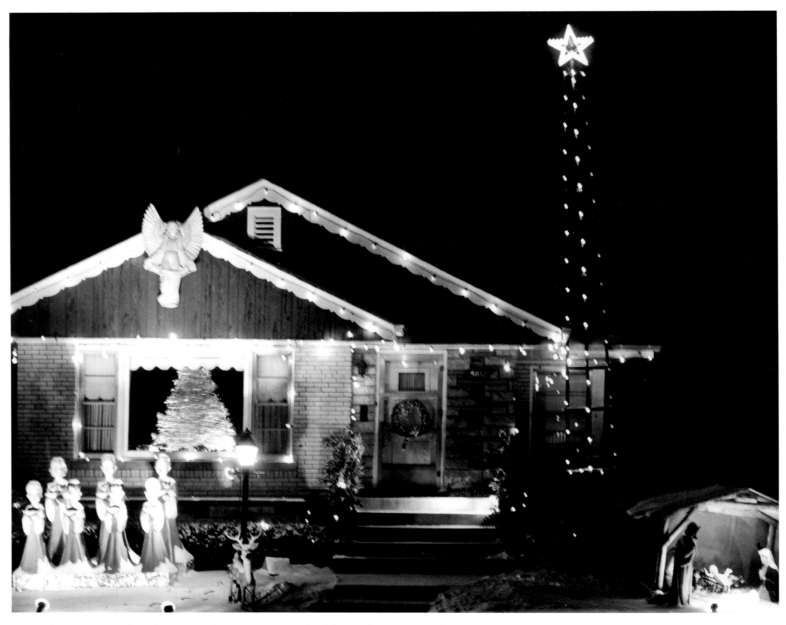

Home decorations in the Chicago area became increasingly elaborate beginning in the 1950s. Here, in 1958, an angel overlooks a choir, while a star shines above a manger scene.

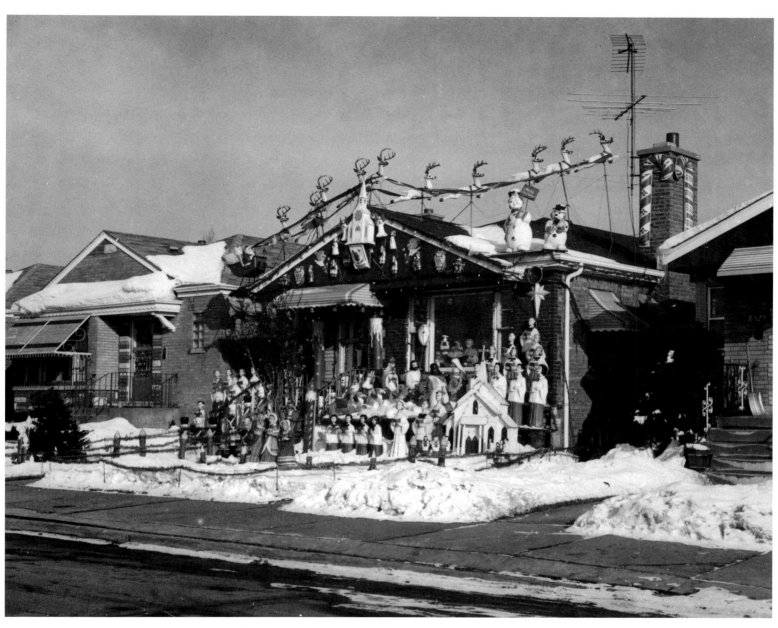

Many home displays mix the secular with the religious, such as this heavily decorated house seen in December 1969.

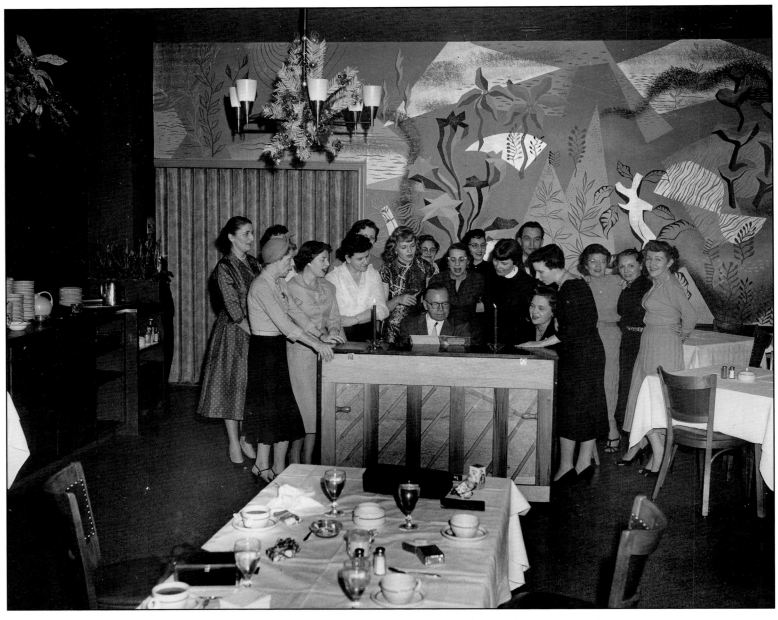

Home isn't the only place where people celebrate the holidays. Here, office staff gather with co-workers to sing carols . . .

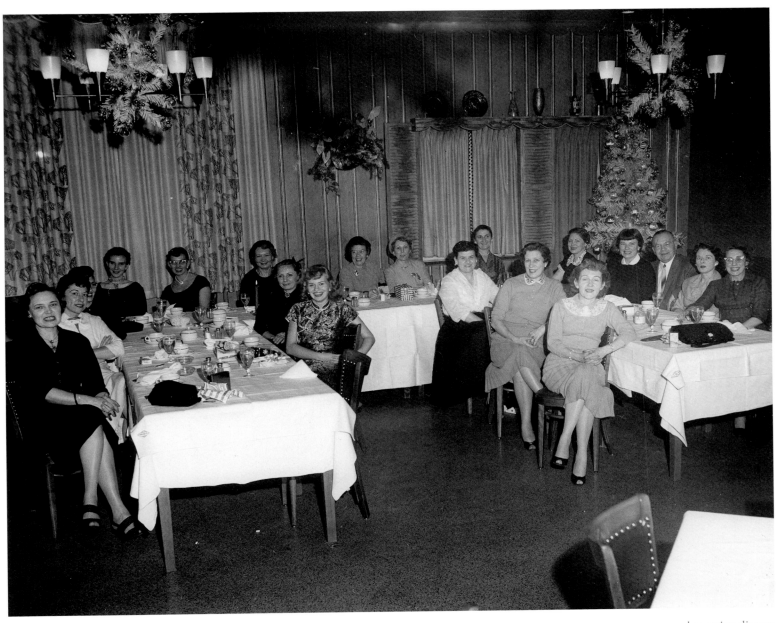

. . . and to enjoy dinner.

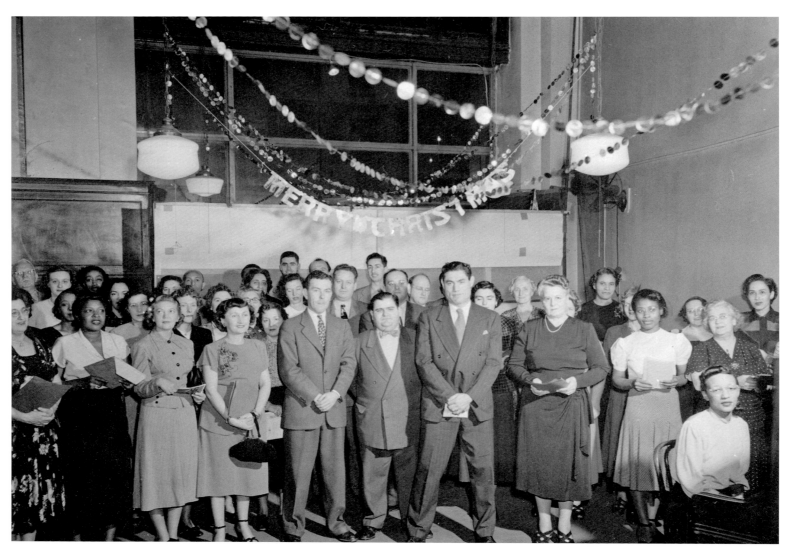

Office staff celebrate the holidays together.

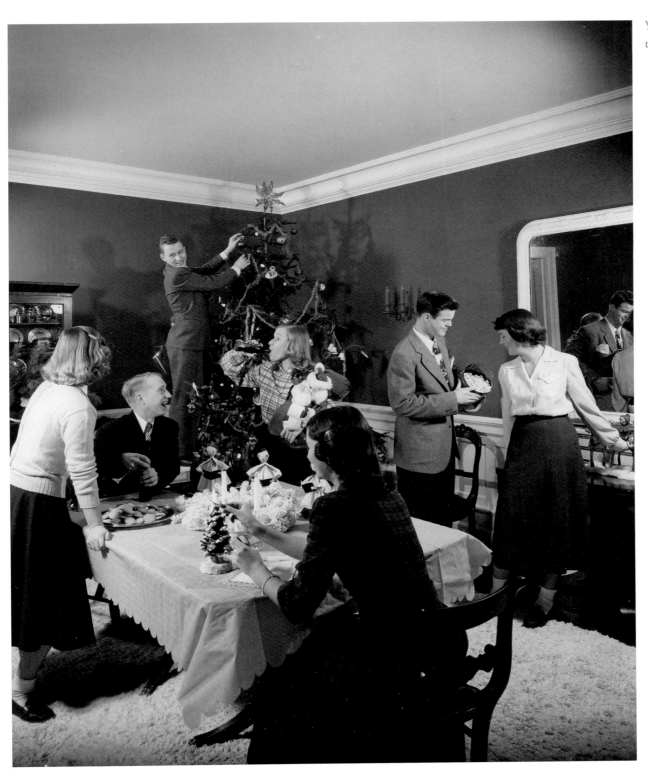

Young people at a tree-trimming party, ca. 1950

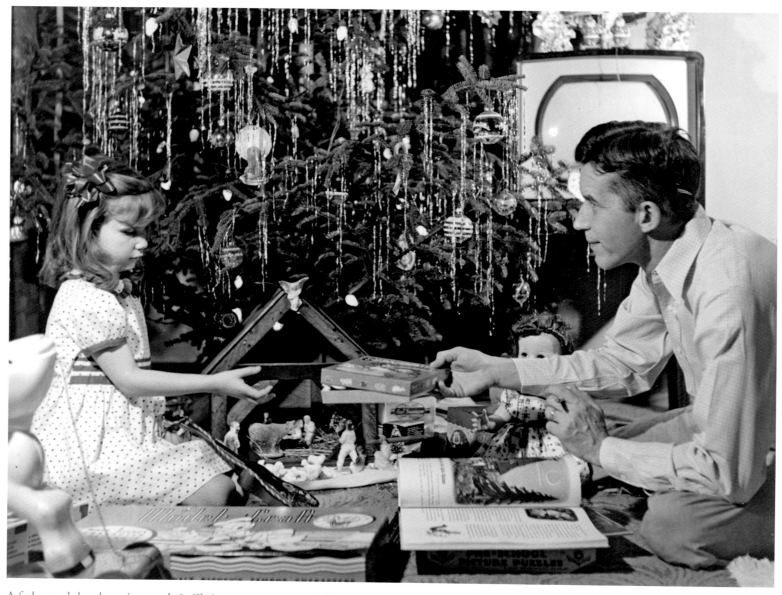

A father and daughter sit near their Christmas tree surrounded by an abundance of presents as well as a Nativity scene, ca. 1950.

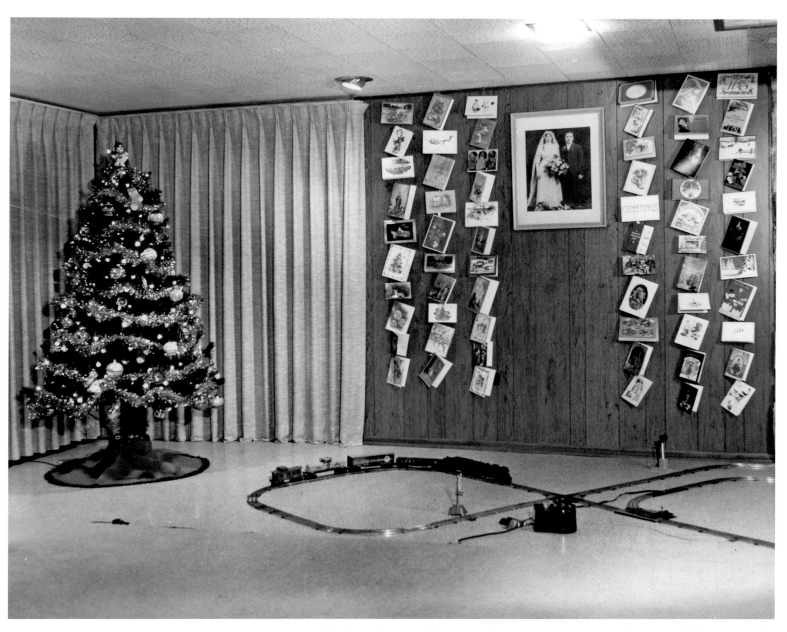

A recreation room gets decked out for the holidays, complete with a tree, trains, and an array of Christmas cards.

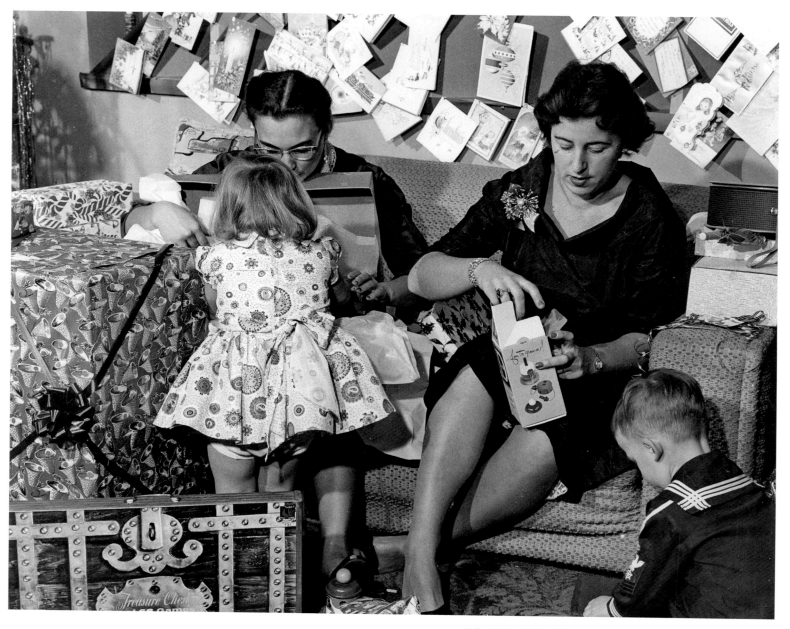

The Schmidt family opens presents on December 25, 1957.

A member of the Schmidt family at Christmas.

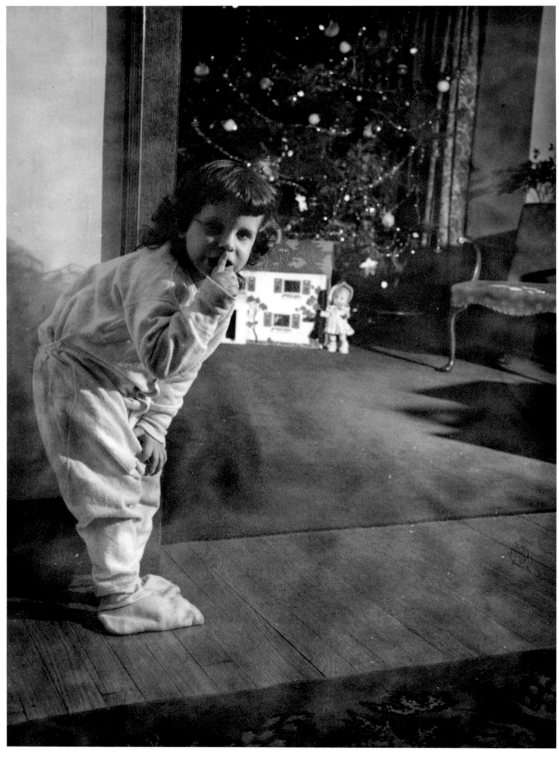

A little girl in pajamas warns against even whispering, in case Santa is in the house delivering presents.

Children share a Christmas kiss in front of a tree before exchanging gifts.

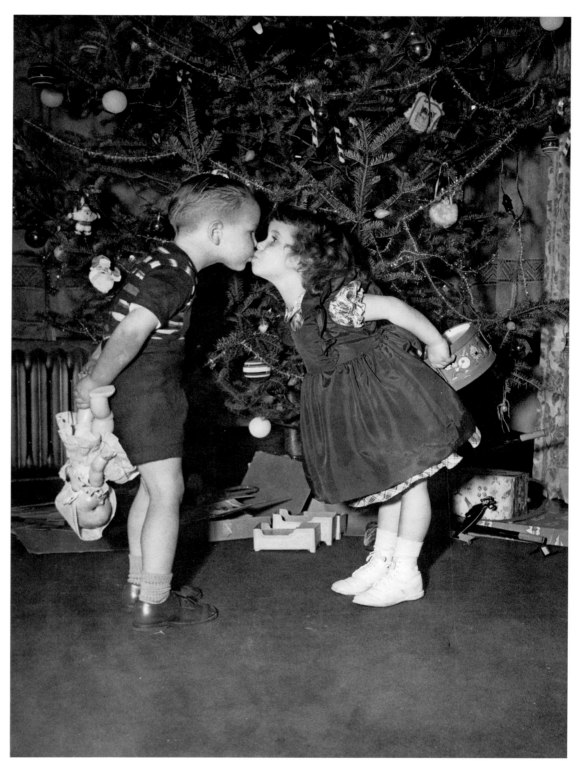

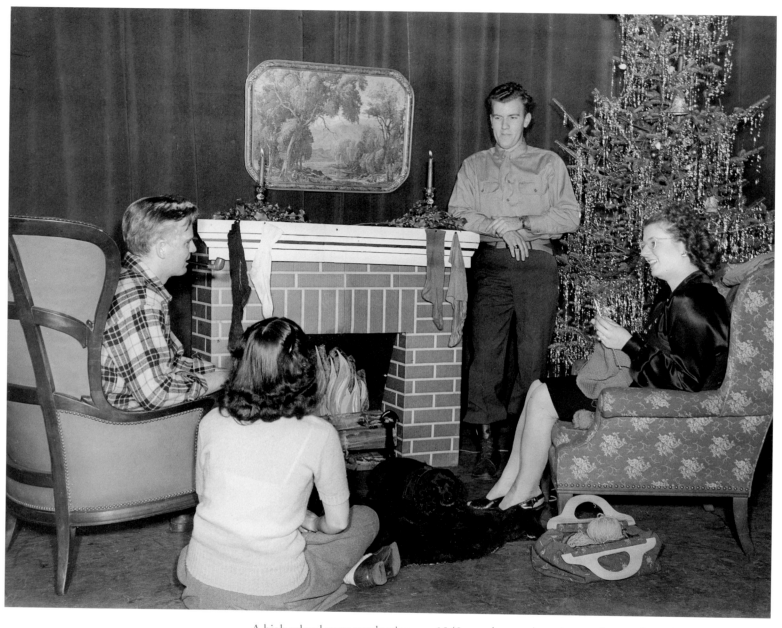

A high school stage production, ca. 1942, touches on the poignant theme of war during the holidays.

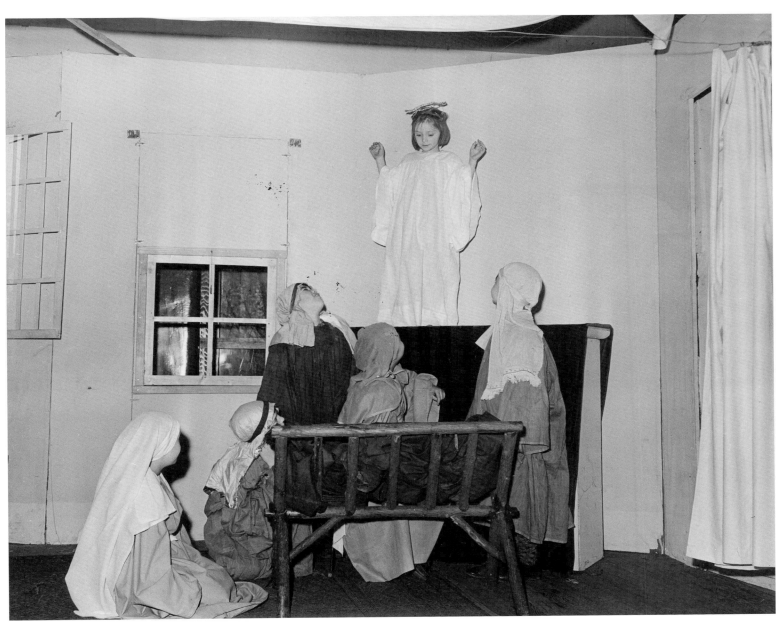

Schoolchildren stage a production of the Nativity story.

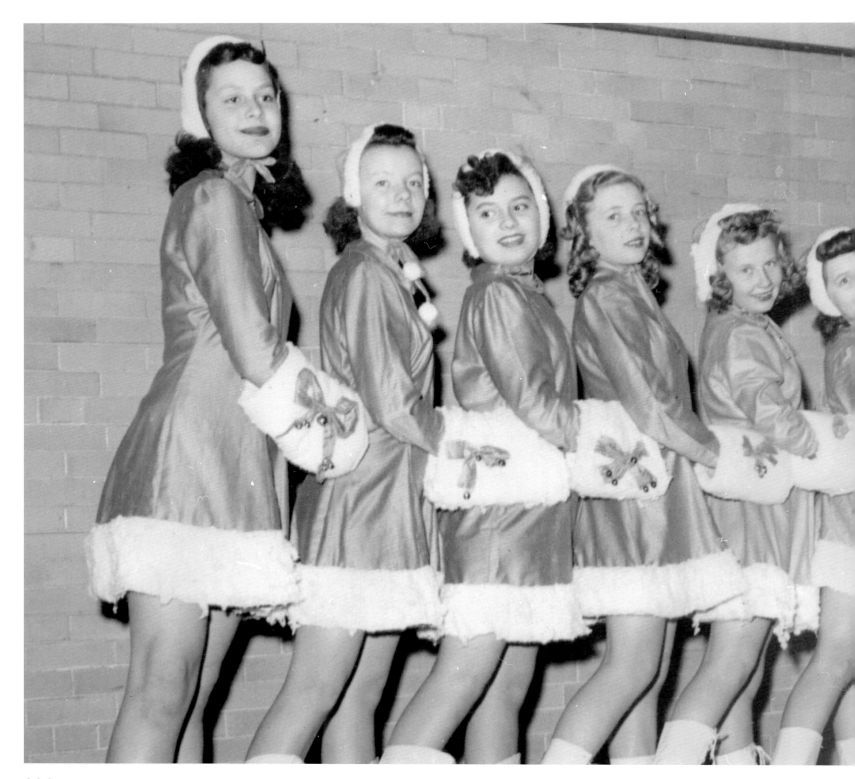

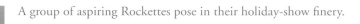
A group of aspiring Rockettes pose in their holiday-show finery.

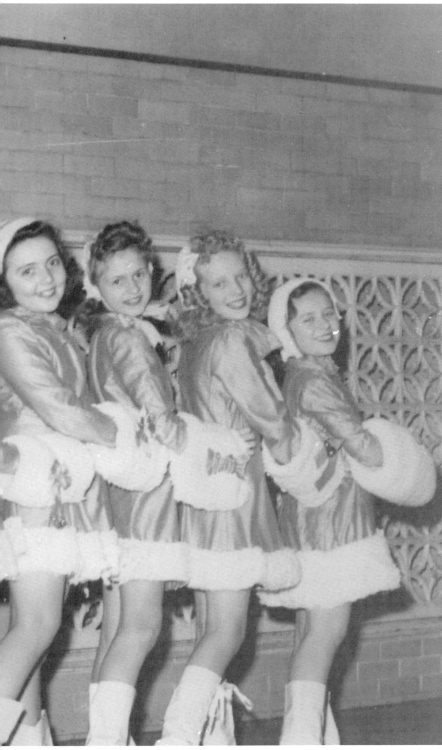

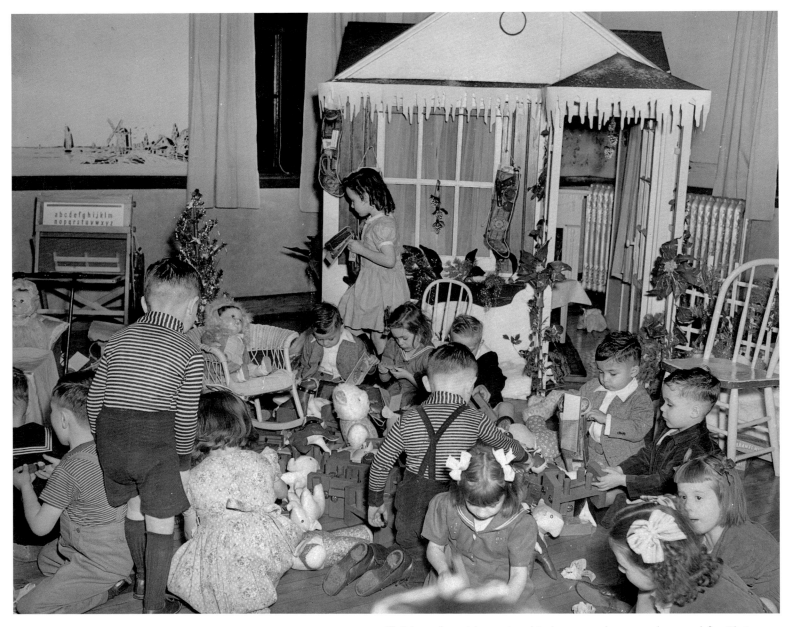

Children play with toys in a kindergarten classroom decorated for Christmas.

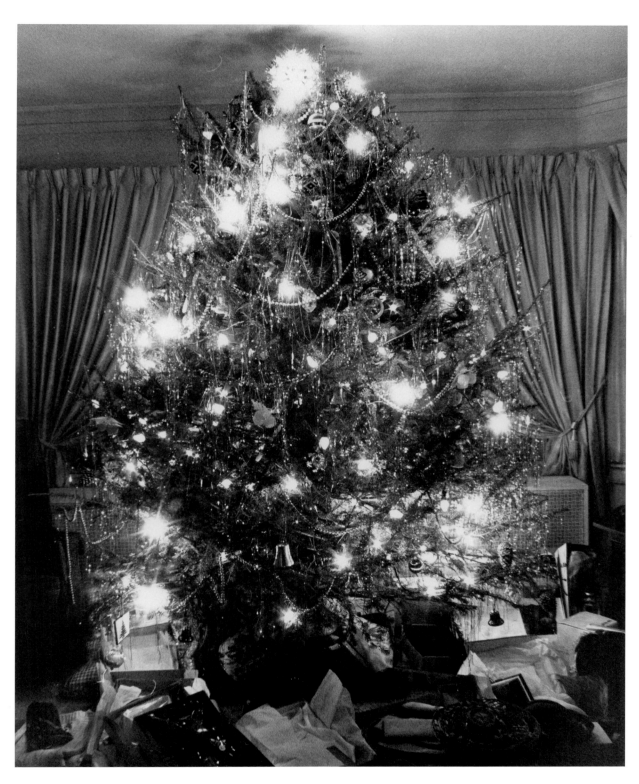

A brilliantly lit Christmas tree at 4574 North Merrimac, Chicago.

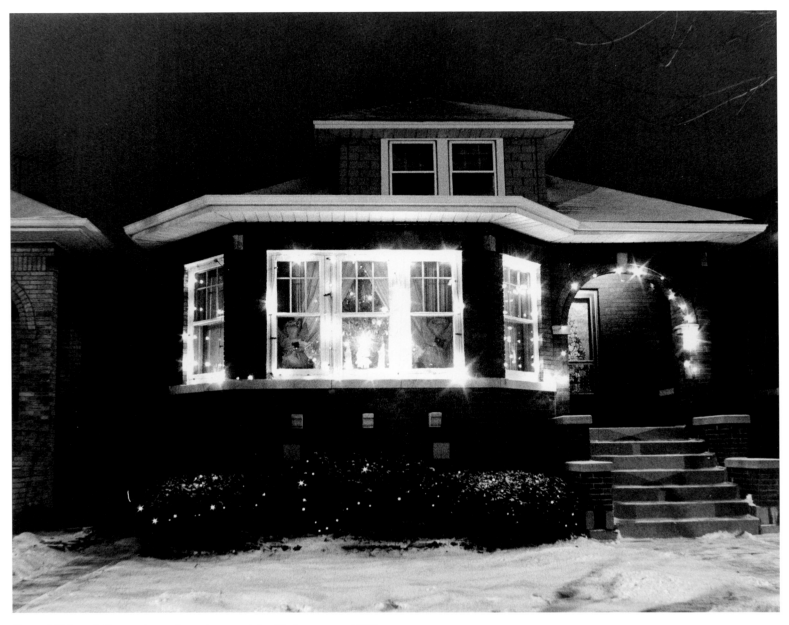

One of Chicago's famous bungalows decorated for Christmas, ca. 1979.

HERE COMES SANTA CLAUS

ST. NICK AND HOLIDAY SHOPPING

Generations of Chicagoans grew up greatly anticipating a visit to Santa Claus at Marshall Field's on State Street. His presence there attested to not only fulfilling children's Christmas wishes, but also to merchants' desire to increase Christmas sales. While Santa's roots lay in Christian tradition, his evolution in America is tied closely to the commercialization of the holiday, a trend that also saw increasingly elaborate Christmas merchandising and window displays at stores such as Marshall Field's.

The rotund, rosy-cheeked gentleman who we recognize today as Santa Claus represents a long evolution and a mixture of various traditions. His origins lie with St. Nicholas, born in 280 A.D. in Turkey, and who was known as the protector of children. Christians celebrated his feast day on December 6; even after the Reformation, when the Protestant church discouraged the recognition of saints, Nicholas remained popular, particularly in Holland, where he was known as Sinter Klaas. Dutch immigrants brought this tradition to the United States. In the early nineteenth century, the wide distribution of engravings of the saint standing near a mantel from which stockings hung, bulging with food, dramatically increased Nicholas's popularity and his association with gift-giving. These early images often depict a tall man dressed in earth-toned furs, walking with a staff, sometimes with a rather stern expression on his face—a far cry from the jolly figure so eagerly anticipated by children today.

Author Washington Irving popularized St. Nicholas in his stories, and Santa's legendary Christmas Eve journey was described to great popular appeal in Clement Moore's "A Visit from St. Nicholas." Combined with cartoonist Thomas Nast's drawings, Santa evolved into a cheerful, kindly gentleman in a red suit who spread goodwill throughout the world. Coca-Cola ads featuring Santa, launched in 1931, helped reinforce the image.

Eventually, department stores and other merchants began to use Santa and his genial image to help Christmas sales. In 1841, a model of Santa appeared in a Philadelphia store, attracting huge crowds. Soon, stores were hiring men to dress up as the kindly gift-giver. Today, almost every mall and many department stores host Santa and his elves to the delight—and occasional teary-eyed dismay—of children. Santas also appeared on street corners throughout Chicago soliciting donations for charities; for Santa not only gives gifts but encourages others to give to those less fortunate.

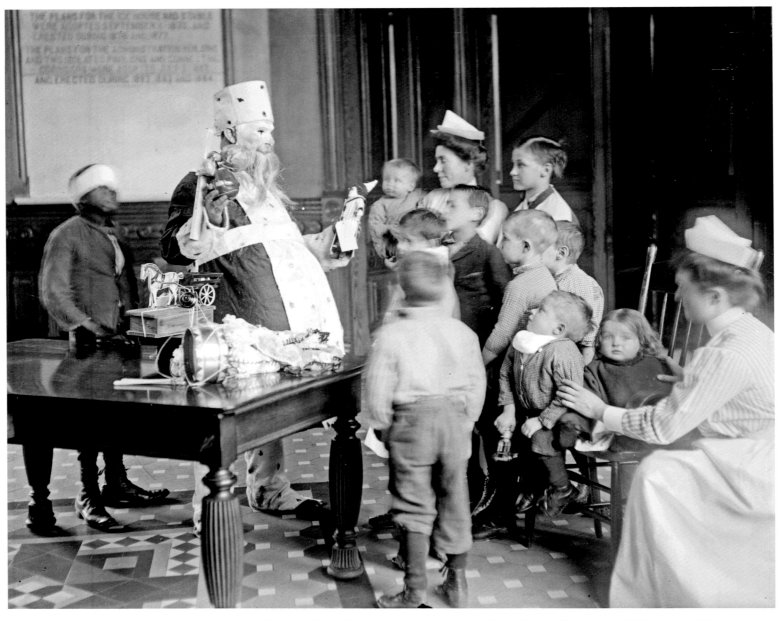

Santa (who wears not just a beard but a mask for his entire face) visits with young patients at Cook County Hospital in 1909. In the 1900s, images of Santa differed greatly from the rotund, rosy-cheeked, jolly gentleman we're used to seeing today.

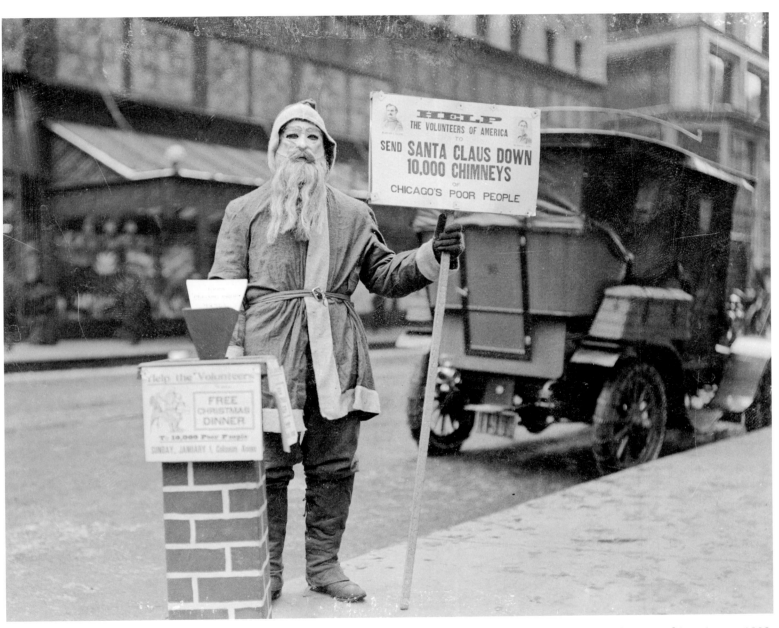

Another masked Santa, this one raising money for Volunteers of America, ca. 1902.

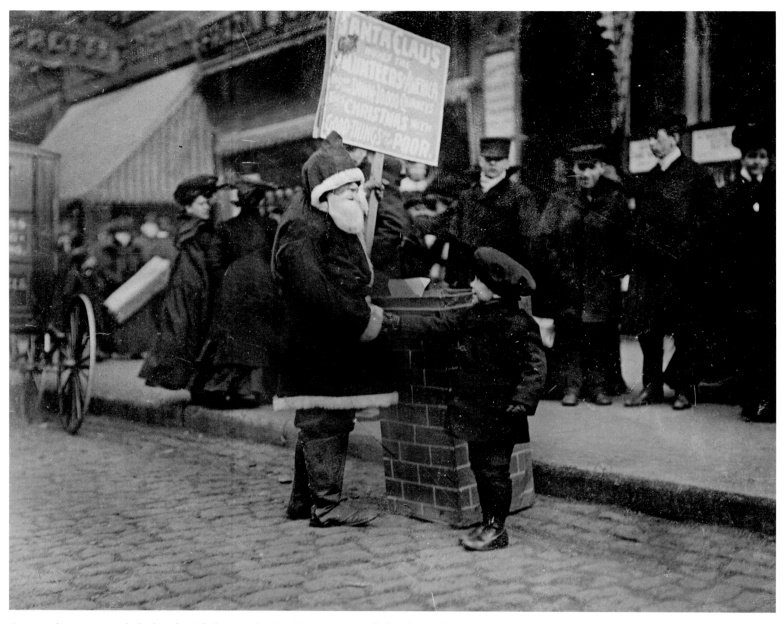

A young boy stops to shake hands with Santa, who is raising money to help Chicago's poor, ca. 1903.

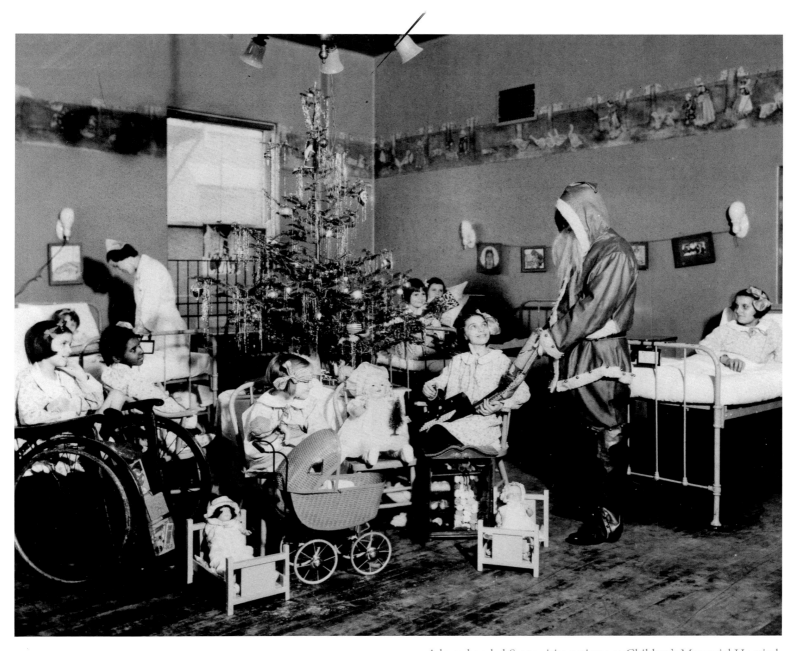

A lean, hooded Santa visits patients at Children's Memorial Hospital.

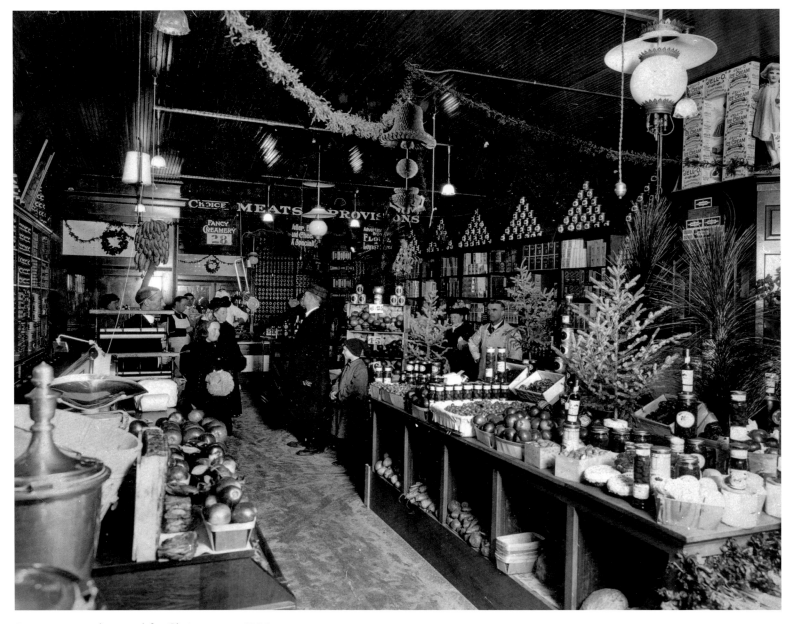

A grocery store decorated for Christmas, ca. 1900.

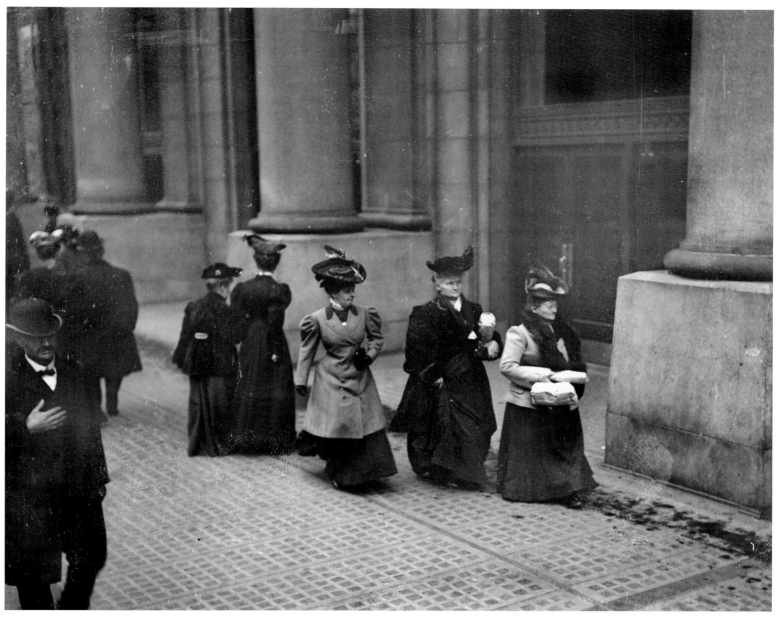

Ladies dressed in their finest walk past the main entrance to Marshall Field's while Christmas shopping, ca. 1905.

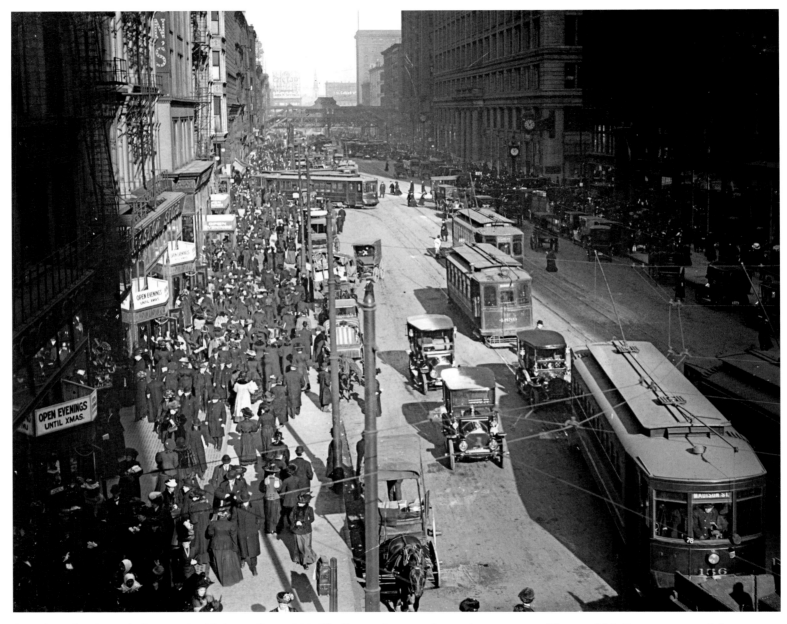

State Street bustles with shoppers in this image from 1909. The Boston Store, at the northwest corner of State and Madison, appears at left, advertising its extended hours for the holiday season.

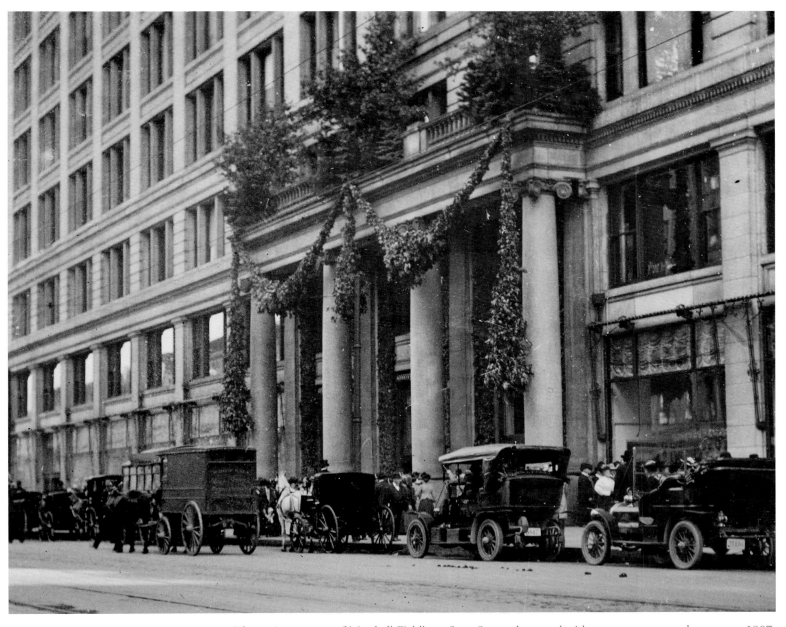

The main entrance of Marshall Field's on State Street, decorated with evergreen trees and swags, ca. 1907.

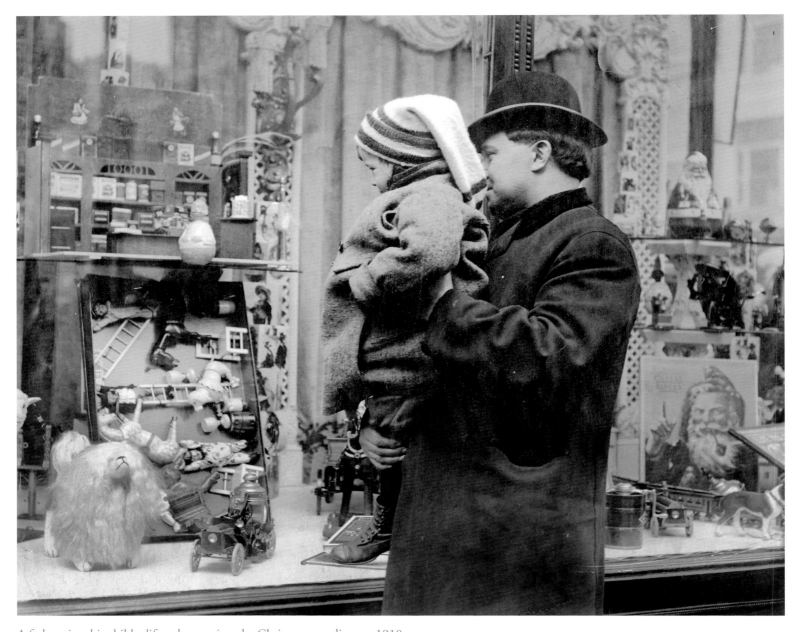

A father gives his child a lift to better view the Christmas goodies, ca. 1910.

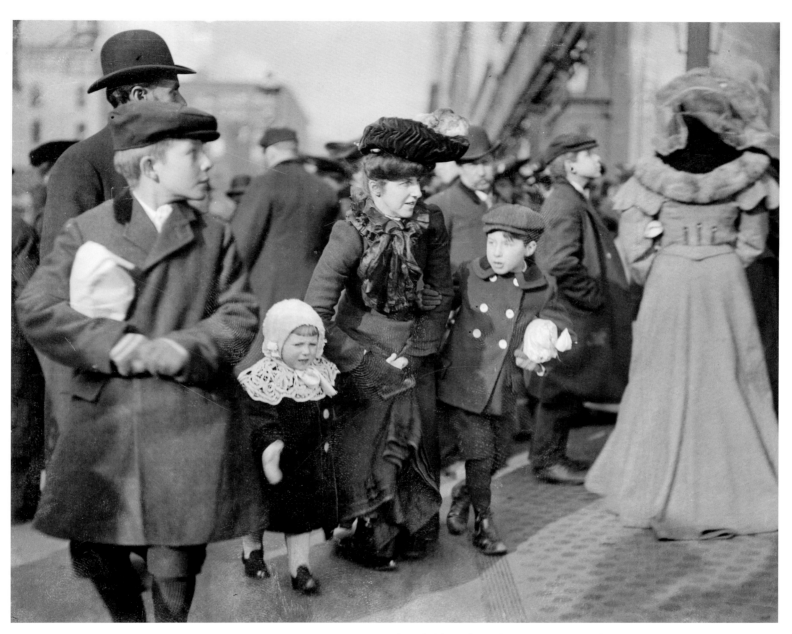

A woman steers her children through the busy streets while Christmas shopping, ca. 1915.

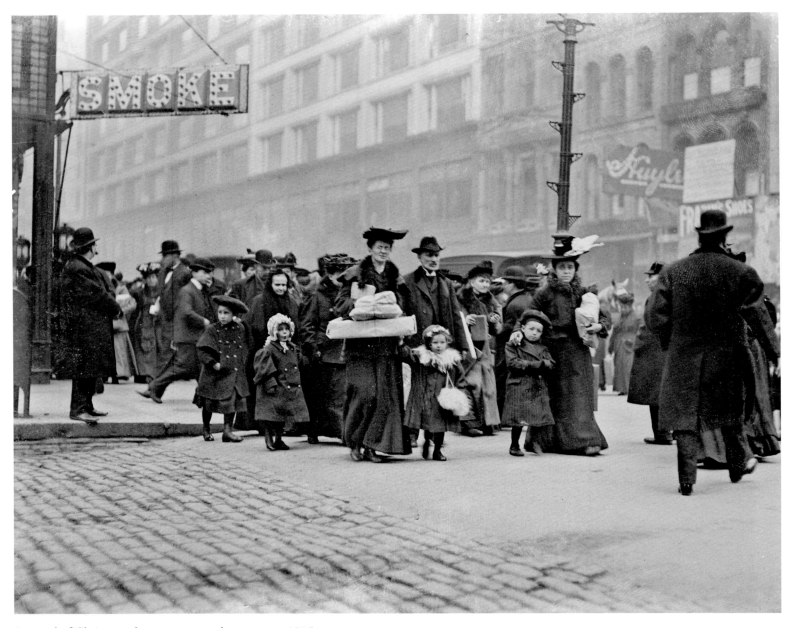

A crowd of Christmas shoppers crosses the street, ca. 1915.

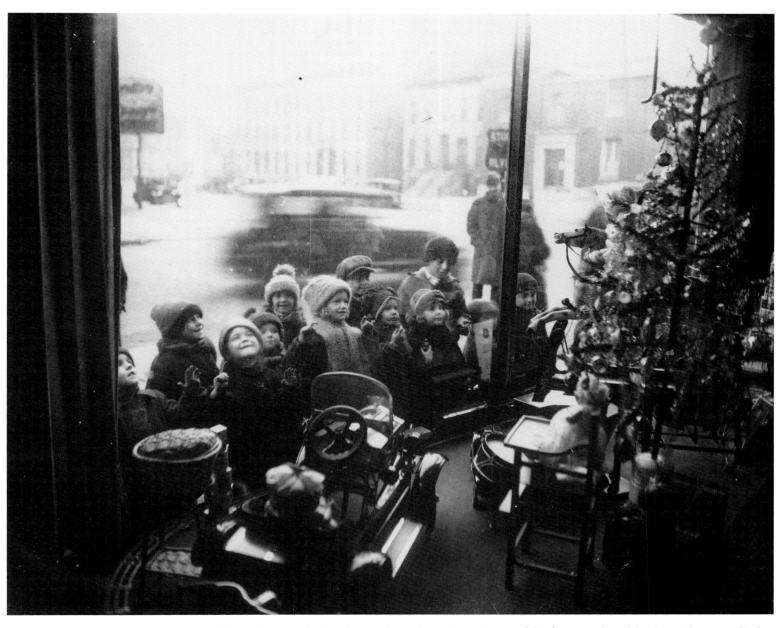

For children, the best window displays have always been the ones full of toys, such as this 1920s Christmas display.

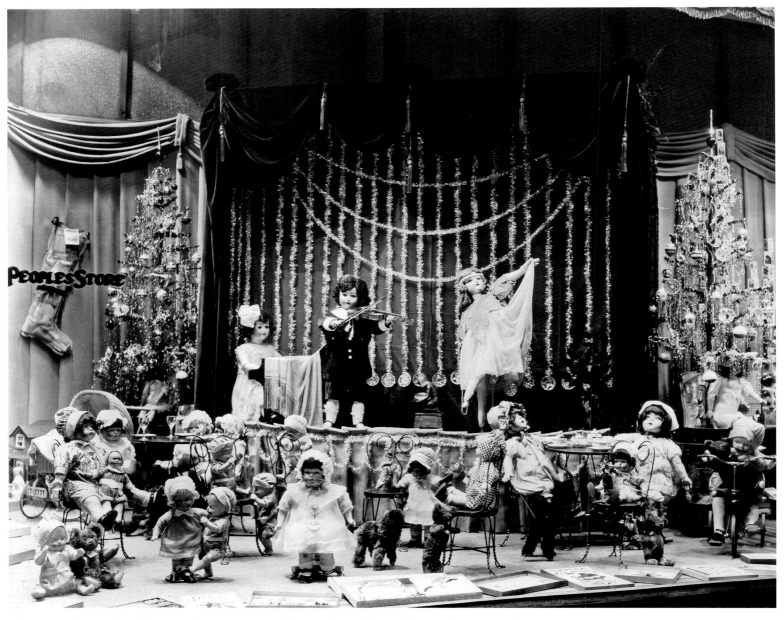

The "Doll Cabaret," a window display at the People's Store at 11201 South Michigan Avenue, ca. 1925.

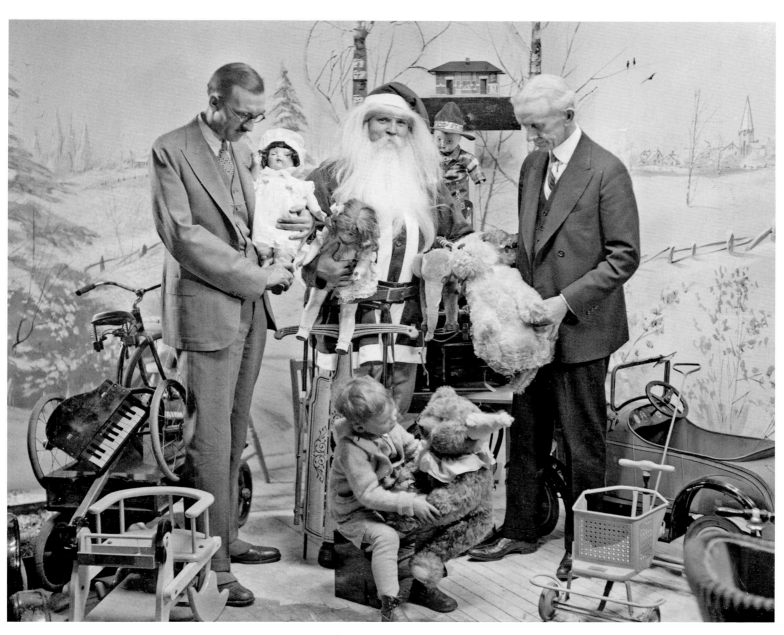

WMAQ radio personality Russell Pratt, at left, appears in a Christmas scene with Santa and surrounded by favorite toys, ca. 1927.

Not even Santa Claus could resist the excitement over "Lucky Lindy" and air travel. Here Santa tries out a substitute for his sleigh just months after Charles Lindbergh's famous 1927 transatlantic flight.

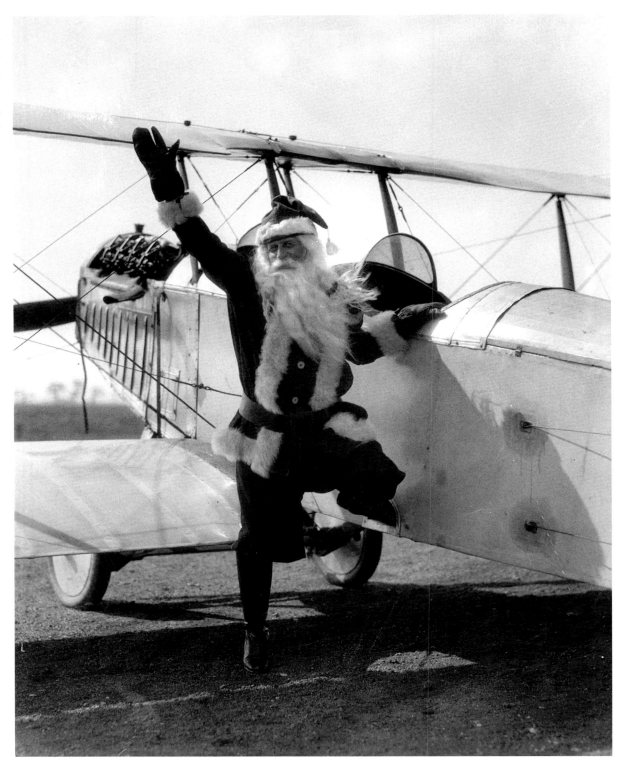

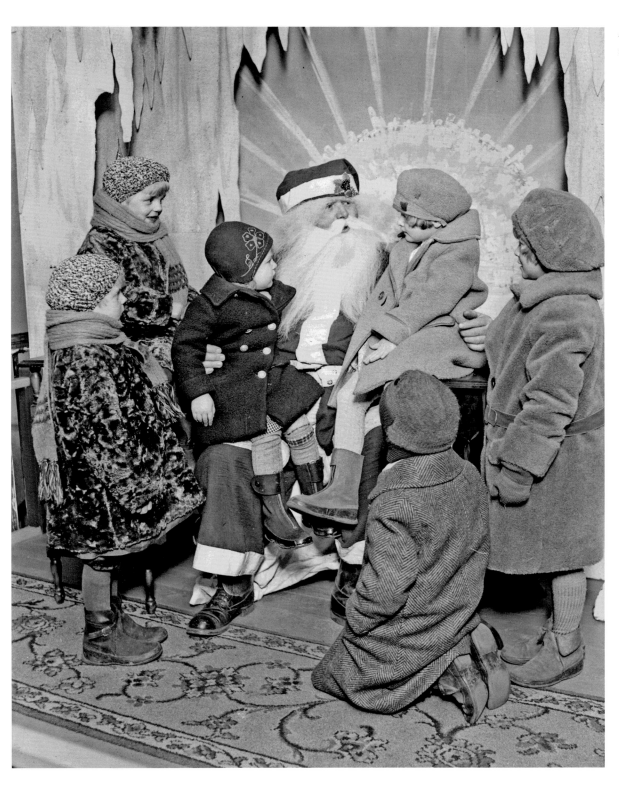

A group of children gather around Santa, ca. 1929.

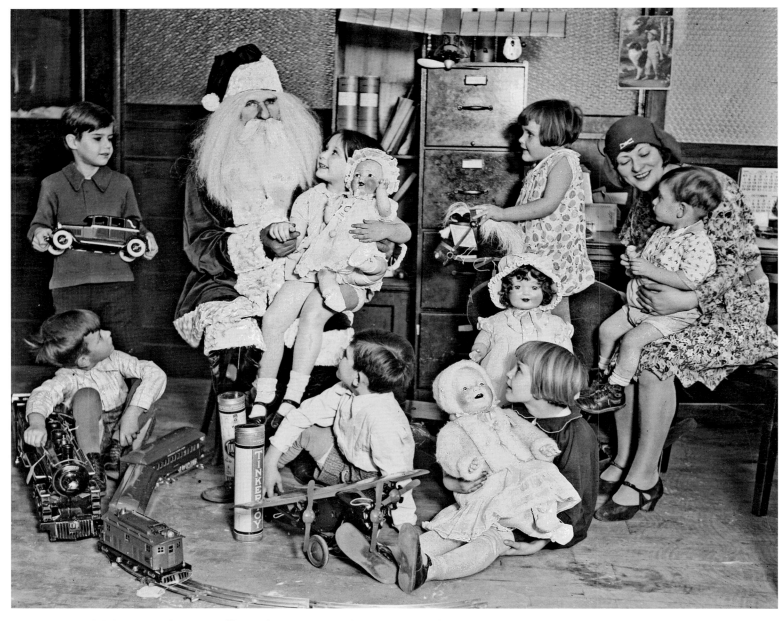

Santa Claus and children together in an office at the Fair Store, a department store located at State and Adams streets, 1929.

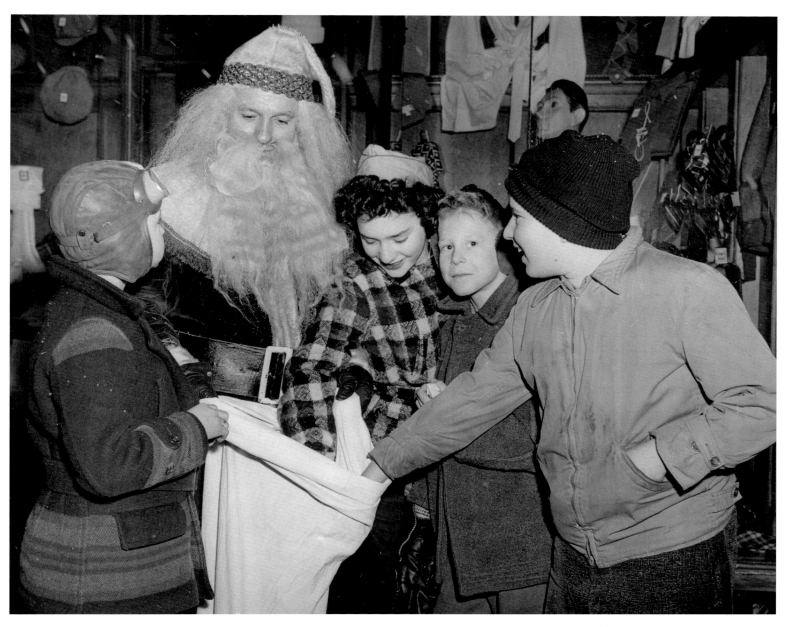

Santa offers gifts to a group of youngsters.

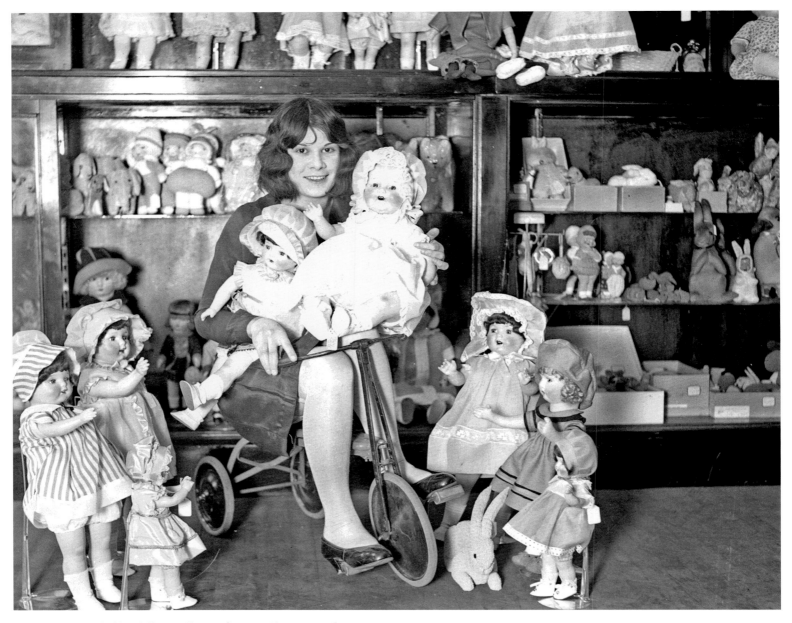

A girl is surrounded by dolls, an all-time favorite Christmas gift, ca. 1928.

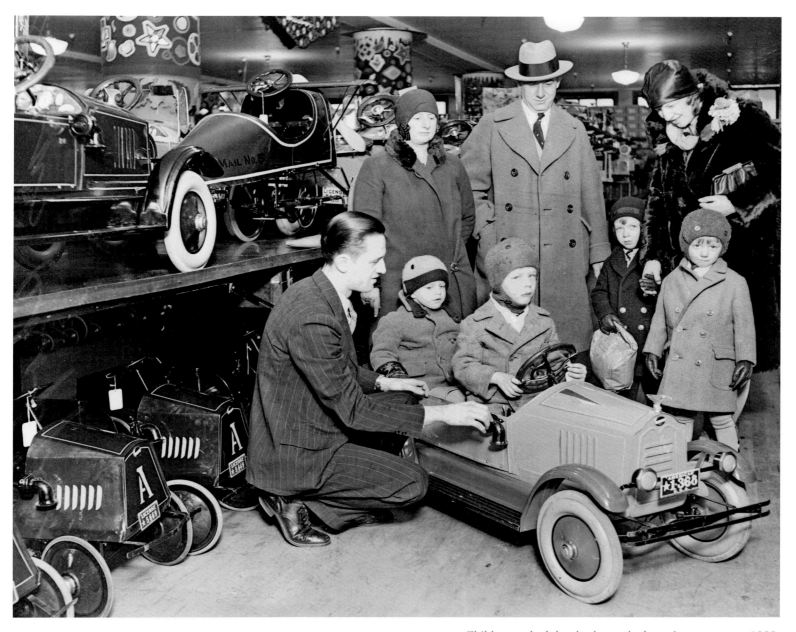

Children and adults check out the latest in toy cars, ca. 1929.

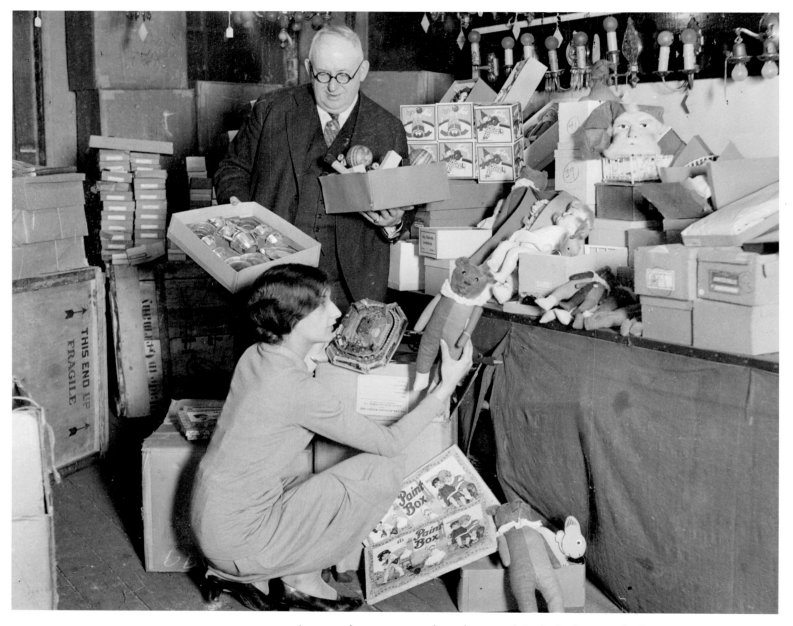

A man and a woman sort through toy stock in the back room of a department store, ca. 1929.

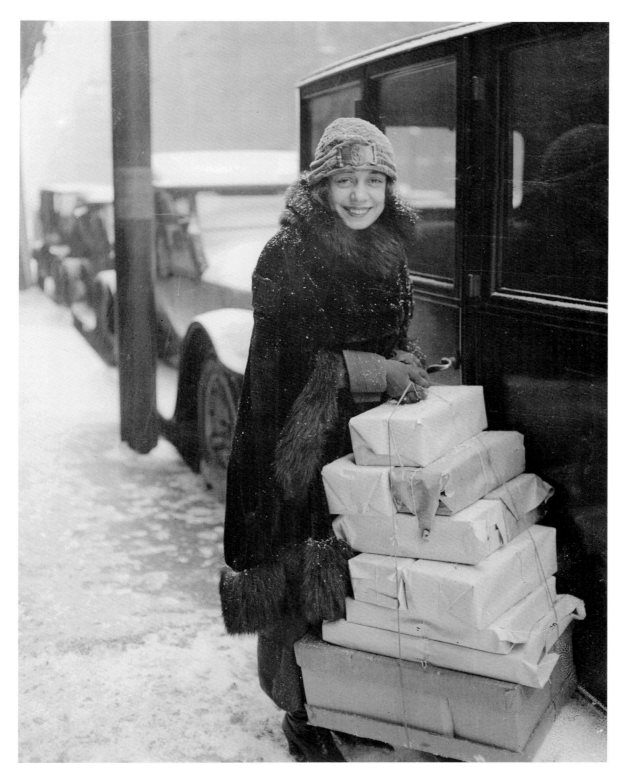

A woman prepares to enter a car with all of her packages in tow after a busy shopping trip, ca. 1929.

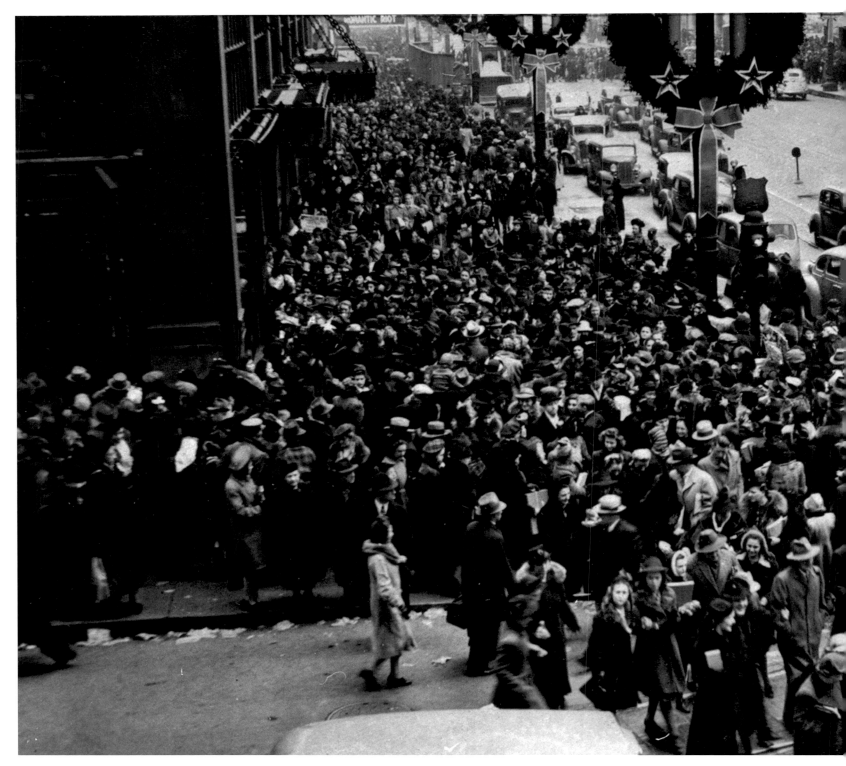

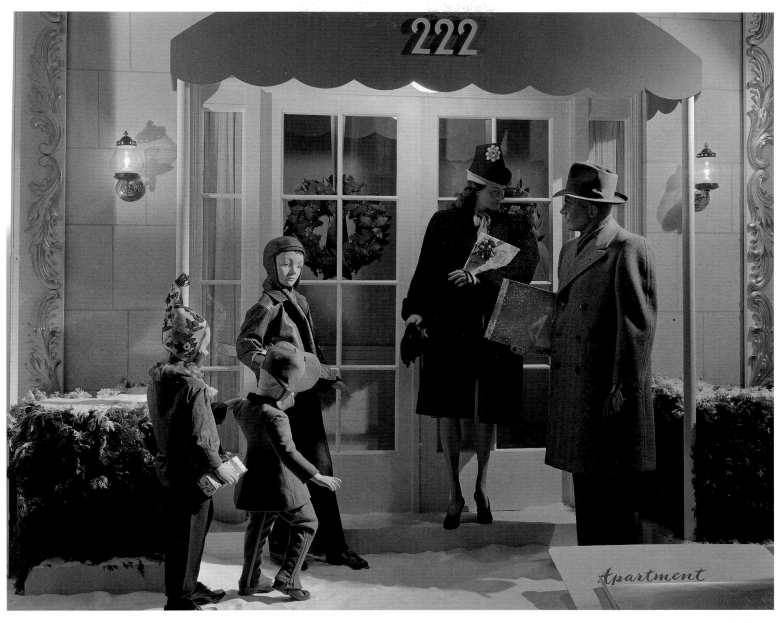

In this window display, a family preparing to celebrate the holiday gathers outside their apartment building.

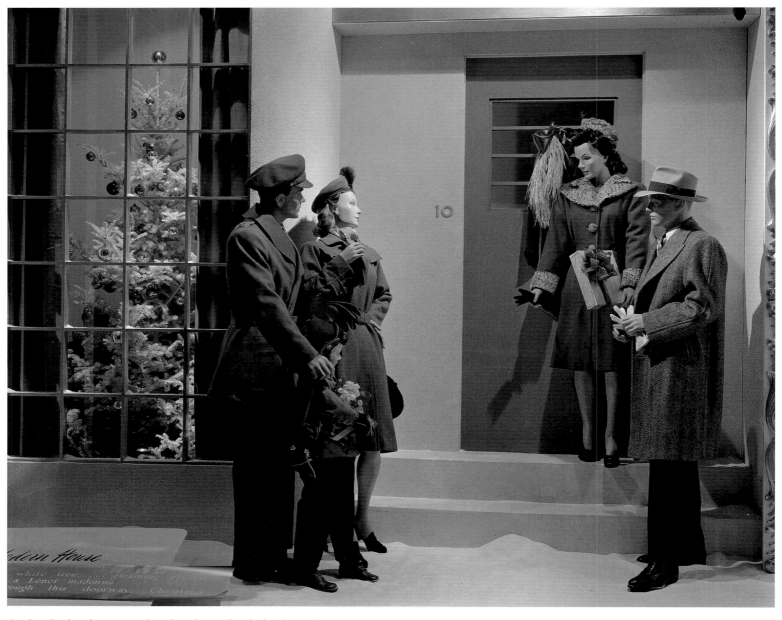

In this display depicting a "modern house," a sleek white Christmas tree appears in the window as another soldier prepares to enjoy Christmas on the home front.

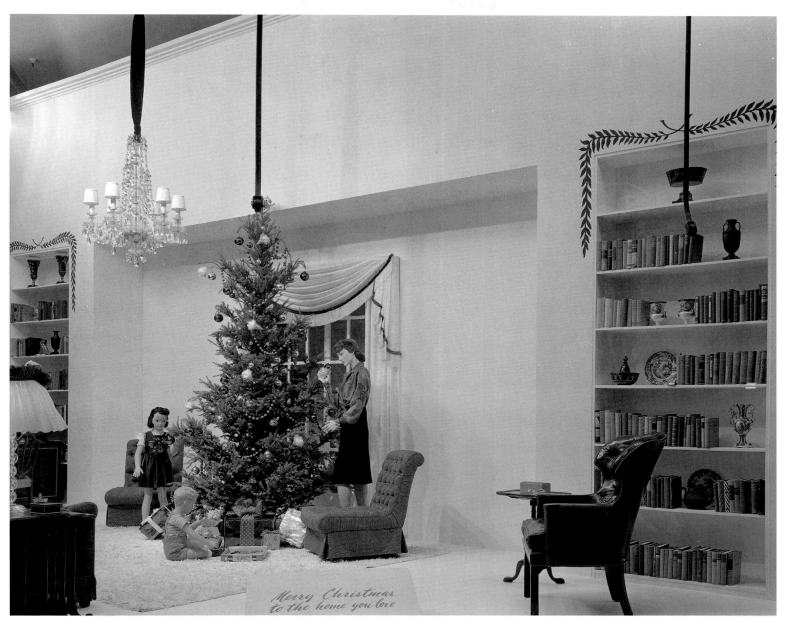

Continuing Marshall Field's window theme, a mother and daughter trim the tree in their bright, modern room.

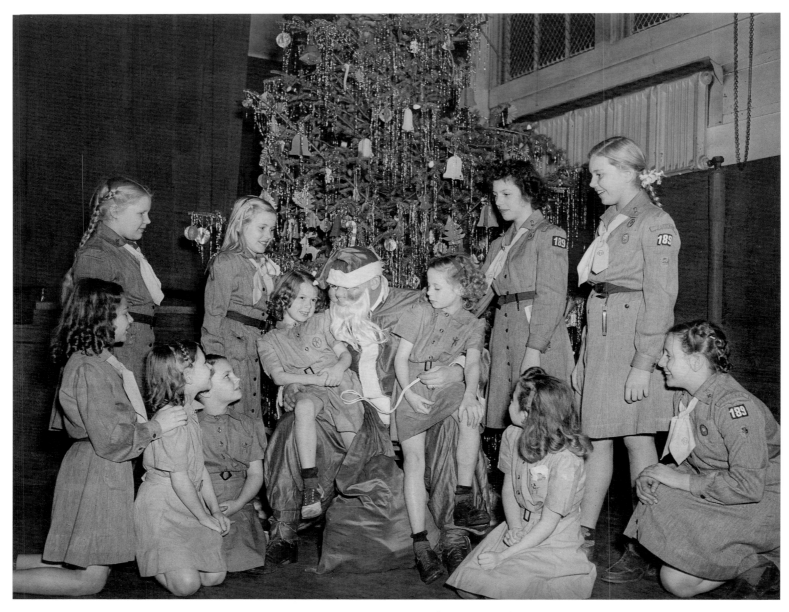

A group of Brownies and Girl Scouts visit with Santa Claus, Christmas 1945.

Even Santa has to clock in and change into work clothes. At Carson Pirie Scott, Pat Moran prepares to greet his public, ca. 1950.

151

Santa checks his
whiskers twice.

152

Now fully into character, Santa listens to the Christmas wishes of a young visitor.

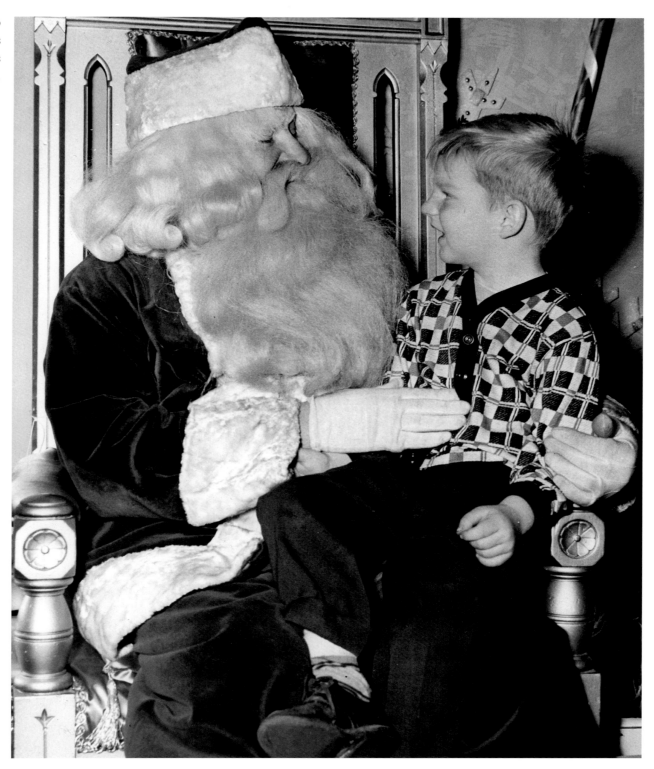

Wieboldt's had several
locations throughout
the Chicago area. Here,
shoppers search for the
perfect presents, ca. 1945.

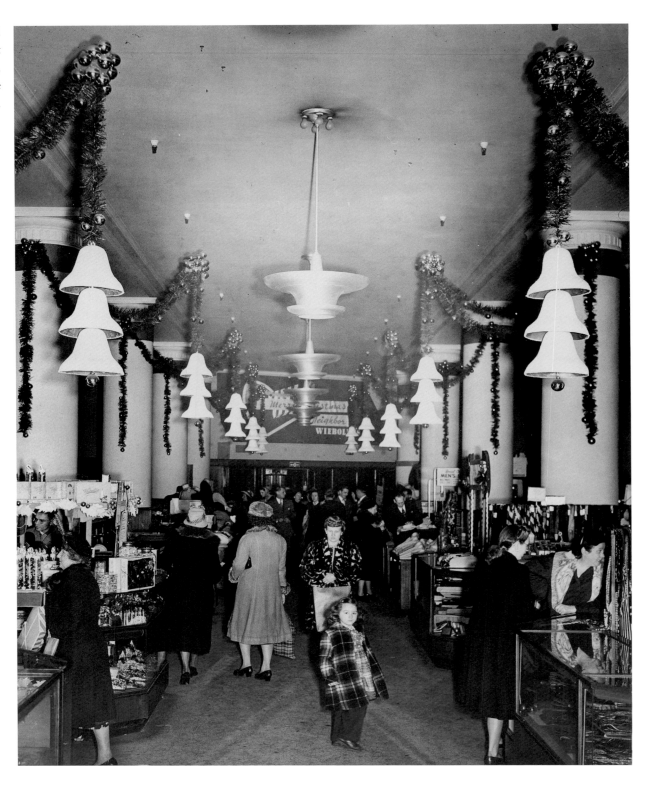

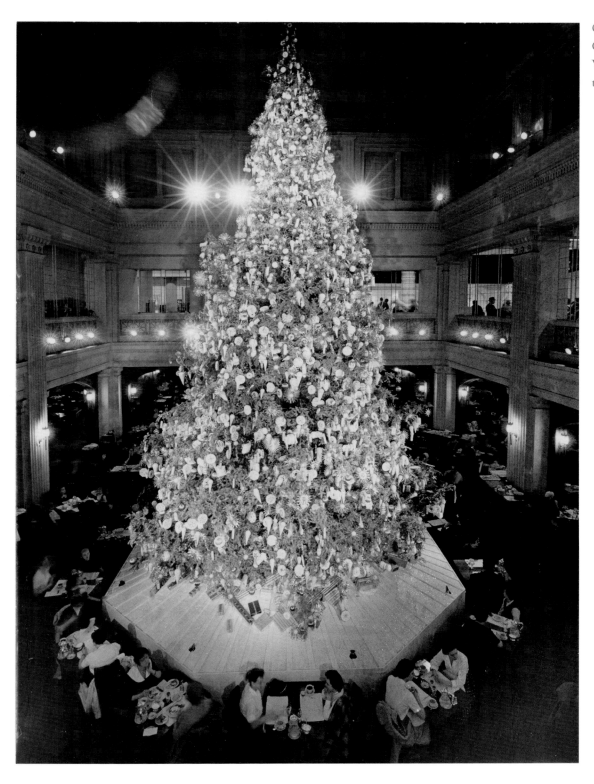

One of Chicago's most treasured
Christmas traditions: lunch at the
Walnut Room next to its immense
tree, seen here Christmas Eve, 1954.

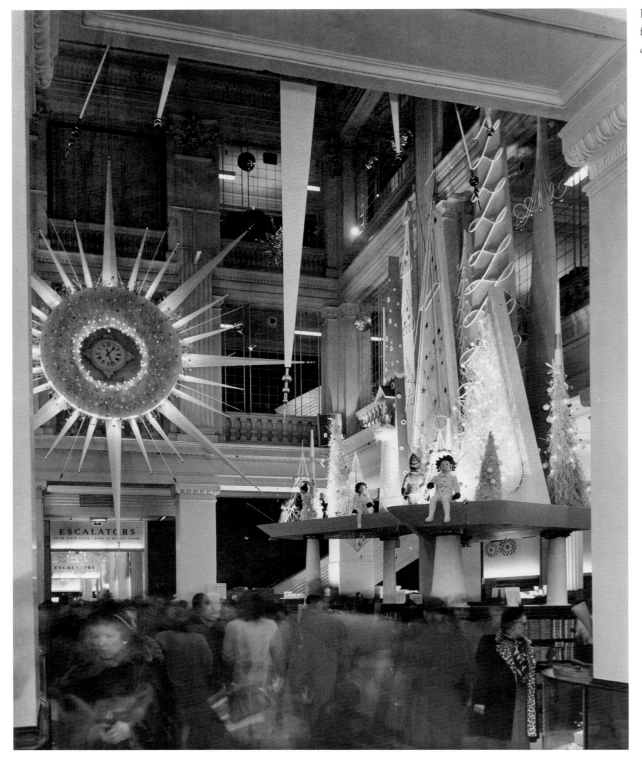

Decorations on the first
floor of Marshall Field's,
ca. 1955.

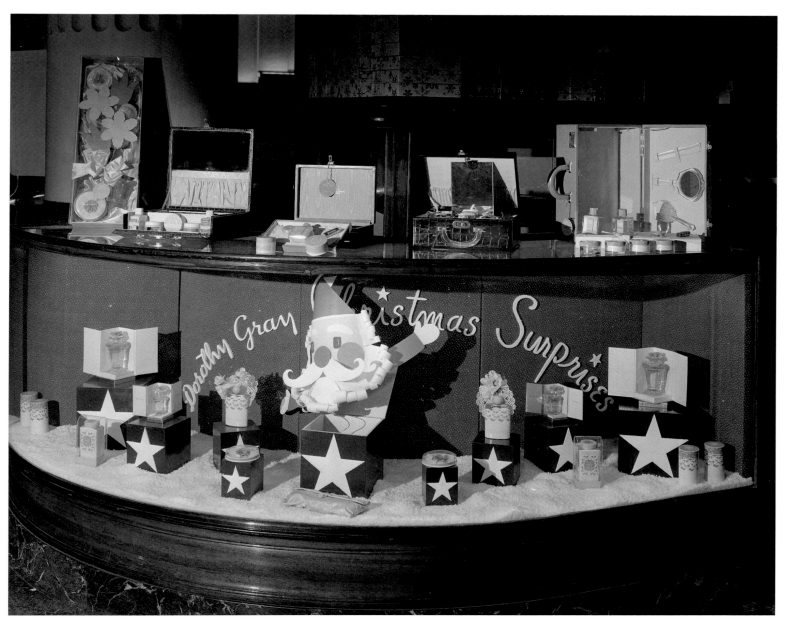

The cosmetics company Dorothy Gray created a display with a variety of suggestions for presents. The company began in the 1910s and was popular for many decades.

This window display features a well-dressed mannequin surrounded by a variety of accessories.

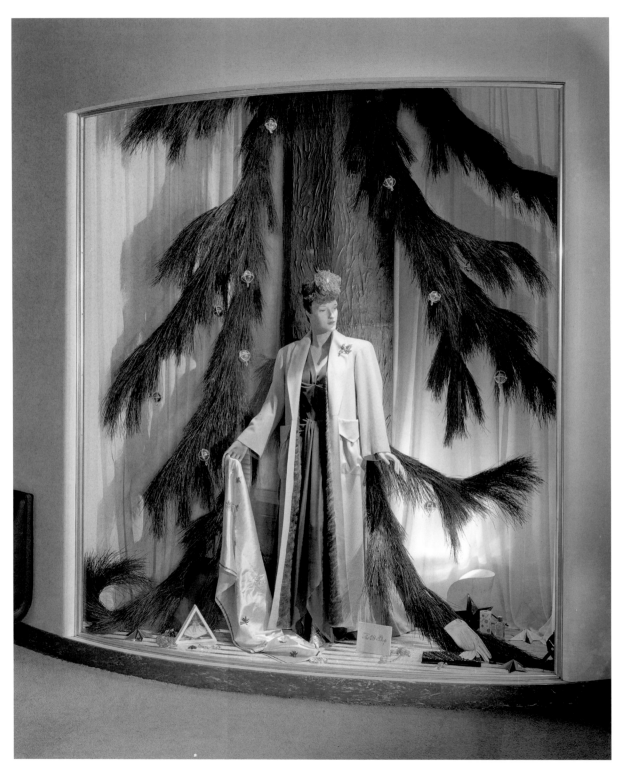

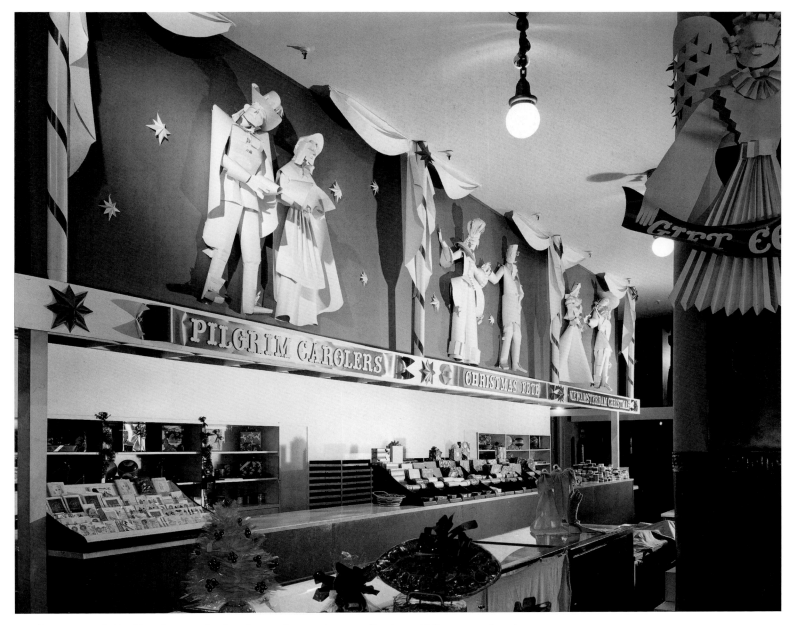

A gift-wrapping desk offers shoppers both a time-saving service as well as beautifully wrapped packages.

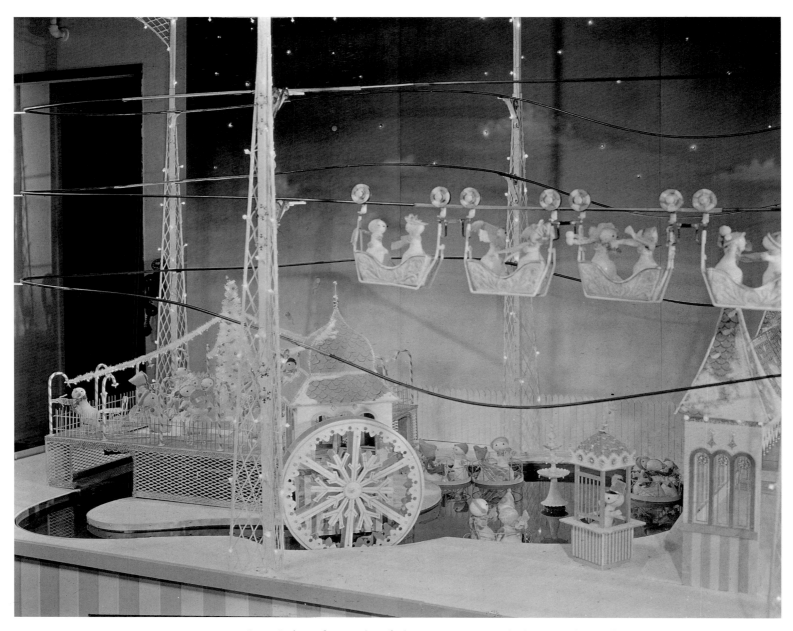

In a window of an unidentified store, an automated Christmas display features a miniature winter scene.

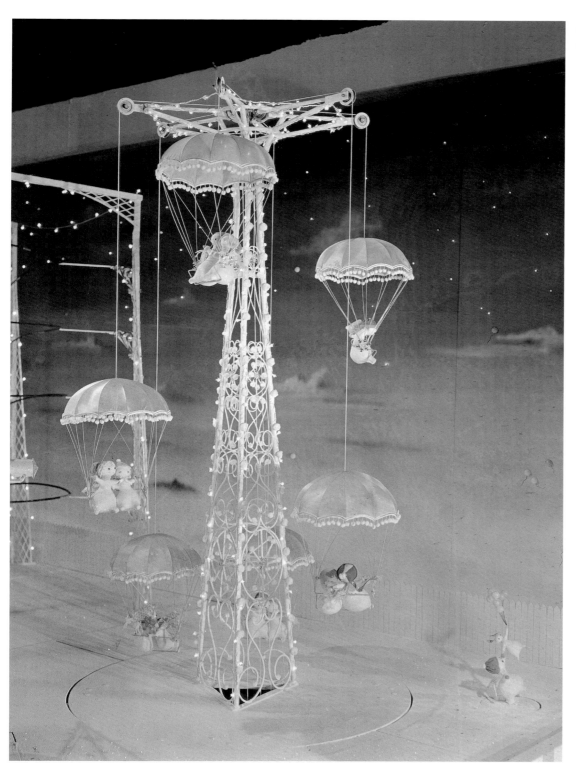

A companion window of the same store.

A cozy, nostalgic Christmas scene. The sheet music for "Silent Night" rests on the organ. The popular carol was first performed in Austria on Christmas Eve, 1818.

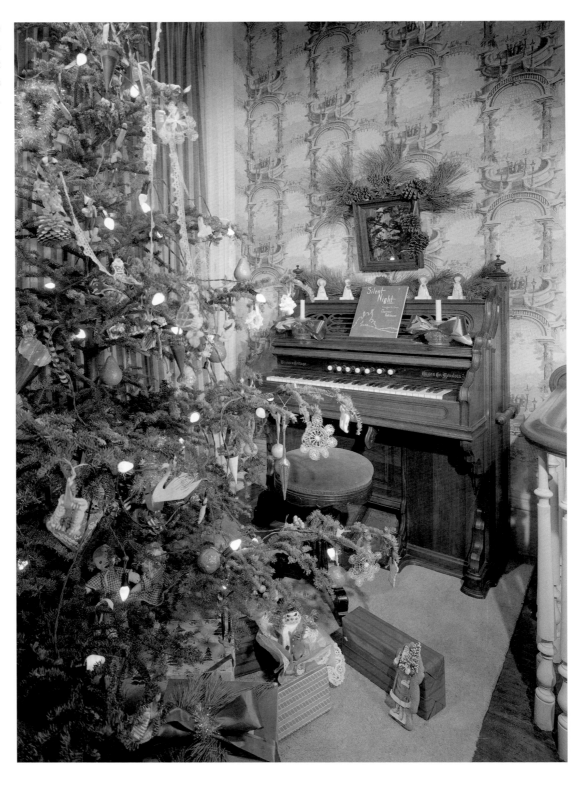

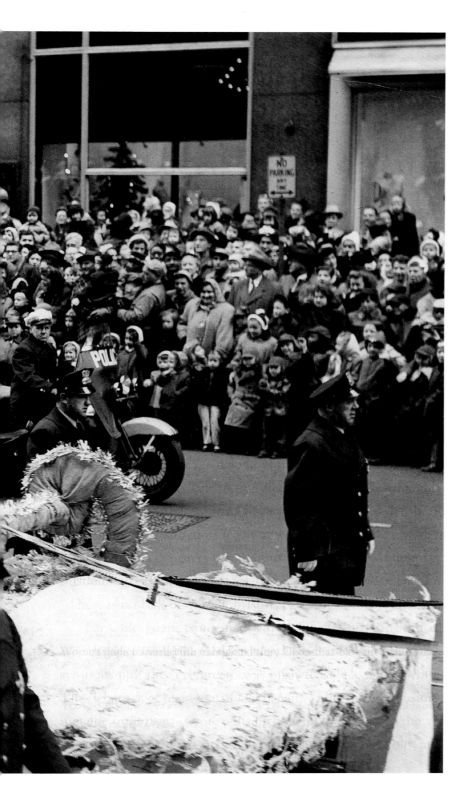

Santa addresses the crowd at the State Street Parade, November 22, 1954.

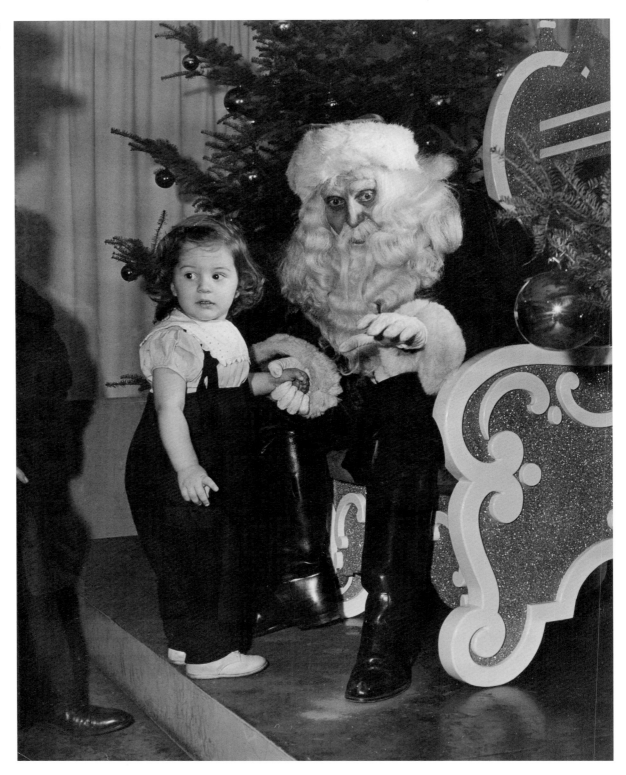

Santa with a young visitor at
Marshall Field's.

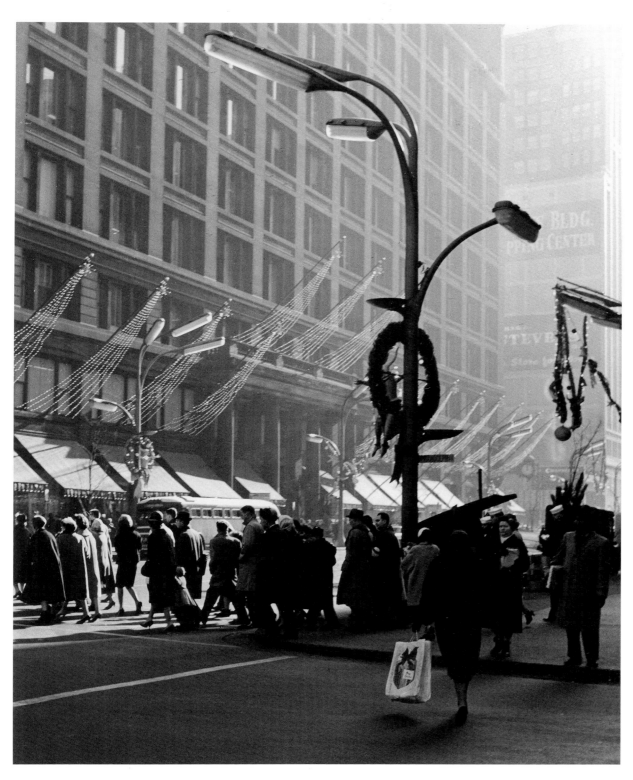

Christmas on State Street
as viewed looking southeast
from Randolph toward
Marshall Field's grand
facade, Christmas Eve,
1960.

A Nativity scene overlooks an entrance to Marshall Field's, December 1961.

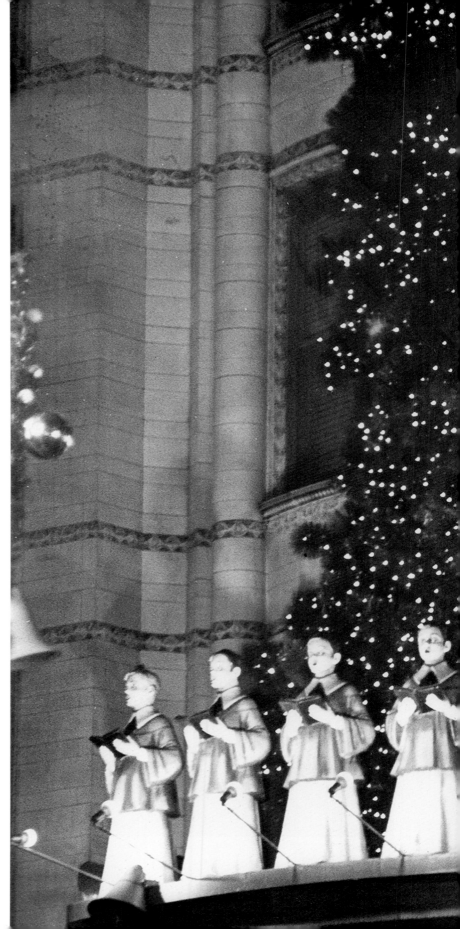

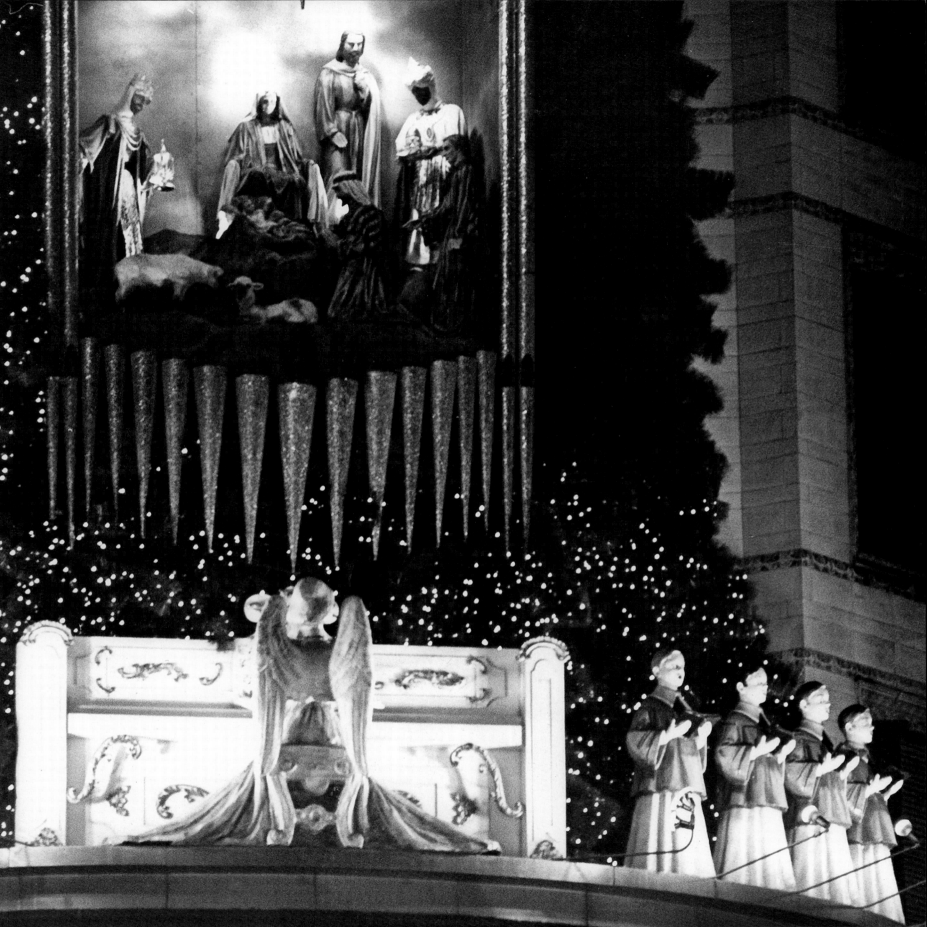

Santa visits with a boy and
girl, December 1964.

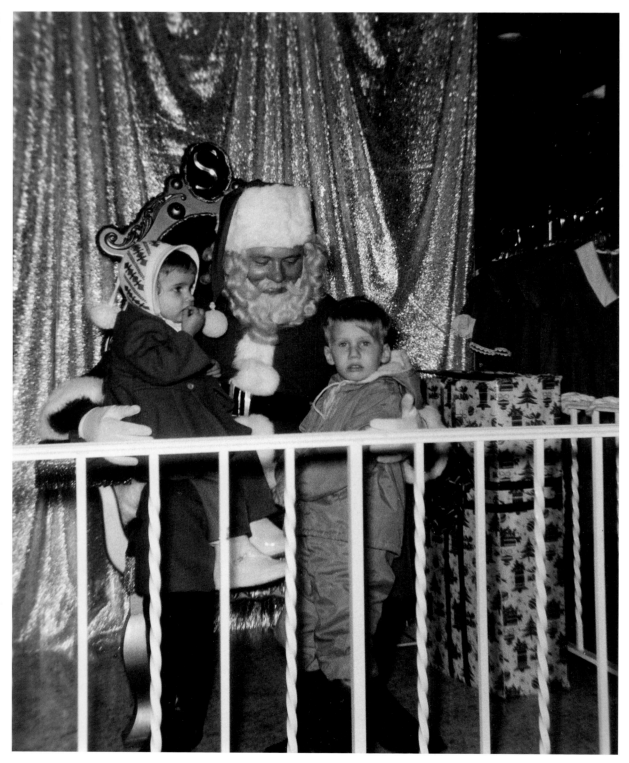

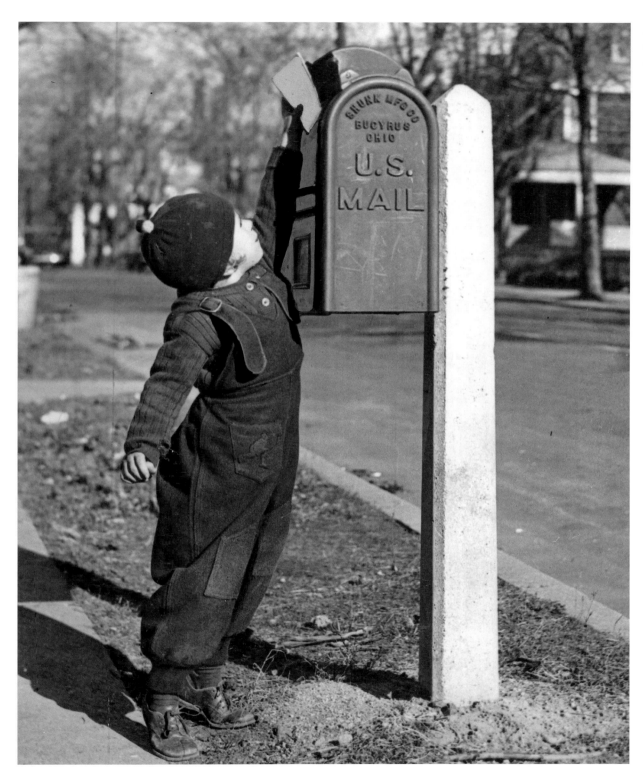

A little girl stretches to drop a letter to Santa in the mailbox.

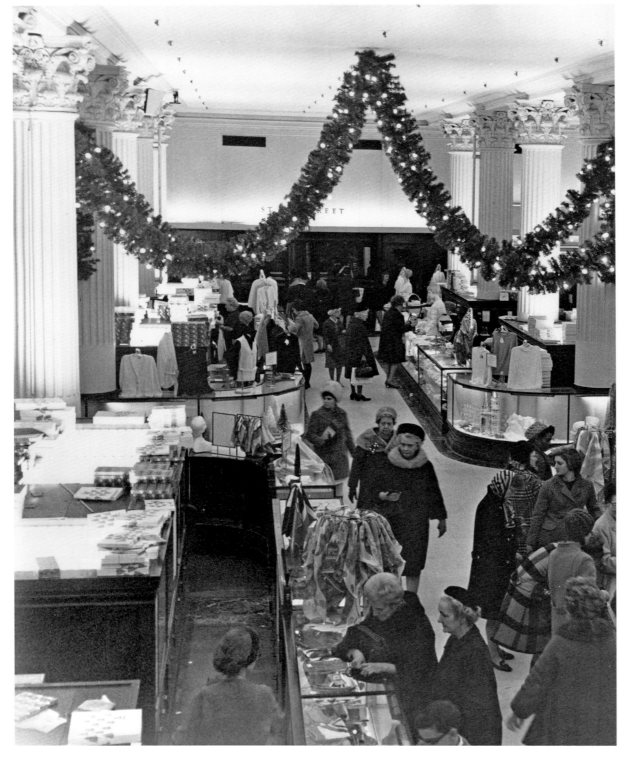

Shopping at Marshall Field's,
Christmastime 1968.

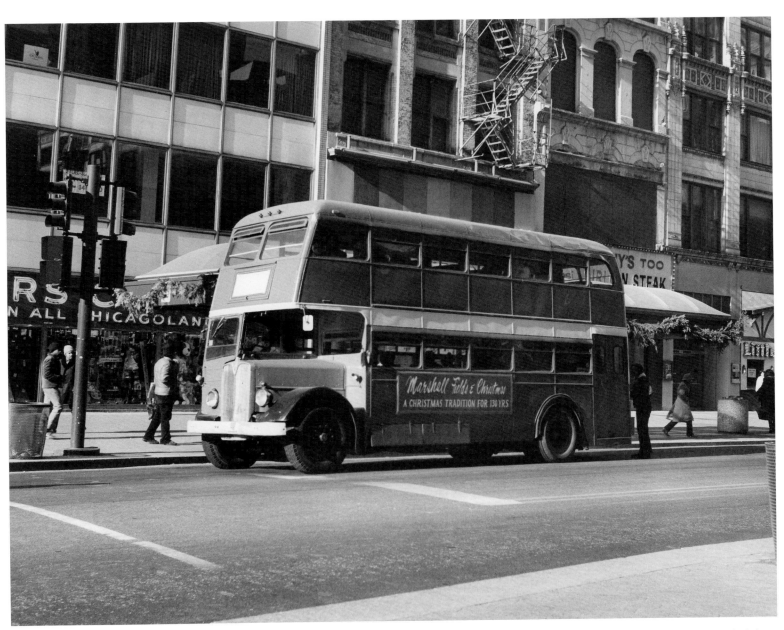

As this double-decker bus proclaims, for over a century Marshall Field's has been a central part of many Chicagoans' holidays.

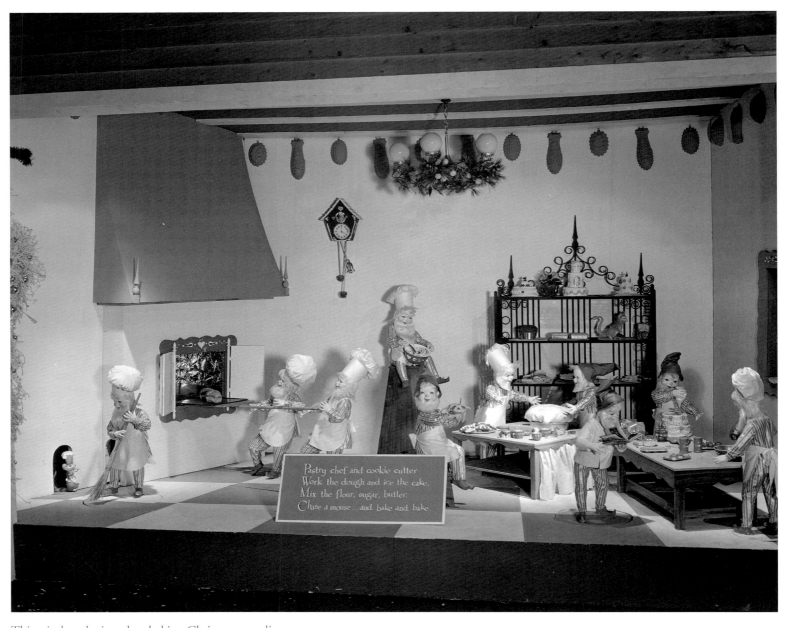

This window depicts elves baking Christmas goodies.

'TIS BETTER TO GIVE

CHARITY AT CHRISTMAS

Donating to the needy during the holiday season is traditional. Cities are shared by the rich and the poor, and Chicagoans have been reaching out to others for as long as the city has existed. Churches have long been the traditional outlet for such assistance, but in the mid–nineteenth to early twentieth centuries, new social service organizations also stepped in to help organize such efforts. Orphanages, hospitals, homes for poor women, and others have focused on Christmas as a special time to encourage private citizens to help others. Newspapers played a key role in publicizing these efforts; many administered their own charities as well. The *Chicago Daily News,* the *Chicago Tribune,* and the *Chicago Defender* all sponsored fundraising activities that became more visible at the holidays.

Charitable assistance, however, sometimes inspired controversy. In 1864, the *Chicago Tribune* reported that "The Directoresses of the Orphan Asylum beg to leave to tender their thanks to those persons who kindly assisted them in preparing a Christmas tree and dinner for the children. The organizers, however, plead for more help throughout the year rather than just at Christmas."

Still, Chicagoans were warned against what the superintendent of the Chicago Bureau of Charities called "indiscriminate giving." "The greatest danger to be apprehended from Christmas giving to the poor lies in the tendency of givers to feel that in providing Christmas dinner or toys they have performed their duty in a charitable way," he admonished. "The Christmas gift is the pledge of human sympathy and fellowship; the actual charity of the remainder of the year is the fulfillment of that pledge."

Other organizations gladly took to the streets to raise money: the Salvation Army began stationing people on busy shopping thoroughfares in the late nineteenth century, a successful strategy that continues today. Children, of course, were of special interest at the holidays, and gift-bearing Santas visited orphanages and hospitals to distribute gifts to the homeless and the infirm.

During both world wars, Chicagoans were encouraged to support the soldiers overseas as well as their families facing hardship at home. Although charities today have become bigger and more sophisticated in response to the multitude of urban problems that face major cities like Chicago, the tradition of charity remains one of the brightest stars of Christmas.

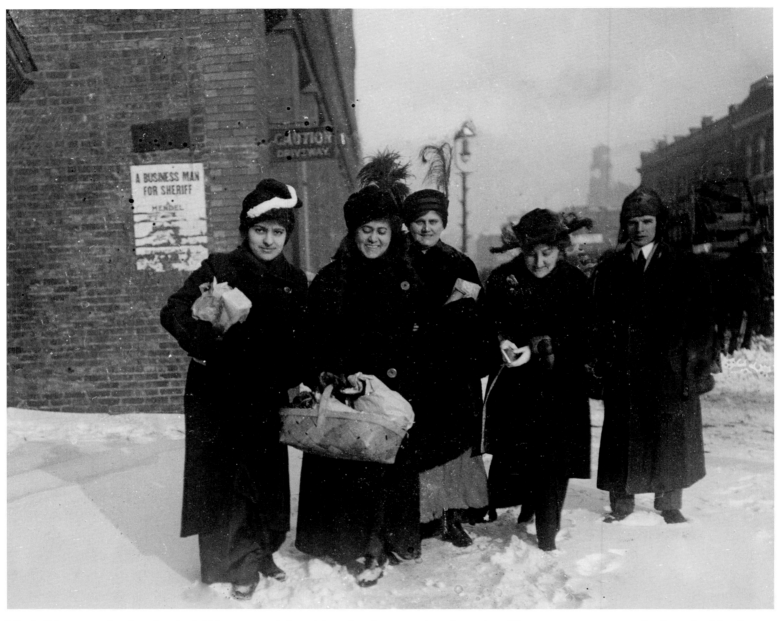

The holiday season has long inspired Chicagoans to help residents less fortunate than themselves. Here, women prepare to distribute food for the poor at Christmas.

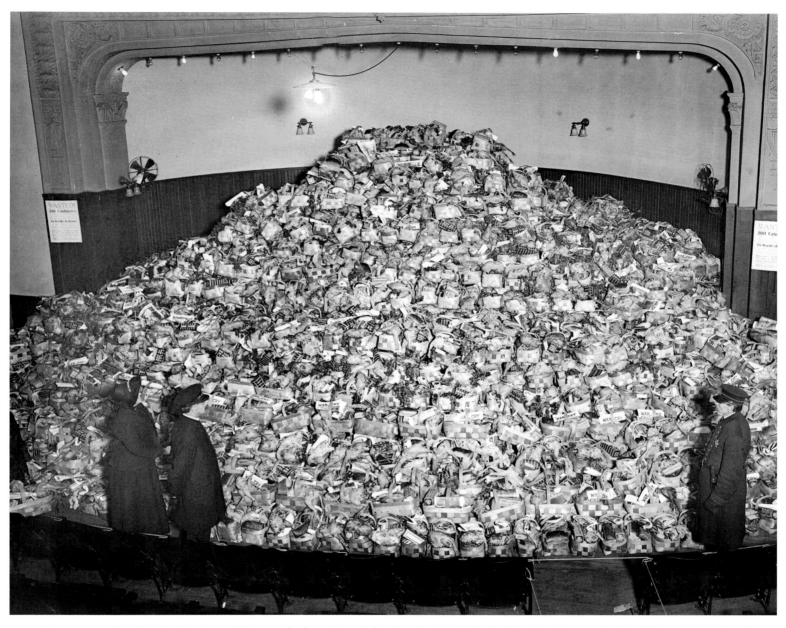

A stage covered with Salvation Army Christmas baskets. Founded in London in 1865, the Salvation Army arrived in Chicago in 1885 and soon became one of the most active social-service organizations in the city.

A view of Salvation Army food baskets piled on a stage on Christmas Eve, 1902.

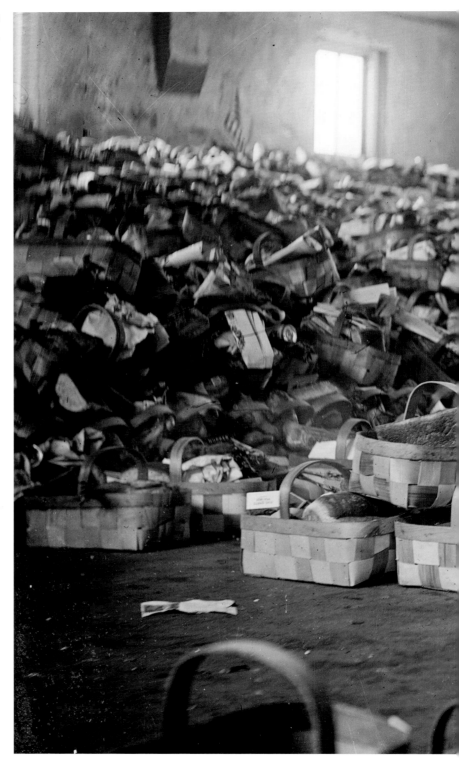

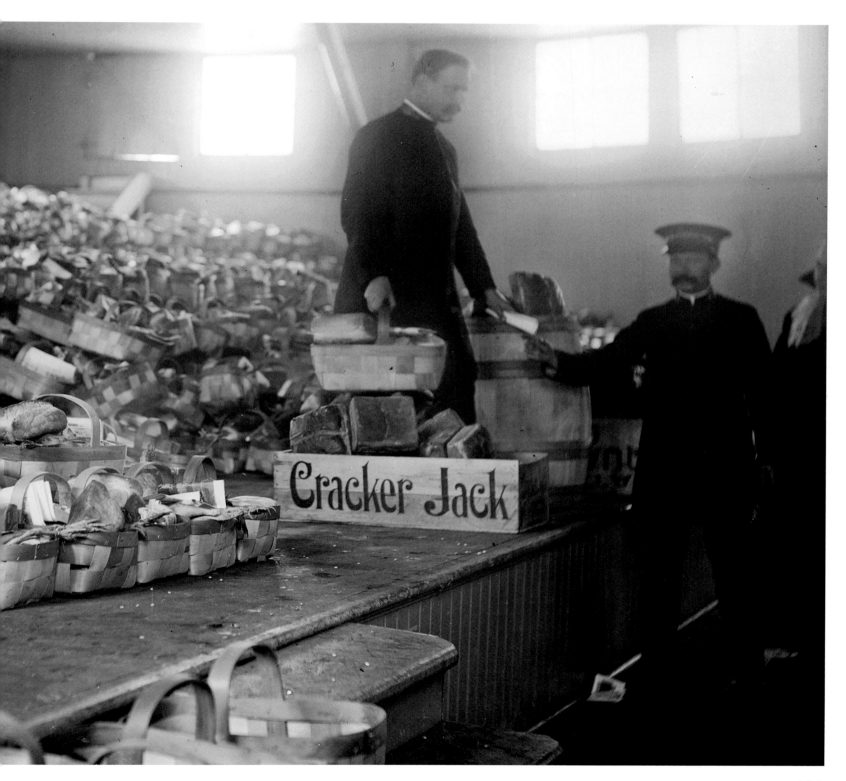

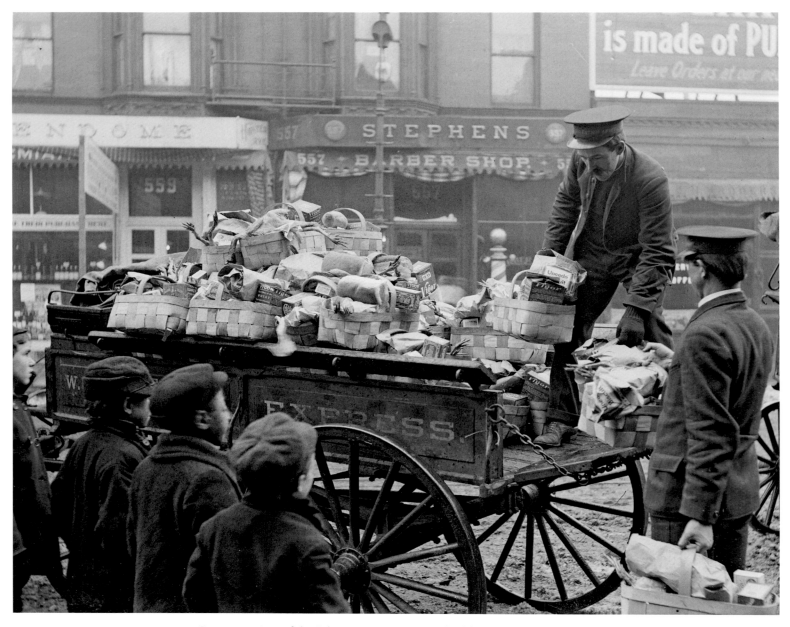

Representatives of the Salvation Army give out food baskets from a wagon on the street on Christmas Day, 1903.

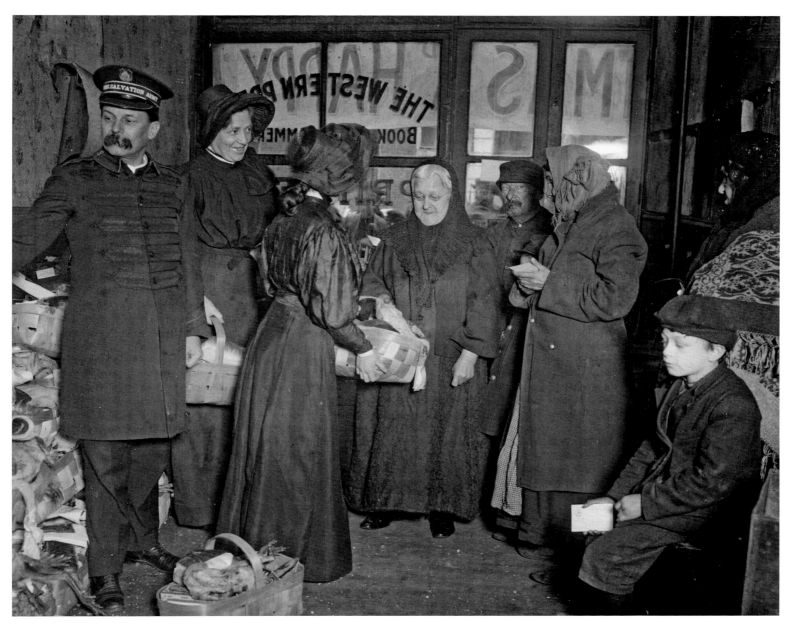

Chicagoans visit a storefront to collect baskets from the Salvation Army, 1907.

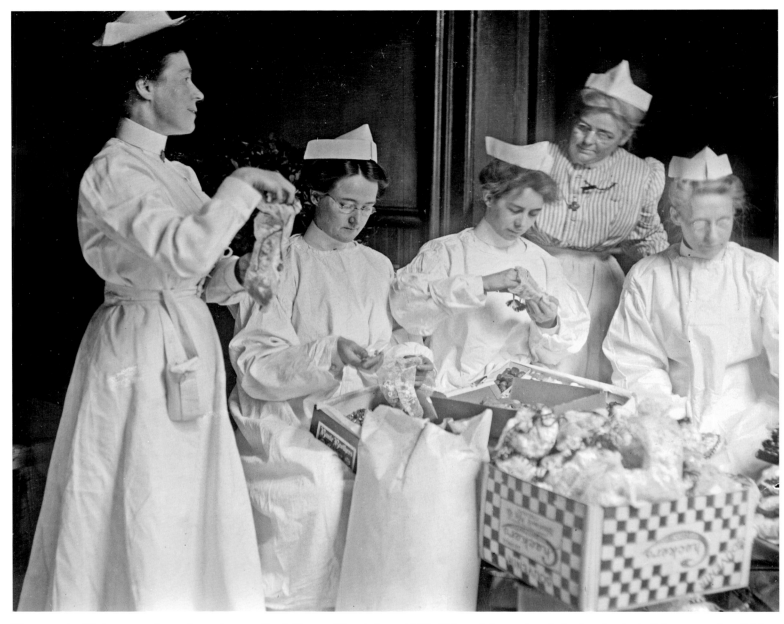

Nurses make Christmas packages for patients at Cook County Hospital, ca. 1909. Gifts and decorations helped make the holidays more cheerful for the ill and infirm.

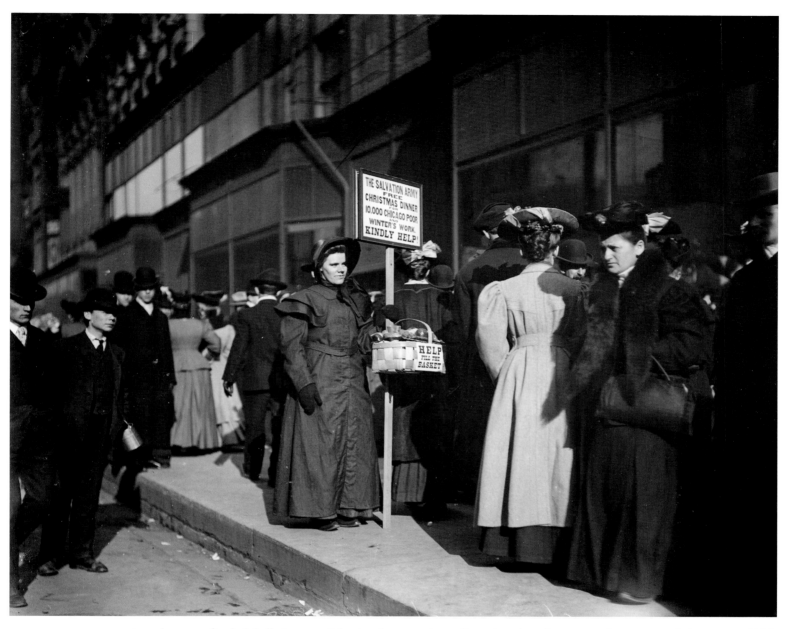

A predecessor of today's bell-ringers, a Salvation Army worker collects donations from passersby on a crowded street, ca. 1905.

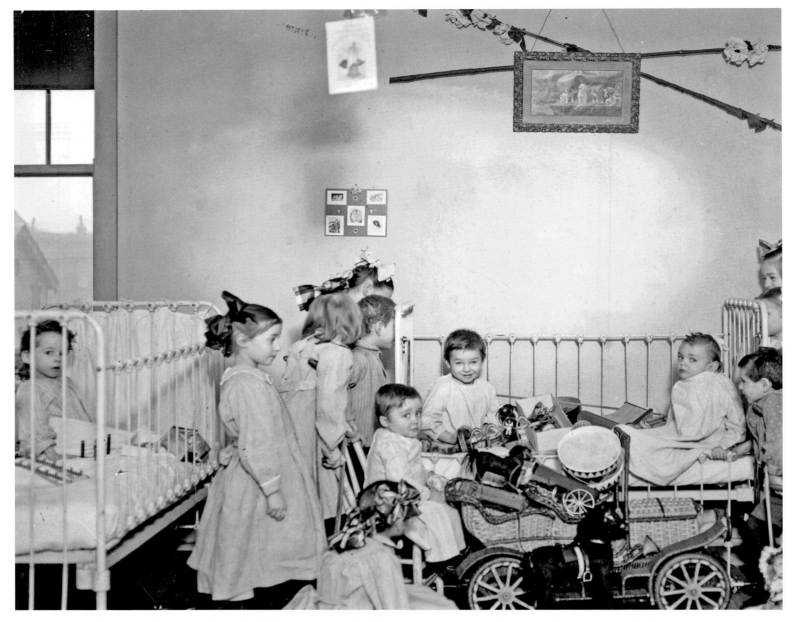

In 1906, at the Home for Destitute Crippled Children, a group of children sit around a cart full of toys during the home's Christmas party.

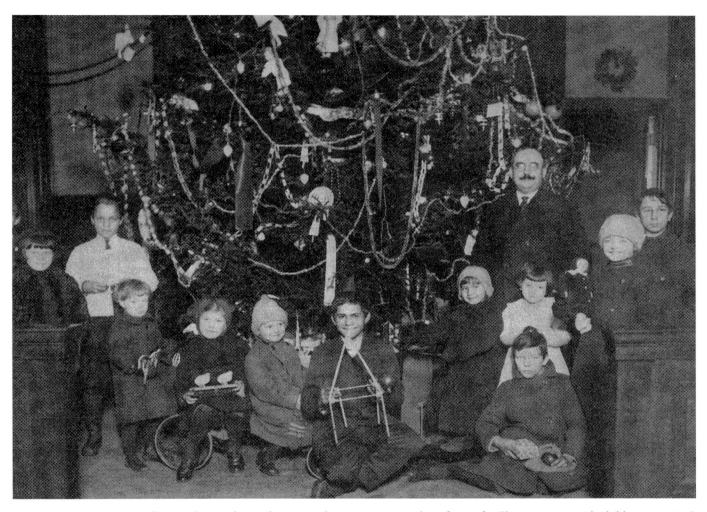

John Stelk, at right, a judge in domestic relations court, stands in front of a Christmas tree with children, ca. 1916.

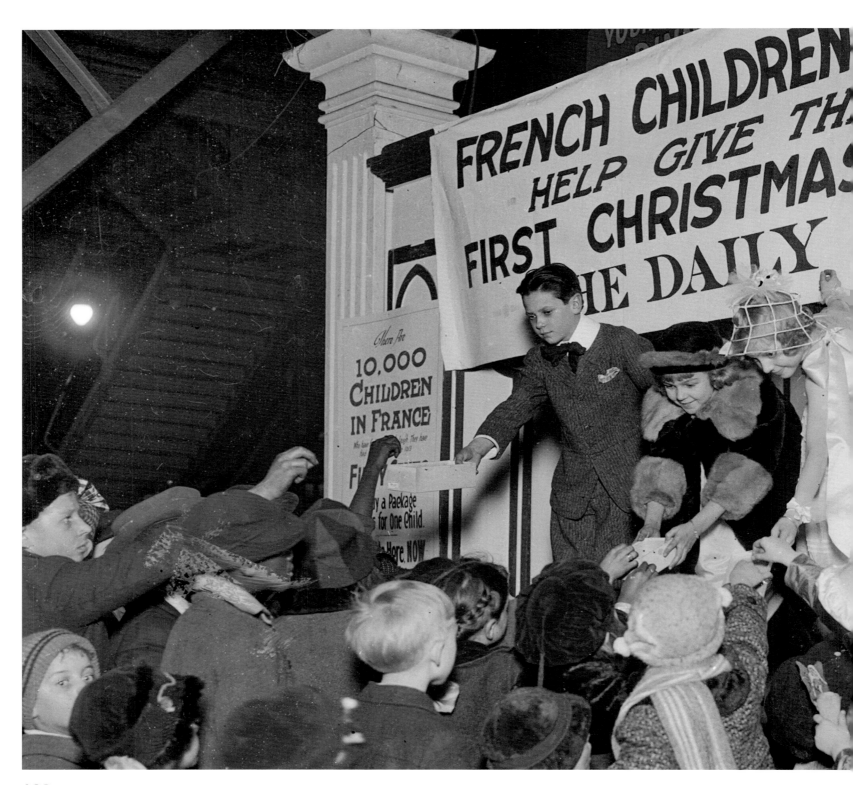

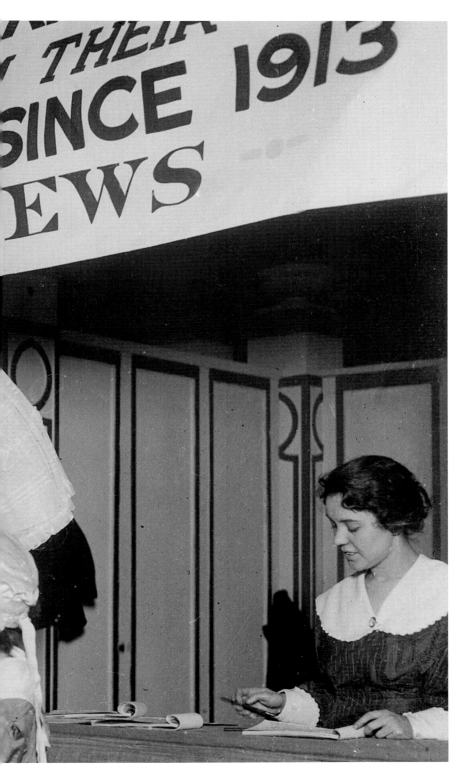

The *Chicago Daily News* administered several charitable funds. In 1917, the paper urged Chicagoans to help 10,000 French children celebrate their first Christmas since the beginning of World War I.

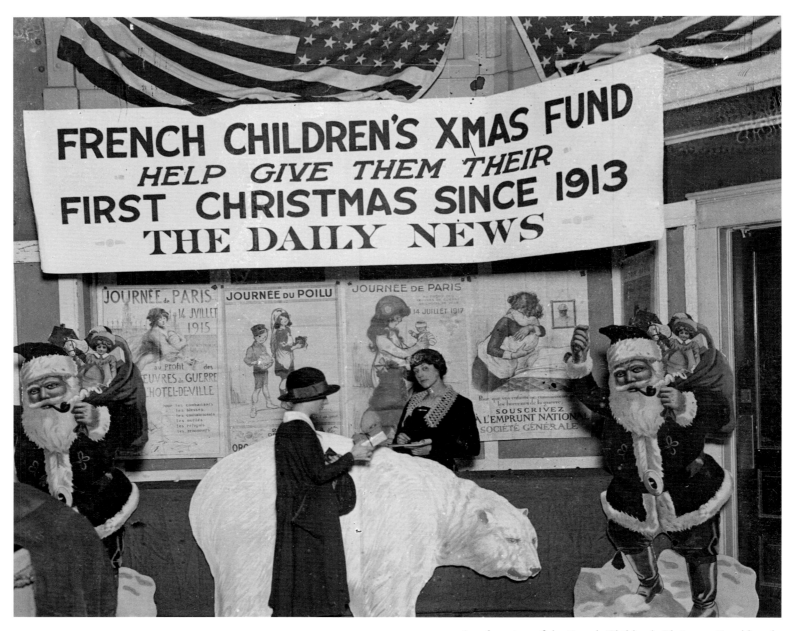

Another view of the French Children's Christmas Fund booth.

Nurses at Cook County Hospital prepare for Christmas by filling bags and baskets with toys and other presents, 1910.

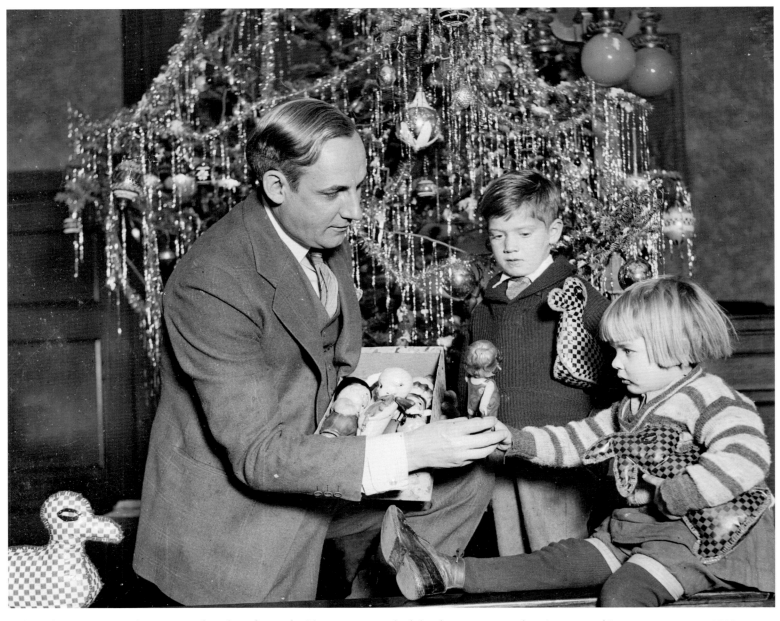

Judge Edgar A. Jonas and two young friends in front of a Christmas tree, which has been set up on the witness stand in a courtroom, ca. 1928.

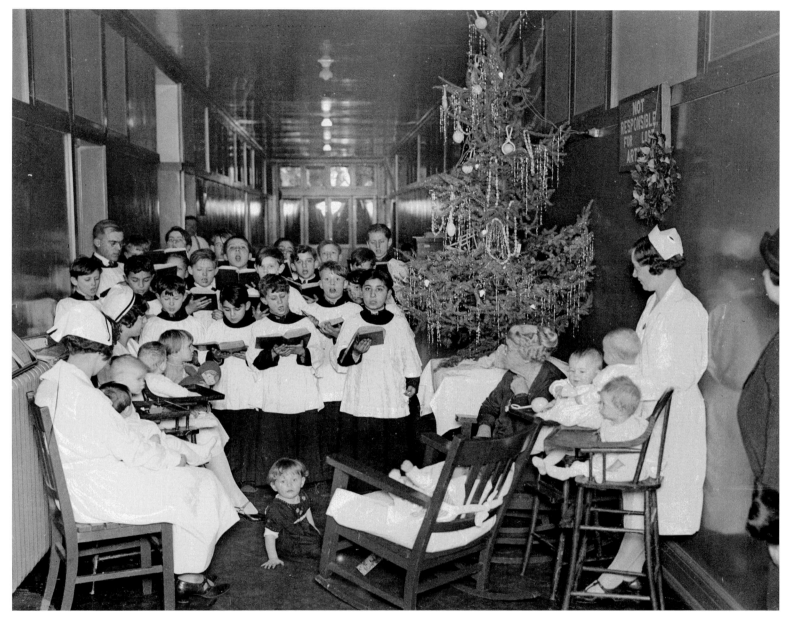

Choirboys sing Christmas carols for patients at the Chicago Daily News Sanitarium in 1926. Located at East Fullerton and North Stockton Drive in Lincoln Park, the sanitarium building still stands and is now a theater.

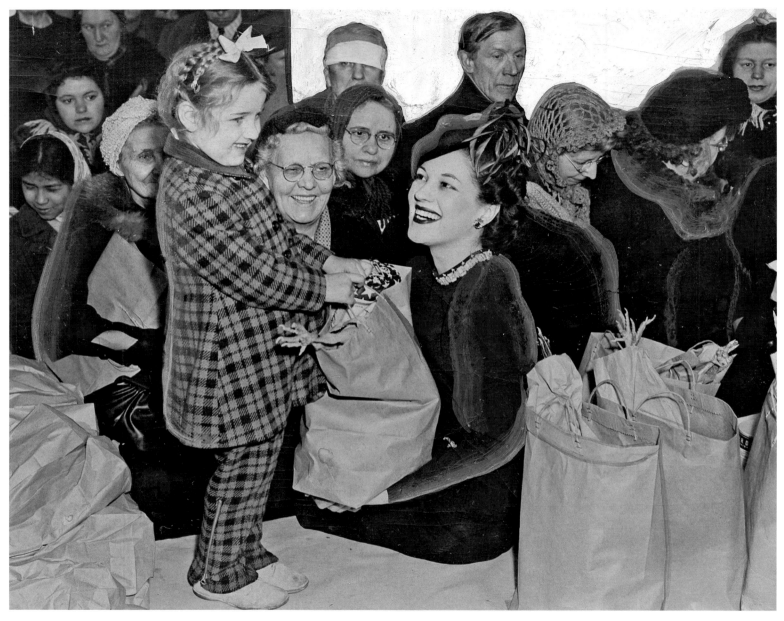

Actress Toni Gilman helps distribute bags of food for the needy at the local Christmas baskets headquarters of Volunteers of America, 1944. Celebrities often donated time and money to the war effort; many served in the armed forces.

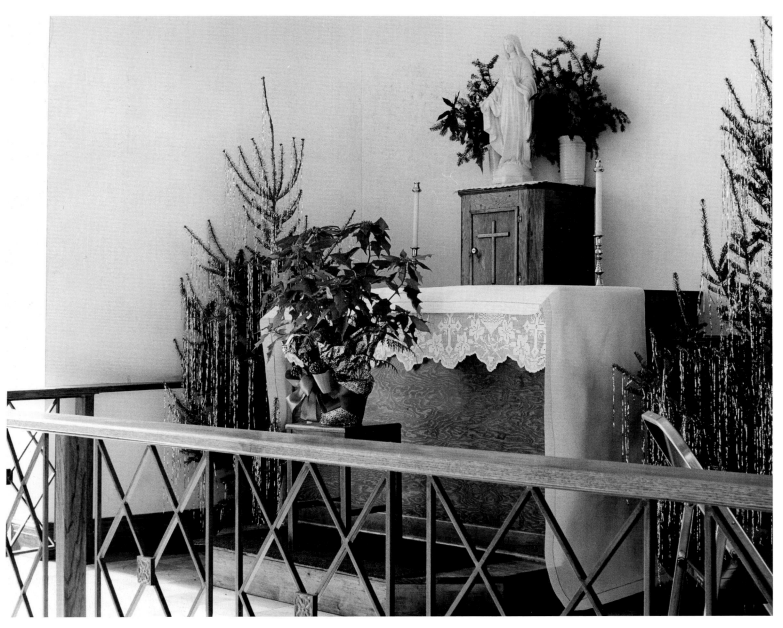

The altar at St. Helena of the Cross, December 1951. Churches have been traditional sources of help for people in need.

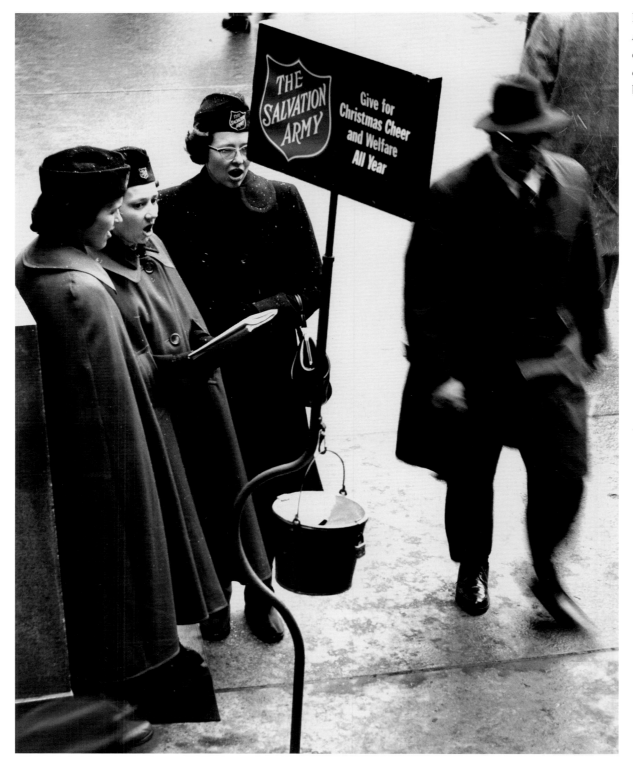

By the early 1960s, Salvation Army members collected donations in the more commonly recognized basket.

A Nativity program at the Chicago Commons, a settlement house founded in 1894.

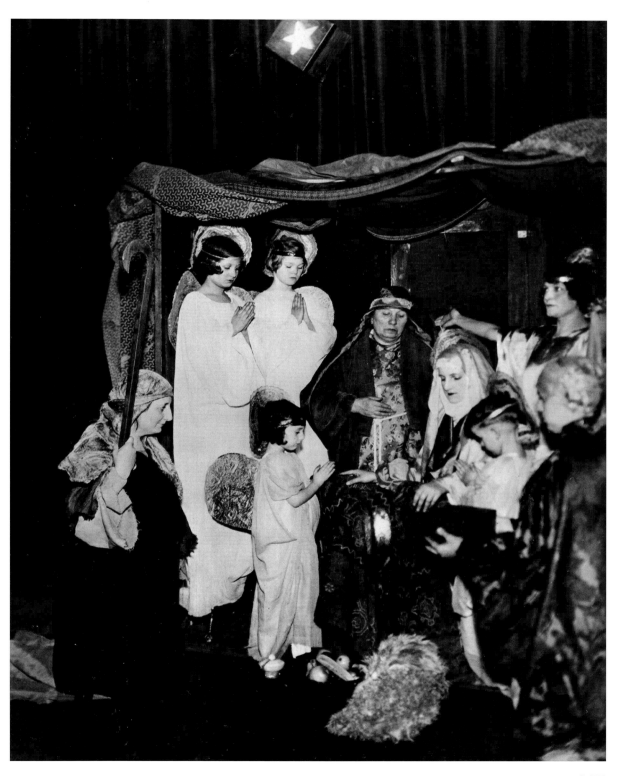

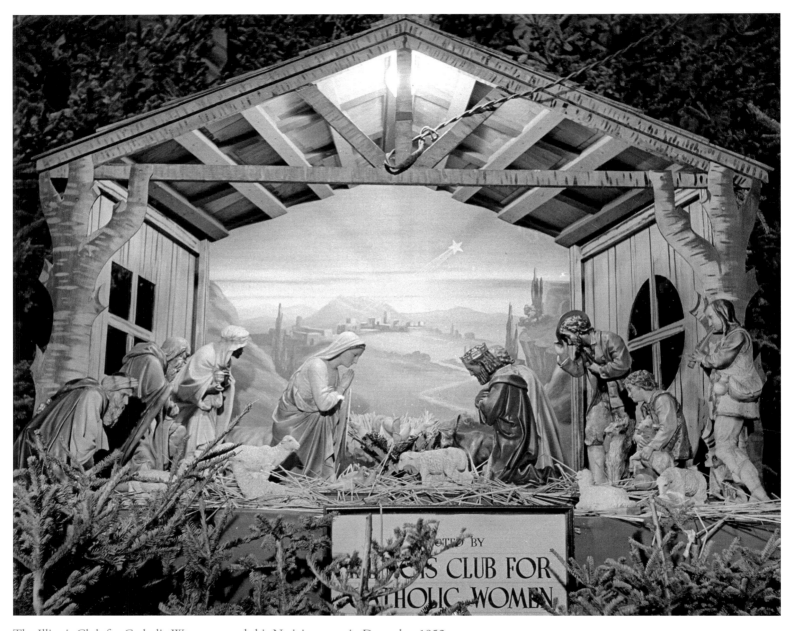

The Illinois Club for Catholic Women staged this Nativity scene in December 1952.

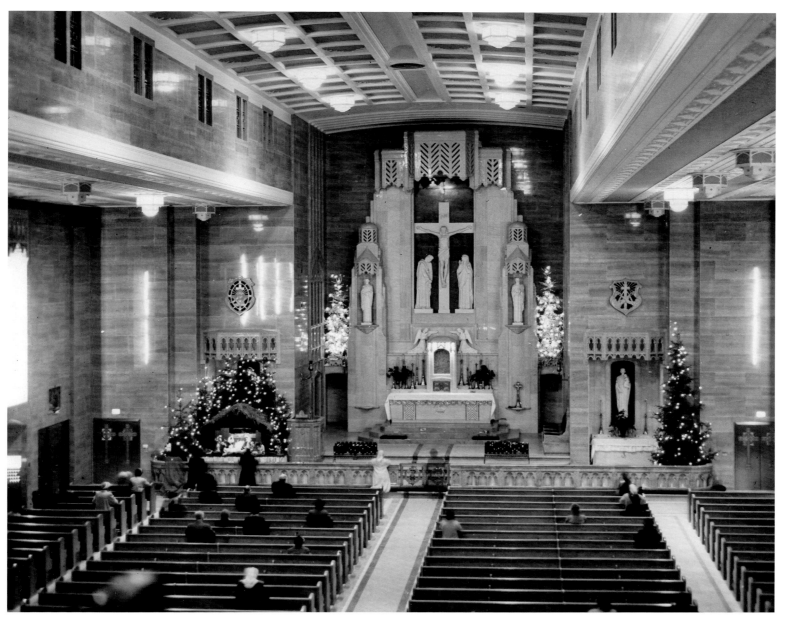

St. Peter's Church on Madison Street in the Loop decorated for Christmas.

NOTES ON THE PHOTOGRAPHS

These notes, listed by page number, attempt to include all aspects known of the photographs. Each of the photographs is identified by the page number, photograph's title or description, photographer and collection, archive, and call or box number when applicable. Although every attempt was made to collect all available data, in some cases complete data was unavailable due to the age and condition of some of the photographs and records.